MW00565098

THREADING TIME:

A Cultural History of

Threadwork

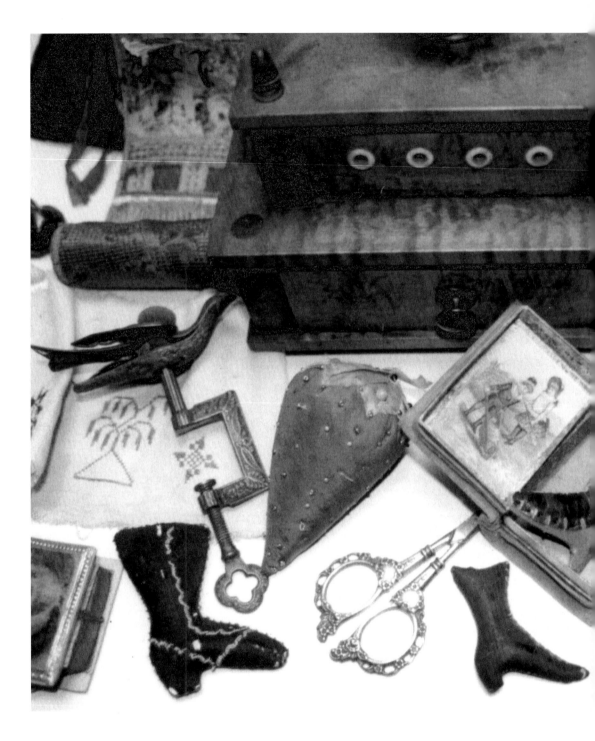

A Cultural

THREADING

History of

TIME

Threadwork

Dolores Bausum

TCU Press
Fort Worth, Texas

Copyright © 2001 by Dolores Bausum

Library of Congress Cataloging-in-Publication Data

Bausum, Dolores.
 Threading time : a cultural history of threadwork / Dolores Bausum
 p. cm.
 Includes bibliographical references.
 ISBN 0-87565-241-7 (alk. Paper)
1. Needlework. 2. Needlework—History. 3. Fancy work. 4. Fancy work—
History. I. Title.

TT750.B28 2001
746.4'09—dc21 00-051225

Design by Barbara M. Whitehead
Title page photo by Barbara M. Whitehead

Contents

Preface

Years ago my mother gave my brother the officer's sword worn by her paternal great-grandfather in the Union army; she gave me the silver thimble used by her maternal great-grandmother, widow of a Confederate soldier. During the winter of 1862, my Confederate ancestor wrote home from his position on the banks of the Mississippi River where "the wind has a fare sweep of us." He requested that his wife, his "dear and affectionate companion," send him "one bed quilt and also my knit shirt." Measles claimed his life soon after, yet his widow persevered, stitching clothing for their infant son and herself using the thimble now in my keeping. In the 1930s, she still occasionally wove cloth by hand on a pedal loom. Her silver thimble is a reminder to me today that shortages of warm clothing, shoes, socks, and blankets have caused perhaps as much human suffering as injuries inflicted in battles.

As a child, I had other reminders that human hands, skill, and time were behind all that I and my friends wore. Our mothers made our gowns, our dresses, and even underpants, which sometimes matched our dresses. I recall the excitement of watching newly acquired fabric evolve before my eyes into shapes of sleeves, collar, and cuffs which almost magically turned into something that would be pulled over my head for hem measurement and later worn proudly to school or church. That was being present at the creation! I was seven years old before I was taken to a store for a ready-made dress, and by then I knew how to look at seams to see how they were finished. Today, however, just two generations later, children and adults commonly blank out curiosity about the origins of finished threadwork products, whether they are mass-produced jeans or hand-woven medieval tapestries.

Perhaps because of my family heritage, I began, after two decades of teaching, to design and sell quilts stitched by master needlecrafters in Virginia. Eventually two of these Virginia-made quilts were presented to first ladies in the White House and others were displayed for several years in American ambassadorial residences in Portugal and Luxembourg. Over time the quilters whose work I represented became more interesting to me than their handworks. I felt compelled to learn more about earlier threadworkers whose effort, creativity, and skill produced both mundane and spectacular articles that have played a role in our physical survival and esthetic delight.

Something else compelled me. As buyers from near and far came to me for quilts in the 1980s, the soft fabrics, wonderful stitchery, designs, and colors in my shop awakened comforting memories in many of the visitors. Time and again I heard someone fondly recall the sewing done by a mother, grandmother, aunt, or other family member. "My mother's quilts weren't fancy," the person might say, "but she would set up a quilting frame in the winter and all her friends would come over to sew in the evening." Or someone would lament, "My grandmother gave a quilt to us when we married but we didn't appreciate what she'd given us." The common thread running through these recollections was a sense that needlework had created an emotional connection between the person who sewed and the person talking to me.

The visitors' reflections interwoven with my own earlier experiences added plausibility to my hunch that work with thread of various kinds has been a pervasive force in the psychological, emotional, and spiritual bonding of humans since earliest times. Believing that I was on to something scarcely explored before, I began searching historical and literary sources for evidence of the influence of earlier threadworkers. As my research progressed, I also "read" images of threadworkers in the rich iconography of visual art such as that found in stained glass, dry point etchings, and the illustrations for a medieval manuscript. Further, I studied countless items of threadwork itself in world-famous museums from Baltimore to Beijing, from Crete to Chicago—and I examined evidence of threadwork dating back at least thirty thousand years. My account itself is limited to North America, Western European, and biblical sources. My conception of threadwork throughout was generic, including all kinds of work done in and with thread, yarn, or fibers.

Threading Time: A Cultural History of Threadwork is the result of

my nine-year exploration of a portion of our culture that is far more important than is usually imagined. There is reason to conclude that for thousands of centuries humans associated spinning, weaving, and stitching fibers with their own interdependence and survival. The current, perhaps unconscious, expression of this age-old association of interwoven fibers with human experience is found in a metaphor we commonly use to convey the concept of shared traditions, values, and beliefs—the fabric of society. A rip in the fabric can be alarming; mending it from time to time is necessary to avert instability or even chaos. The connection between woven cloth and stability may be expressed also when we speak of "frayed relations" and "patching up relations" between individuals, groups, and countries. An attempt to discover the likely origins of such concepts and why they have meaning today has been part of the effort to test my theory that work with thread, since earliest times, has both created and reinforced a variety of life-sustaining bonds between individuals who are contemporaries as well as between individuals of different generations and cultures; between humans and their cultural traditions, beliefs, and objectives; between humans and the divine.

Acknowledgments

Henry, my companion for half a hundred years, and our adult children, David and Ann, faithfully paid out the ball of thread which secured me in a seemingly endless labyrinth of research and writing. Loyal friends and total strangers helped spin the ball of thread. Judy Alter, my editor, Robbie Anna Hare, my agent, and Susannah Driver-Barstow, who read and critiqued three drafts of the entire manuscript, recognized the originality and importance of my endeavor. To each and all I am grateful. It is my hope that you who read this will join in celebrating our heritage from those who have clothed us and kept our faith and dreams alive with threads.

IN HONOR of threadworkers who have played a vital, though often undervalued, role in our human relations, physical survival, and cultural experiences.

A Time to Sew

Two seminude figures, standing under an apple tree encircled by a serpent, introduced visitors to an exhibition of seventeenth-century English needlework at the Baltimore Museum of Art.[1] Embroidered circa 1660 by a now-unknown person, the silk-thread representations of Adam and Eve in the Garden of Eden are as recognizable in the embroidered picture as they have been for centuries in other media. A milkmaid and a shepherd, both dressed in Elizabethan fashion by the discreet needleworker, gaze at the scantily clad couple. Inscribed in tiny stitches at the top of the 14"x12" canvas is the age-old tale of cautionary hope:

> CREATED GOOD AND FAIRE /
> BY BREACHE OF LAWE A SNARE /
> DESIRE TO KNOWE /
> HATH WROVGHT OVR WOE /
> BY TASTINGE THIS/ TH' EXILE OF BLISSE /
> BY PROMIS MADE /
> RESTORD WE BE /
> TO PLEASVRES OF ETERNITYE.[2]

The embroiderer based this scene on an engraving published as the frontispiece of the Bishops' Bible, an English-language Bible printed in London in 1583. With silk and metallic threads and a few square inches of linen, the diligent threadworker conveyed ideas that for centuries

have provided a psychological and emotional bond in Western culture. The central figures in this embroidery are among the best-known images in European art. Yet as the twenty-first century begins, few persons are likely to know how the gravity-defying fig leaves on Adam and Eve influenced Judeo-Christian culture in the past and affect society to this day. What connection, for example, have the couple's loincloths to our understanding of human sexuality and to the age-old mystery of human suffering? Biblical tradition, where the idea of fashioning clothing is almost as old as human existence, suggests answers to these questions.

Reflections in a Needle's Eye

The oldest poems in the Hebrew Bible indicate that Adam and Eve sewed fig leaves together and made themselves aprons or loincloths.[3] These ancient poems also state that God made garments of skins and clothed the woman and the man before they left the Garden of Eden.[4] Thus the Old Testament story of Creation includes two references to the tailoring of clothing for humans.

The sacred texts containing the poems, prayers, history, laws, and prophecies of the ancient Israelites were written over a period of more than a thousand years.[5] "From very early times," according to Hebrew literature scholar James L. Kugel, "sages and scholars in ancient Israel had made a practice of looking deeply into the meaning of these sacred writings, and, with each new generation, their insights and interpretations were passed on alongside the texts themselves."[6] Thus, continues Kugel, the Israelites inherited a body of traditions along with what became the Bible's various books. The interpretation of the Eden story, which large numbers of twentieth-century Jews and Christians in the West learned early in life, closely parallels the one pictured on the seventeenth-century embroidery exhibited at the Baltimore Museum of Art. According to this way of thinking, sinless Adam and Eve lost their innocence by yielding to the tempter serpent; consequently God, their creator, drove them from the Garden of Eden into a world of woe. But this is not the only version of the story that has been told through the centuries. Religious spokespersons, writers, and artists have invoked the story of Adam and Eve in Genesis to support a multitude of ideas ranging from the fourth-century claim that all sexual desire is sinful to the

1776 declaration that all humans are created equal.[7] The time and place in which people live influence how they perceive the first couple's behavior in Paradise.

Some early biblical interpreters took particular interest in the first couple's decision to make themselves loincloths and in God's subsequent act of clothing the man and woman. In the *Book of Jubilees,* written about 150 years before the birth of Jesus, a Palestinian Jew asserts that just as God clothed Adam and Eve, so Jews must "cover their shame and not go naked as the Gentiles" do in public places.[8] The Jewish custom forbidding nakedness in public baths and gymnasia was not arbitrary or trivial, according to the early author, but required of humans from the beginning.

Although this and other negative images of Adam and Eve appeared in ancient Jewish texts as well as in the New Testament, for most of the first four centuries following the birth of Christ, according to Elaine Pagels of Union Theological Seminary, Jews and Christians regarded the primary message of Genesis chapters 1–3 as "affirmation of human freedom to choose good or evil."[9] The exercise of free will, freedom from demonic powers, freedom from social and sexual obligations, and freedom from tyrannical government were all possible and God given if one practiced self-mastery. Nevertheless, notes Pagels, within a hundred years after Christianity became the official religion of the Roman Empire in the early fourth century C.E., interpreters transformed the story of Adam and Eve from a message of freedom into a tale of bondage, suffering, and sin for all humanity.[10] Why did such a radical change occur?

The Christian theologian and bishop Augustine (c. 354–430 C.E.) was particularly influential in shaping the somber new interpretation of Genesis 1–3. Augustine denied that human beings have free moral choice; instead, the bishop argued that Adam's desire for control over his own will became the root of sin in the whole human race.[11] Augustine viewed Adam and Eve's decision to eat the forbidden fruit of the Tree of Knowledge and their subsequent decision to cover their nakedness as revealing that they experienced shame and guilt along with carnal desire after they chose to disobey God. The penalty for Adam and Eve's disobedience passes forever from generation to generation through semen at the moment of conception, according to Augustine's interpretation, and "every human being ever conceived through semen

already is born contaminated with sin."[12] "[M]an by his very nature," he wrote, "is ashamed of sexual desire."[13] Proof for this "is the universal practice of covering the genitals and of shielding the act of intercourse from public view."[14] Thus the fig leaves-cum-loincloths were Augustine's symbol of the fall of humankind.

Augustine's ideas encountered strong opposition from some of his contemporaries. However, he persistently and persuasively asserted his views. Church leaders continued the debate over original sin even as Augustine's ideas slowly gained acceptance in Western Christendom. Early Church leaders adopted his negative image of human nature, and it became a prevalent influence in Western culture. Pagels concludes that the idea of original sin survived and became the basis of Christian doctrine for 1,600 years in large part because it gives a meaning to human history. "Many people need to find reasons for their sufferings," Pagels asserts, and they "often *would rather feel guilty than helpless*" in a world of purposeless chaos.[15] Human existence is not meaningless in Augustine's way of thinking: all people, like Adam and Eve, make choices and are responsible to a providence that can be merciful.[16]

The seventeenth-century embroiderer's scene beneath the apple tree reinforces this centuries-old psychological and emotional bond of human guilt, remorse, and need for forgiveness from each other and from God.

Many others through the ages, from medieval artisans to contemporary cartoonists and journalists, have also found inspiration in this traditional image of the original seamstress and seamster. To give just three recent examples: A 1994 *The New Yorker* cover featured a drawing by cartoonist Edward Sorel titled "The Fall." In it a stern-visaged God is shown pushing Adam and Eve au naturel out of a lush green garden toward a single bamboo rake in an area carpeted with dry autumn leaves.[17] Also in the 1990s, humor columnist Art Buchwald announced that he was writing the "real story of Adam and Eve," and he offered his readers an advance look at his work in progress.[18] His plan included the legendary Fall complete with the Tree of Knowledge, forbidden fruit, serpent, and other well-known elements.

American poet Charles Harper Webb suggests that envy and/or vanity caused the first couple to clothe themselves: "The serpent didn't hiss / to Adam and Eve, 'Hide your nakedness.' / He wore his best suit / and whispered, 'Look at this!'"[19]

Thus for many of us an irrational, erotic Eve, and a spineless, pliable Adam must forever answer the Grand Inquisitor: "Who told you that you were naked?"

The Third Tailor

The third tailor in Eden was the Creator who also made the evening and the morning and every living creature and said it was good. The ancient Hebrew story states simply: "And the Lord God made garments of skins for the man and for his wife, and clothed them."[20] The evidence in the Genesis account that clothing was the only possession that God provided for Adam and Eve to take from Paradise underscored, for Augustine, the connection between clothing, sexual desire, and sin. For over a thousand years, from the time of Augustine to the Protestant Reformation, the Roman Catholic Church taught its faithful to see that divine tailor as an angry God. The garments that Adam and Eve wore as God banished them from the Garden branded the pair guilty of disobedience.

In the sixteenth century, however, Protestant reformer John Calvin (1509–64) portrayed a more benevolent image of the divine tailor. Calvin taught that by providing Adam and Eve with clothing God expressed paternal love for the couple and softened his separation from them.[21] In *Paradise Lost* (1667) the Puritan John Milton envisioned God as "pitying how they stood / Before him naked to the air, . . . / As father of his family he clad / Their nakedness with skins of beasts. . . . "[22] Another seventeenth-century English poet, John Taylor, in *The Praise of The Needle* (1631), noted that Adam and Eve's needlework set a useful precedent:

> The use of Sewing is exceeding old,
> As in the sacred Text it is enrold:
> Our Parents first in Paradise began,
> Who hath descended since from man to man:
> The mothers taught their Daughters, Sires their Sons,
> Thus in a line successively it runs
> For generall profit, and for recreation,
> From generation unto generation.[23]

✜ ✜ ✜

> And by the Almighti's great command, we see
> That Aarons Garments broydered worke should be;
> And further, God did bid his Vestments should
> Be made most gay, and glorious to behold.[24]

Evidence of the association of clothing with a caring provider also can be seen in a small silver plaque made in eleventh-century Spain, perhaps as a book cover, by a Byzantine craftsman. The plaque, titled "The Robing of Adam and Eve," portrays God as Christ assisting Eve as she pulls a tunic over her head; Adam, already robed, stands solemnly to Eve's left. The metalcrafter lived in an age when limited sources of fuel made clothing the primary means of providing warmth for humans. His simple image is a metaphor for a theme that continues through the ages: the gift of clothing is a gift of life. Like the seventeenth-century embroiderer whose seminude Adam and Eve we saw earlier, this solitary craftsman also conveyed theology with the work of his hands. But his theology differs from that of the embroiderer. In his creation we find an alternative to the seemingly ubiquitous medieval rendering of a stern God showing disobedient Adam and Eve the Garden gate or sitting on his heavenly throne in final judgment of all humankind.

Today Carol Meyers, Duke University linguist and archaeologist, also suggests a non-Augustinian interpretation of the Eden story. She has analyzed the original Hebrew language of Genesis 2 and 3 in the context of archaeological discoveries about the nature of rural village life in ancient Palestine. Her conclusion is that the earliest Jewish and Christian communities used the Genesis stories as they used many other parts of the already ancient and sacred literature of Israel: to help them deal with their own sociological and theological concerns.[25] Genesis 2 and 3, writes Meyers, can be interpreted as "a tale meant to help human beings come to grips with the nature and meaning of their own existence. In this sense, the biblical creation stories differ fundamentally in purpose from scientific explanations or theories of origins."[26] The Genesis narrative is couched in temporal language because it presents human life, which exists in time, explains Meyers, and not because the specific characters existed in time. The Creation story is a parable of the human situation in ancient Israel.

Meyers believes that the Edenic stories of Genesis helped the ancient Israelites adjust to the sparse resources of their mountainous

land "in the earliest period of their . . . self-consciousness as Yahweh's people."[27] The ancient Israelites were "frontierspeople," and the production of subsistence goods such as clothing was essential to their survival in the Palestinian highlands of "thorns and thistles."[28] Archaeological evidence supports the idea that each household provided for its own needs and "reveals the almost ubiquitous use of needles, spindle whorls, and other clothing-related tools in domestic contexts."[29] A father-God who made clothing for his needy children would have strong resonance for such a people.

Benevolent views of the divine tailor may be rare, yet they show that it is possible to infer from the Genesis story that the Almighty Creator anticipated his fragile creatures' need for clothing during future cold nights and hard days of toiling as they cut cisterns and cleared rocky hilltops outside Eden.

Twentieth-century scholar Robert A. Oden suggests there is an alternative to the image of God as either chastising judge or loving father. To clothe, he reports, is regularly employed in the Hebrew Bible in the context of a presentation of a gift from a person of superiority—social, religious, or kinship—to that person's subordinate. The garment and its formal presentation are symbolic indicators of the status of the presenter and of the receiver.[30] Consider these examples: the clothes, ring, and chain given by the Egyptian pharaoh to Joseph in conferring high office upon him; the vestments presented to Aaron and his sons denoting their sacred status; the long robe worn by Tamar symbolizing her position as the king's maiden daughter. Oden concludes: "Yahweh's act in presenting clothing to [Adam] and [Eve] is not a gracious concession. It is an authoritative marking of the pair as beings who belong to a sphere distinct from that of the divine. . . . [It] is a significant symbolic act that firmly distinguishes humans from the divine."[31] Thus at least three distinct images of God as threadworker can be imagined today: a stern judge, a provident father, a Holy Other.

A Coat Woven into History

Clothing figures prominently in another well-known biblical story that opens dramatically: "Now the Lord said to Abram [Abraham], 'Go from your country . . . to the land that I will show you.'"[32] Historians

believe that Abraham left his native Mesopotamia about 1800 B.C.E. to migrate to Canaan. At the time he left, and for perhaps a thousand years earlier, the southern part of Mesopotamia (now Iraq) had cities with 8,000 to 12,000 inhabitants who believed that their city belonged to one particular god or goddess. Temple economies arose in which a chief priest distributed the products of the city and the harvest of the surrounding land to clothe and feed the citizens. Amid the temple precincts were workshops for producing textiles and other goods.[33]

Abraham left this land of urban development to go as a pioneer to the sparsely settled hill country of Canaan, the ancient name of western Palestine. His descendants in the new land included a son, Isaac, and a grandson, Jacob. When Jacob was an old man living in the land where his grandfather Abraham had been a stranger, he "made . . . a long robe with sleeves" for his son Joseph.[34] Whether Jacob, or those who perhaps helped him, were skilled craftspersons is unknown. The biblical account states only that Jacob's gift was, as is true of much threadwork today, a labor of love. The garment conveyed Joseph's preferred status in his father's eyes. Jacob, so it is said, "loved Joseph more than all his children because he was the son of his old age."[35]

Even when recalling Jacob's youthful selfishness in lying to his father, Isaac, and stealing from his brother, Esau, one may still view Jacob with compassion by picturing him as a gray-haired father planning and weaving a colorful robe for his youngest son. Perhaps as Jacob sees the work progress, he remembers deceiving his own bedridden, aged father. This gift for Joseph could symbolize an epiphany for Jacob, a token of his gratitude for the blessings God bestowed on him despite his earlier misdeeds. Jacob is, of course, unaware of the future. Soon after the ornamental tunic is completed, it causes tragedy in the family when Jacob dispatches Joseph to check on the welfare of his older brothers and the flock they tend beyond the vale of Hebron. With neither father nor son dreaming that years will pass before they will see one another again, Joseph, arrayed in the new garment, goes out to find his eleven brothers. When they see that the beautiful coat is for Joseph, all but the eldest seethe with envy. They rip off the new coat and sell Joseph for twenty pieces of silver to Midianite merchantmen passing by on their way to Egypt.

With Joseph bound for a foreign land, his brothers cleverly and cruelly use the work of their father's imagination to disguise their own das-

tardly deed. They slaughter a goat and dip the ill-fated coat in the fresh blood. Then they present the blood-stained, torn coat to their dumb-struck father. They might as well have flung the damaged garment in the old man's face, and, in a sense, they did. Recognizing the once beautiful coat, Jacob cries: "It is my son's robe! A wild animal has devoured him; Joseph is without doubt torn to pieces."[36] Then Jacob tears his own garments, puts sackcloth on his loins, and mourns for his missing son.

The decorated robe made by Jacob is woven intricately into Western tradition. For some, it is a symbol of parental love, whether wise or foolish. For others, it epitomizes sibling envy and wrenching family estrangement. It is also seen as an example of God's using events in history—even acts of human weakness—as means to divine ends. This simple story of misguided love and envy is often one of the earliest moral tales children encounter. Allusions to it are obvious in the Broadway musical *Joseph and the Amazing Technicolor Dream Coat* and in the multicolored garden plant called Joseph's coat.

The biblical robe, however, refuses to be reduced to triviality. It continues to symbolize human decisions and actions that were historically decisive, including the enslavement of Abraham's descendants in Egypt and their eventual release from captivity and return to the Promised Land. The robe remains a direct link in much contemporary Judaic and Christian tradition—from belief in God's deliverance of Abraham's descendants from bondage in Egypt to belief in the possibility of God's intervention in human affairs. Finally, a thread runs from the clothing sewed in Eden to the coat woven in Canaan; each garment signals the beginning of a fateful journey to a new land.

Sewing for the Glory of God

The Book of Exodus tells the story of Jacob's descendants on their way from Egypt back to Canaan.[37] It also contains the earliest biblical reference to threadworkers who devote their work to God's glory. In the course of the Israelites' forty-year trek back to the Promised Land, God speaks on Mount Sinai to their leader, Moses, saying, "have them make me a sanctuary, so that I may dwell among them. In accordance with all that I show you concerning the pattern of the tabernacle . . . so you shall make it."[38] God describes in great detail his requests for the

contents of the tabernacle and the tent that will cover it. Among the materials He requests for the entrance of the tent and the gate of the court are "ten curtains of fine twisted linen, and blue, purple, and crimson yarns; you shall make them with cherubim skillfully worked into them."[39]

And needlework "most gay and glorious to behold," as seventeenth-century English poet John Taylor said, is commissioned for the priests who will serve in the tabernacle:

> [M]ake sacred vestments for the glorious adornment of your brother Aaron. . . . [S]peak to all who have ability, whom I have endowed with skill. . . . These are the vestments that they shall make: a breastpiece, an ephod, a robe, a checkered tunic, a turban, and a sash. When they make these sacred vestments for Aaron and his sons . . . they shall use gold, blue, purple, and crimson yarns, and fine linen.[40]

After Moses descended from Mount Sinai and gave God's instructions to the people journeying with him, "all the skillful women spun with their hands, and brought what they had spun in blue and purple and crimson yarns and fine linen; all the women whose hearts moved them to use their skill spun the goats' hair."[41] One can see in such phrases as "whom I have endowed with skill" and "all . . . whose hearts moved them to use their skill" that God established a standard of willing competence for the workers. Even today some protest they have no talent for sewing, knitting, or other crafts while others refer to their God-given skills in these and other pursuits.

Let us now praise unknown threadworkers, male and female, who through the ages have woven, embroidered, and sewed in temples, cathedrals, synagogues, and all other houses of worship. From hand-wrought needlepoint cushions in the National Cathedral in Washington, D.C., to hand-embroidered altar cloths in one-room wooden churches of Appalachia, the tradition endures. Many Amish and Mennonite women, for example, go faithfully to their churches once a week to sew for others less fortunate; some also annually make and donate a quilt to be sold at an auction to raise money for relief work among the needy around the world. Like the ancient Israelites, these artisans traditionally use bright blue, purple, and crimson colors in their needlework. These colors are called Amish today.

A modern visitor also finds these vivid colors in Prague's Josefov, or Jewish Town, in linen as well as velvet curtains "wrought with needle-work" of intricate and beautiful designs. A collection of curtains, made over the past four hundred years to cover doors of the ark containing the sacred Torah scrolls, were on display in the Maisel Synagogue in 1997. Each curtain was unique in design, although several included embroidered representations of the sacred gate for the court of Solomon's temple. The sixteenth-century curtains in the collection featured an assortment of minute flowers, plants, and animals, which reflected that period's newfound aesthetic appreciation for beautiful and rare plants.

The Torah curtains are powerful symbolic images of God's hidden word. They also illustrate the continuing power of visual images to reach out and engage the viewer, just as does that seventeenth-century embroidered representation of Adam and Eve in the collection at the Baltimore Museum of Art. In the centuries-long debate about whether written words or visual images are superior as tools for human communication—a competition that continues among developers of computer software programs—threadworks such as these support the case for the communicative power of graphics.

A guide at the Maisel Synagogue in Prague noted that men embroidered all the Torah mantles on display there. Her information is not surprising considering that for centuries only Jewish boys received formal religious instruction and learned to read Hebrew. Only they could approach the Torah and read from it as they celebrated their passage into adulthood at a bar mitzvah. Since the bat mitzvah has in recent years become commonplace for Orthodox and Reform Jewish girls, the privilege of embroidering Torah screens may become traditional for Jewish women as well as men.

Portrait of a Capable Woman

The Book of Proverbs characterizes a "capable woman" or "virtuous woman" in the context of ancient Israelite society approximately six hundred years after the Exodus of the Israelites from Egypt. Among the attributes ascribed to her in Proverbs 31 are various threadwork skills:

> She seeks wool and flax, and works with willing hands. . . . Her

> lamp does not go out at night. She puts her hands to the
> distaff, and her hands hold the spindle. . . . She is not afraid for
> her household when it snows, for all her household are clothed
> in crimson. She makes herself coverings; her clothing is fine
> linen and purple. . . . She makes linen garments and sells them;
> she supplies the merchant with sashes. . . . Give her a share in
> the fruit of her hands, and let her works praise her in the city
> gates.[42]

A distorted portrait of this woman stands out in the memories of some who, as children early in the twentieth century, heard Mother's Day sermons based on Proverbs 31. These homilies tended to skim lightly over this scripture's references to threadwork and concentrate instead on the conjugal and maternal pieties that are only a portion of the passage:

> The heart of her husband trusts in her. . . . She does him good,
> and not harm, all the days of her life. . . . Her children rise up
> and call her happy; her husband too, and he praises her: 'Many
> women have done excellently, but you surpass them all.'[43]

The above focus was narrow. The poet's unabridged description of a capable woman in ancient Israelite society, including her diligence at producing and marketing garments, conveys a powerful ideal of womanhood. This is a supremely gifted woman. She is a wife, a mother, a creator of high-quality textiles, a skilled seamstress, and a businesswoman with management skills related to labor and commerce:

> She is like the ships of the merchant, she brings her food from
> far away. She rises while it is still night and provides . . . tasks
> for her servant-girls. She considers a field and buys it; with the
> fruit of her hands she plants a vineyard. She girds herself with
> strength, and makes her arms strong.[44]

No submissive, dependant female is pictured here. This woman is corporate-board material, an ideal role model for a twenty-first-century woman. Over the centuries some have conveniently ignored portions of this portrait, while others have exploited this biblical idea of a "capable woman" by excessively burdening young girls and women with hard work. Either way, this woman clothed in fine linen and unafraid for her

household when it snows has influenced the fabric of life in the West and perhaps that of other parts of the world.

A Time to Tear

One other important use of threadwork by the Israelites deserves recognition here. They deemed clothing worthy for sacrifice in moments of deep sorrow or remorse, and it played a role in ritually symbolizing the end of life itself. A well-known poem of the preacher's in the Book of Ecclesiastes includes a reference to this sacred purpose: "For everything there is a season, and a time for every matter under heaven . . . a time to be born and a time to die . . . a time to mourn and a time to dance . . . a time to tear [rend] and a time to sew."[45]

The words "tear" and "tore" occur numerous times in the Bible. Consider these four examples:

> When Reuben returned to the pit and saw that Joseph was not in the pit, he tore his clothes.[46]

> Then Jacob tore his garments, and put sackcloth on his loins, and mourned for his son many days.[47]

> But Tamar put ashes on her head, and tore the long robe that she was wearing; she . . . went away, crying aloud as she went.[48]

> Then David took hold of his clothes and tore them; and all the men who were with him did the same. They mourned and wept. . . .[49]

In each instance cited above, the context suggests neither irrational grief nor anger, but a deliberate ritual use of clothing to help a person negotiate painful separation. A "time to tear" clearly refers to the ancient ritual of tearing garments as a sign of mourning.[50]

The depth of unspeakable feeling which the Renaissance artist Raphael associated with the practice of tearing one's clothing in times of deep sorrow is reflected in "St. Paul Rending His Garments," a drawing in the J. Paul Getty Museum. The drawing shows the apostle's entire body twisted in agony, while both his hands pull at the toga wound round his shoulders. His head is turned aside, his eyes are down-

cast in shame or sorrow. His lips are parted as though he is groaning.

To this day, Orthodox Jewish mourning rites involve the symbolic tearing of a garment and wearing a torn fragment of cloth for seven days. When, for example, Menachem Schneerson, the grand rabbi of the Lubavitcher Jews, died in 1994, "as far as the eye could see, there were bearded men dressed in the Hasidim's traditional black pants, coat and hat," reported the Associated Press, and "men tore their shirts or jacket lapels" while "women wept wildly."[51] And after the assassination of Israeli Prime Minister Yitzhak Rabin, one rabbi reportedly referred to "the old Jewish custom of ripping one's clothing in grief," adding: "We have to make a tear in our shirt over profaning the name of God, over the fact that such a thing happened in Israel."[52]

Clothing protects individuals against physical suffering and exposure to humiliation.[53] A cry of helplessness and forsakenness invades the soul of an individual who is forced to bare himself or herself. Yet the ritual rending of clothing has been, and continues to be, an attempt to communicate with the Holy Other. It denotes a rip in the fabric of human relationships and time and, ironically, a fateful journey into a new world. Once more clothing becomes the medium of the message; it is the connecting bond symbolically broken.

Only six direct references to "sew" or "sewing" occur in the King James seventeenth-century Bible translation; yet products of sewing are repeatedly mentioned. "Garment," for example, occurs almost two hundred times, while words such as "cloth," "clothing," and "clothes" are used even more frequently. Still, the preacher in Ecclesiastes balances them on his scales: a time to rend and a time to sew. The parallel construction suggests that "a time to tear" (death) is the opposite of "a time to sew" (life). A wonderful thought for threadworkers: their labor, their creations are equated with the most profound human experiences, the beginning and end of life itself.

The poetry in the Book of Ecclesiastes calls us to remember how the symbol of clothing reverses itself in Holy Writ: God creates and clothes Adam and Eve in Eden; man and woman destroy clothing when the thread of human life is severed. We can conclude that early threadwork was important for much more than covering for the human body: it provided language and ceremony which nourished the human soul, as in "O Lord my God, you are very great. You are clothed with honor and majesty, wrapped in light as with a garment. You stretch out the heav-

ens like a tent. . . .You cover [the earth] with the deep as with a garment. . . ."[54]

Documentation of Early Threadwork

Words and phrases such as spindle, distaff, flax, and fine twined linen embroidered with needlework appear in biblical passages quoted above. What did such words mean to people long ago, and when did they learn to spin, weave, and embroider? Scholars continue searching for answers to questions about early textile crafts. In addition to reports found in biblical narratives, historical and archaeological evidence suggests humans made clothing in the centuries before the Old Testament stories developed and were written down, as well as in the centuries in which the ancient Israelites may have looked to those stories for a reflection of and a guide through their own actual material circumstances. By the late Bronze Age (circa 1400–1200 B.C.E.), which scholars now think of as the time of the Exodus of the Hebrews from Egypt, people living in the eastern Mediterranean area would have had thousands of years to discover and develop the materials and means to manufacture textiles for clothing and other uses.

"The textile industry is older than pottery and perhaps even than agriculture. . . . [but now] we have forgotten that this was for generations the most time-consuming single industry," writes linguist and archaeologist E.J.W. Barber.[55] More than thirty thousand years ago, notes Barber, the principle of producing thread by strengthening fibers through the twist was known, and remarkably little improvement in the making of thread occurred during the following fifteen to twenty thousand years.[56]

New York University archaeologist Randall White compared materials he found in outcroppings at the base of the Pyrenees Mountains in 1993 with French Paleolithic artifacts in the Logan Museum at Beloit College in Wisconsin. White concluded that 130 Aurignacian beads and pendants made of soapstone and ivory, found by archaeologist Alonzo Pond in 1924 and now in the Logan Museum, "were probably sewn onto a garment" thirty thousand or more years ago by Cro-Magnon peoples who used shells and stones for clothing ornamentation.[57]

Many museums today contain artifacts that provide evidence of textile crafts developed and used in the period 35,000–8,000 B.C.E. The

Museum of National Antiquities located at Saint-Germain-en-Laye, outside Paris, preserves one of the largest collections of skin-working tools in the world. Artifacts such as stone scrapers for cleaning and softening hides from this period before written history and needles, some with very fine eyes, made from natural materials such as stone or bone are on display there. Museums in Lucerne, Athens, London, and elsewhere hold prehistoric artifacts that illustrate the slow progress of humanity in developing the tools and arts of fiber crafts. In supplying their clothing needs for tens of thousands of years, early humans exploited a wide range of natural materials including stone, bone, antlers, shells, ivory, and tree bark as well as vegetable fibers, animal skins, and stringy animal tissue.

Archaeologists found the first proof of prehistoric weaving in the 1960s at Jarmo in northeastern Iraq. They carbon-dated evidence, consisting of imprints of thread and cloth preserved on two small balls of clay, to circa 7000 B.C.E.[58] In December 1999, three archaeologists— Olga Soffer, James M. Adovasio, and David C. Hyland—reported finding impressions of early textiles on a number of ancient fragments of both fired and unfired clay. The oldest of the textile impressions dated to 29,000 B.C.E. Adovasio estimates that "weaving and cord-making probably goes back to the year 40,000 B.C.E. 'at a minimum,' and possibly much further."[59]

At the present time the Judean desert in Israel is among the earliest sites where archaeologists have found actual textiles. There, in a small, dry cave at Nahal Hemar, weft-twined and netted cloths and bags as well as mats and baskets, were found and carbon-dated to the pre-ceramic Neolithic period of about 6500 B.C.E.[60] The earliest evidence of linen weaving found in Egypt "seems to be the swatch of coarse linen found in a Neolithic—early 5th-millennium—deposit" in the desert of Faiyum.[61] Barber notes "that fiber crafts were busily developing throughout the early Neolithic in this entire area."[62] According to a report published in 1993, archaeologists from the University of Chicago and Istanbul University discovered a nine-thousand-year-old woven fabric in an area of southern Turkey. Robert Braidwood and Halet Cambel found the 3x1-½-inch textile wrapped around the handle of a tool made from an antler which, being calcium rich, helped preserve the fabric.[63] Even earlier textile finds are likely to be reported in the future.

Textile workers used a variety of fibers and techniques for early spinning and weaving. Flax was the fiber almost universally found and used to weave linen. Wool fibers from sheep or goats appear less frequently in prehistoric textile finds than flax, and they appear earlier in ancient Palestine and Bronze Age Greece than in Egypt which "clung to its archaic but excellent linen manufacture until Roman times."[64] Some but not all early spinners likely used a simple stick (later called a distaff) to hold a mass of carded fibers; a piece of string wound loosely about the fibers held them in place. A spinner probably held this stick or distaff in the bend of the left arm or thrust it into the ground nearby. With the bare fingers of the right hand, the spinner could draw fibers such as wool or flax from the distaff and twist them as he or she pulled them into a continuous piece, thereby producing yarn or thread.

Since spun fibers untwist very quickly unless they are held by some means, the original spinners must have learned through experiment to wind the fibers on a second stick (later labeled a spindle). Through trial and error, these original spinners likely also learned that, when they added a lump of mud or clay, a stone, or a piece of wood to the spindle, fibers wound more smoothly as the spindle revolved. This added weight also kept the yarn from slipping off the spindle. Such weights, called whorls, were often molded, carved, or painted attractively. Archaeologists have found tens of thousands of prehistoric clay whorls in Egypt, Palestine, Greece, and elsewhere. Clay survives well, but ancient spindles and distaffs, usually made of perishable wood, are rarely found undamaged. Some distaffs made in more recent centuries have been works of art themselves. The Folk Art Museum in historic Nauplion, Greece, for example, preserves a large, impressive collection of hand-carved wooden distaffs with fantastic designs as delicate and varied as snowflakes.

The rudimentary basics of textile weaving are familiar to anyone today who as a child wove pot holders. Something is needed to hold one group of fibers stretched taut, end to end, while the weaver inserts another group of fibers, one by one, between one or more of the fibers under tension. A frame or loom holds the first group of threads, called warp, taut as the weaver pushes the other threads, called weft, through the warp. The warp threads stretched on the loom and the cloth partially woven in the warp are referred to as the web.[65]

Looms of several kinds were among the first objects invented for the

making of cloth. Each kind provided a means of holding the warp threads stretched under tension so that the weaver could separate them and insert the weft threads. Depictions on excavated dishes and cylinder seals, and particularly on tomb paintings in Egypt, suggest that the people in Neolithic Egypt, Palestine, and Mesopotamia developed a simple weaving loom consisting of two separate wooden beams pegged firmly into the ground some distance apart. Warp threads were stretched between the two beams. Then one or two weavers, sitting on the ground, worked weft threads into the warp. Such looms are known as two-beam horizontal ground looms; some weavers still use them today in Greece, Turkey, and elsewhere in central Asia. There is even speculation that Delilah worked at a ground loom in ancient Palestine when she wove Samson's hair into a web as he slept.[66] "If you weave the seven locks of my head with the web and make it tight with the pin," Samson promised, "then I shall . . . be like anyone else." When he later awoke, Samson "pulled away the pin [of the beam], the loom and the web."[67] Apparently he left in haste, with the locks of his hair interwoven in the web and the wooden beam of the loom dangling around his shoulders!

In Israel (ancient Palestine), Greece, Turkey, Hungary, and other areas that later became known as countries of Europe, workers (some calculated as early Neolithic) constructed looms vertically rather than at ground level. Looms like this are now referred to as one-beam vertical warp-weighted looms. Standing more or less upright, the loom's warp beam was securely fastened between two trees or in a wooden framework. Weavers attached one end of each warp thread to the wooden beam suspended about six feet above ground; they tied stone or clay weights to the lower end of groups of warp threads to keep them taut so that the weaver could push the weft threads to and fro in the web stretched from the beam. Weights excavated at scattered Neolithic sites confirm the widespread use of this type of loom. Representations in Cretan Linear Script A and on vases from early classical Greece provide further evidence that two or more standing weavers started work at the beam above their heads and pushed each completed weft row up toward the beam.

Weavers used a third primary loom in the prehistoric era. It is known now as the two-beam, vertical loom and was developed circa 1500 B.C.E. The persons who made this loom gave the horizontal ground loom side supports and lifted it upright to lean against a wall or

be held upright by two posts. This loom is similar to tapestry and rug looms still used today in Africa, central Asia, and the Near East, and by the Navajo Indians of the American Southwest. In all three types of pre-historic looms, a snub-nosed, short stick, wound about with thread, was used in place of fingers as the means for passing weft threads across the warp threads. Much later in the West—about the tenth century—this stick evolved into a shuttle, a device usually made of smooth wood and hollowed to contain thread or yarn that unwinds as it passes to and fro between warp threads.[68]

By 3000 B.C.E. (more than a thousand years, according to scholars, before Abraham left Mesopotamia) the inhabitants of the Fertile Crescent needed cloth for new reasons. They had by then invented several textile devices that were important in processing the foodstuffs they grew in irrigated gardens. Pictures of one of these devices, the bag press, have been found on the walls of Egyptian tombs constructed about this time. Cloth sails, another innovative use of textiles that developed in the changing technological environment of the ancient world, improved navigation of the Nile.

While preparing fibers to weave and weaving itself were still time-consuming tasks and remained so until the Industrial Revolution of the eighteenth century, evidence such as that cited above indicates that Abraham and Sarah, their grandson Jacob, and their descendants were heirs to an already ancient textile legacy.

Notes

1. "Adam and Eve", an embroidered picture displayed in the exhibition *In PRAYSE of the NEEDLE,* at The Baltimore Museum of Art, Baltimore, Maryland: August 13, 1997 – February 15, 1998.

2. Ibid.

3. Genesis 3:7. All biblical references in this chapter are taken from the New Revised Standard Version Bible (Nashville: Thomas Nelson, Inc., 1989).

4. Ibid., 3:21.

5. James L. Kugel, *The Bible As It Was* (Cambridge: Belknap Press, 1997), p. xiii.

6. Ibid.

7. Elaine Pagels, *Adam, Eve, and the Serpent* (New York: Vintage Books, 1989), pp. xix–xx.

8. Quoted by Pagels, p. 12.

9. Pagels, p. 97.

10. Ibid., pp. 97, 99.

11. Ibid., p. 109.

12. Pagels, p. 109; Kugel, p. 72.

13. Augustine, *De Civitate Dei,* 14, 17, as quoted by Pagels, p. 112. Pagels' interpretation of Augustine's views, as reported in *Adam, Eve, and the Serpent,* forms the basis of my summary of his views.

14. Augustine, *Confessions* 8, 5, as quoted by Pagels, p. 112.

15. Ibid., p. 146.

16. Ibid., pp. 146–147; Jaroslav Pelikan, *Mary Through the Centuries: Her Place in the History of Culture* (New Haven: Yale University Press, 1996), p. 41.

17. *The New Yorker,* October 3, 1994.

18. Art Buchwald, "Adam & Eve: The Real Story," *The Washington Post,* October 5, 1993.

19. Charles Harper Webb, reading "Buyer's Remorse," on *All Things Considered,* National Public Radio, February 8, 2000.

20. Genesis 3:21.

21. Robert A. Oden Jr., *The Bible Without Theology: The Theological Tradition and Alternatives to It* (New York: Harper & Row, 1987), p. 96.

22. Ibid., 96–97, quoting John Milton. See *Paradise Lost,* ed. S. Elledge (New York/London: Norton, 1975), p. 218 (book 10, verses 211–22).

23. John Taylor, "The Praise of the Needle," lines 57–64, The Chadwyck-

Healey *English Poetry Database* at the Electronic Text Center, University of Virginia, Charlottesville.

24. Ibid., lines 67–70.

25. Carol Meyers, *Discovering Eve: Ancient Israelite Women in Context* (New York: Oxford University Press, 1988), p. 72.

26. Ibid., p. 79.

27. Ibid., p. 120.

28. Ibid., pp. 53–56.

29. Ibid., p. 143.

30. Oden, pp. 100–101.

31. Ibid., p. 104.

32. Genesis 12:1.

33. Melvin Kranzberg and Carroll Pursell, *Technology in Western Civilization,* vol. 1 (New York: Oxford University Press, 1967), pp. 26–28.

34. Genesis 37:3.

35. Ibid.

36. Ibid., 37:33–34.

37. Israel Finkelstein, director of the Institute of Archaeology at Tel Aviv University, says that while both Orthodox and secular Jews prize the biblical stories for their symbolic value to modern Israel, archaeology has turned up no physical remains to support accounts such as the Bible's story of the Exodus: "There is no evidence for the wanderings of the Israelites in the Sinai desert." See Gustav Niebuhr, "The Bible, as History, Flunks New Archaeological Tests", *The New York Times,* July 29, 2000.

38. Exodus 25:8–9.

39. Ibid., 26:1–10, 31–37.

40. Ibid., 28:2–5.

41. Ibid., 35:25–26.

42. Proverbs 31:13, 18, 19, 21, 22, 24, 31. In a neighboring area of the Israelites, a king of the eighth century B.C.E. boasted that "in my days, a woman might go alone [in 'dangerous' places] with her spindles, thanks to Baal and the gods." Whether women actually could walk about safely in broad daylight without fear of rape, kidnapping, or murder remains to be attested. Quoted by James L. Kugel, *The Great Poems of the Bible,* (New York: The Free Press, 1999), pp. 145–146.

43. Ibid., 31:11, 12, 28, 29.

44. Ibid., 31:14-17.

45. Ecclesiastes 3:1, 2, 4, 7.

46. Genesis 37:29.

47. Ibid., 37:34.

48. 2 Samuel 13:19.

49. Ibid., 1:11–12.

50. While this biblical practice lingers as a reality for some, for others today

it is familiar as a figure of speech, as in a newspaper editorial concerning the possible forced departure of a powerful committee chairman in Congress: "We recall that there was much rending of garments when former Senator Lloyd Bentsen gave way to Daniel Patrick Moynihan as chairman of the Senate Finance Committee. . . ." Editorial, "The Rostenkowski Story," *The Washington Post,* July 21, 1993.

51. "Lubavitcher Jews mourn leader's death" (Associated Press), *The Beloit Daily News,* June 1994.

52. Daniel Williams, "Rabbis' Reaction to Killing: 'We have to make a Tear in Our Shirt,'" *The Washington Post,* November 10, 1995.

53. On his deathbed, Frederick William I of Prussia listened as his son played on a flute the hymn, "Naked I came into the world, naked I shall leave it." The dying king protested, "No, not quite naked. I shall have my uniform on." Quoted by Karl S. Guthke in *Last Words: Variations on a Theme in Cultural History* (Princeton: Princeton University Press, 1992), p. 5.

54. Psalms 104:1–2, 6.

55. E. J. W. Barber, *Prehistoric Textiles: The Development of Cloth in the Neolithic and Bronze Age* (Princeton: Princeton University Press, 1991), pp. 4–5.

56. Ibid., pp. 39, 78.

57. "The World's Oldest Necklace," *Beloit Magazine,* Beloit College (September 1993), pp. 10–11.

58. Barber, pp. 126–127.

59. Natalie Angier, "Furs for Evening, but Cloth Was the Stone Age Standby," *The New York Times,* December 14, 1999.

60. Barber, pp. 12, 132.

61. Ibid., pp. 48, 145.

62. Ibid., p. 132.

63. *Piecework Magazine* (November/December 1993), p. 24.

64. Barber, p. 77

65. A linguistic connection now exists between the ancient web of a weaving loom and the Information Age's Internet and World Wide Web. Web sites on the Internet may have, in software language, "threaded" messages on them, and the person who services an Internet site, or Web page, is called a Web master. In earlier centuries a weaver, particularly a female, was a webster. Tim Berners-Lee, a British physicist who created the "www." by inventing a scheme for linking data on a particular subject or series of subjects on different computers in different places, has written *Weaving the Web* (San Francisco: Harper, 1999).

66. Kax Wilson, *A History of Textiles* (Boulder: Westview Press, 1982), paperback edition, p. 40.

67. Judges 16:13–14.

68. Barber, p. 85 footnote.

Athena's Gift

2

The goddess Athena was accustomed to bathing in Lake Voulismeni, a body of water that stretches along the northeastern coast of Crete. Hidden in mountains above the lake is the deserted Dictaean cave in which the mythic god Zeus was believed to have been born. This legendary setting remains alluring to visitors who believe the Greek myths, after three thousand years, still have meaning.

Twentieth-century scholars have confirmed the reality of the Greek Bronze Age; they recognize it as lasting from about 1900 B.C.E. until the twelfth century B.C.E.[1] Stories about the Bronze Age are thought to have been orally transmitted from generation to generation, becoming in the eighth century B.C.E. the basis of a written text for two epic poems that we know as the *Iliad* and *Odyssey*. Whether writing alone or not, the poet Homer played an important role in putting the poems into the form acclaimed today as the first great works of European literature. These and other myths, penned nearly three thousand years ago, continue to capture the imagination and interest of each new generation in the West. New translations continue to be published. Not surprisingly, ideas found in the myths, including concepts of human destiny and heroic tragedy, remain influential in Western culture.[2]

Homer weaves into the *Iliad* and *Odyssey* scenes that spotlight the importance of textiles in a world where they are a measure of wealth, like gold, and are considered among the most valuable treasures one can offer as a sacrifice to the gods, present as a token of respect to a guest,

or pay as ransom to an enemy. Scholars today know that the months and years of skilled labor required to hand weave a richly patterned fabric in the Bronze Age would have enhanced its value. "Finespun robes," "glossy tunics," "shimmering veils," "billowing sails," "robes stiff with embroidery," and "cloaks stitched tight to block the wind" were woven and sewn, writes Homer, by skilled hands.[3]

An Alexandrian scholar of the second century B.C.E. believed that Homer took portions of the *Iliad* from a surviving figured "tapestry" woven by Helen of Troy.[4] If so, the poet described something he had actually seen when he wrote that Helen was weaving a web that depicted battles between the horse-taming Trojans and bronze-armored Achaeans. Scholars today have found evidence that the vertical, warp-weighted loom, useful in weaving tapestries, reached southern Greece about 5000 B.C.E., well before Homer.[5] Textile historian E.J.W. Barber notes "clearly *Homer* believed that women were weaving figured 'tapestries' long before his time."[6] Barber concludes that one of the most interesting points to come out of her prolonged study of prehistoric textiles is "the implication that heirloom 'tapestries' recording the earlier mythic history of the Greeks may have survived from Mycenaean times through the Dark Age [when writing disappeared] into the Archaic Greek period when Homer lived."[7] These tapestries would have displayed to Homer the threadwork skills of the Trojan War period, notes Barber, and would have aided Homer and the other bards in remembering the content of their epics.

Supporting evidence of Bronze Age textiles is on display in Crete's remarkable Herakleion Museum; its collection of carbon-dated fragments of frescoes, found early in the twentieth century, includes paintings of clothing apparently worn around 1400 B.C.E. One fragment reveals an elegant lady wearing a sumptuous gown, her dark curly hair partially hidden by a red sacral knot. On a miniature fresco nearby, women in blue and white dresses—with pleats and inserted fabrics—also suggest that gifted designers and threadworkers lived in Bronze Age Crete.

Homer may have obtained further clues concerning textiles from pottery made during the late Bronze Age and early Iron Age; surviving artifacts in museums in Greece and other countries suggest that weaving patterns were used to enhance the beauty of such pottery.[8]

From whatever sources Homer gained his knowledge of textiles, he

added realistic and magical touches to his mythical gods and mortals by including vivid details such as: "an old wool-worker," "a veil of white linen," "an embroidered leather helmet strap," "a red robe woven with flowered braiding," and "chairs draped with crimson covers." Perhaps more numerous than his references to threadwork itself are the poet's metaphorical uses of textile imagery; for example, the gods "weave snares and spin events out as fate," men "weave schemes and tell fine yarns," soldiers "weave webs of disaster."

Known sources of physical evidence about prehistoric textiles in the West remain limited. Into the early twentieth century archaeologists underestimated the information contained in the fragments of soiled rags or threads found on their digs, and most discarded prehistoric remains that would have provided clues about early textile arts. Although today scraps of such evidence are carefully carbon-dated and preserved whenever possible, myths such as the *Iliad* and the *Odyssey* remain valuable for their clues regarding threadworkers and textiles in prehistoric cultures.

The *Iliad*

The plot of Homer's myth, the *Iliad*,[9] needs little explication. The poem is devoted to the final days of a ten-year war between the Mycenaean Greeks and their Trojan rivals in what is called the Trojan War. While the war drags on, rivalry over Trojan women captured as spoils of battle causes a feud between the Greek king, Agamemnon, and one of his warriors, Achilles. When the feud diverts Achilles from battle, the Trojan king's son, Hector, kills his loyal squire. In revenge Achilles kills Hector, and the *Iliad* ends with an uneasy truce for Hector's funeral. This plot is the legendary thread on which Homer strings the numerous episodes in his story.

Early in the *Iliad*, Homer introduces three women whose association with threadwork is closely related to the war effort: Hector's wife, Andromache; his mother, Queen Hecuba; and his brother's wife, Helen, whose abduction by Paris had provoked the Greeks to attack the Trojans. To think of the Iliad from the perspective of the home front, imagine a young woman frantically running back and forth along the parapet of Troy's massive stone ramparts. She flings her hands above her head, and then suppresses a shrill cry as she remembers her infant son

in the arms of a servant standing nearby. She is searching for her chariot-driving husband who is somewhere in the dusty ranks of troops on the ground below her. The young woman is Andromache, loving wife of the Trojan hero, Hector, who is fated to die in this tenth year of fighting between the Trojans and Greeks. The battle she sees in the distance has turned in favor of the Greek troops whose king, Agamemnon, urges his men to fight without mercy.

As the fighting worsens and the Trojan forces panic, their king's son, Helenus, urges his older brother, Hector, to go back to the city. "[T]ell our mother to . . . take . . . the largest, loveliest robe that she can find throughout the royal halls, a gift that far and away she prizes most herself, and spread it out across the sleek-haired goddess's knees" in her temple on the Acropolis.[10] The brothers hope this valuable gift will persuade Athena, goddess of wisdom, hand skills, and war, to have mercy on Troy. Queen Hecuba, without hesitation, descends into the scented storeroom where she keeps embroidered robes made by slaves from Sidon. She picks out the longest and most richly decorated robe, one that "glistens like a star."[11] Once she and other women with her reach the temple on the heights of the Acropolis, they beseech the goddess to have compassion for the Trojans, but the goddess shakes her head. While the biblical story of Joseph's robe contains no early clue to its outcome, Homer reveals evidence early in the Iliad pointing to his poem's conclusion: Athena is partial to the Greeks and no sacrifice is likely to persuade her to turn against them. The sacred and mythic stories, however, have something in common; the thread of partiality runs through both. Furthermore, in both stories a garment is given as a token of love or honor, a reminder that the skin garments given to Adam and Eve by the Creator might likewise symbolize something positive. The gifts in Eden and Troy place clothing in a mysterious realm of meaning as a link between humankind and powers beyond human control. Sacrifice of the robe to Athena is one of the myth's many illustrations of the early Greeks' belief in divine intervention in human affairs.

From the queen, Hector rushes to order Paris into battle and discovers Helen blaming herself for the Trojans' suffering. Into the weft of a dark red web she weaves scenes of the bloody battles between the "stallion-breaking" Trojans and the "bronze-clad" Greeks.[12]

Hector finds his wife, Andromache, and their infant son on the ramparts of Troy. He knows that the Trojans face defeat and that his wife is

likely to be taken to a foreign land and forced to labor at a loom, "at another woman's beck and call."[13] Despite this likelihood, Hector tries to reassure his wife:

> Andromache, dear one, why so desperate? . . . No man will hurl me down to Death, against my fate. And fate? No one alive has ever escaped it . . . it's born with us the day that we are born. So please go home and tend to your own tasks, the distaff and the loom, and keep the women working hard as well. As for the fighting, men will see to that. . . .[14]

Like wives of soldiers in all wars, Andromache steels herself to accept separation from her husband; going home to her loom, she begins weaving flowered braiding into a dark red robe for Hector in anticipation of his homecoming after the war.[15] Working with one's hands, she likely knew from experience, concentrates the mind and helps reduce anxiety. Over the centuries this solution has served many a person well.

When Hector and Andromache meet at the Scaean Gate of the city ramparts, when Queen Hecuba offers her robe to the goddess Athena, and when remorseful Helen weaves battle scenes, Homer interrupts the battle story to suggest that textiles play a vital role in the lives of Bronze Age men and women. His additional descriptions of clothing and accessories, such as those of the elaborately woven war belt and corselet worn by King Menelaus and a great purple cloak worn by King Agamemnon, add a sense of reality to the imagined battle scenes. The poet provides evidence that tens of thousands of men are fighting in the two armies. A reader can reasonably assume that many, if not all, of the soldiers wear woven tunics, war belts, corselets, and cloaks, and have handwoven blankets and tents. Thousands of threadworkers, like Helen and Andromache and their servants, are laboring by hand to produce the mountains of clothing, tents, blankets, and sails needed by the soldiers and civilians in these two mythical Bronze Age societies.

Even the immortals in the *Iliad* work at textile crafts. Zeus' daughters, the Graces, "with their labor" make "fresh immortal robes" for the goddess Aphrodite, who had flung her own garment around her son, Aeneas, to protect him from the enemy's flying arrows.[16] And, at the height of the final onslaught, when Athena joins the Greeks to fight against Hector and the other doomed Trojans, she slips off her "supple

robe . . . rich brocade, stitched with her own hands" and puts on a battle shirt, a breastplate, her shield, and her helmet "engraved with the fighting men of a hundred towns."[17]

Further, Homer includes notice that the postwar production of textiles is a consideration to the commander of enemy forces besieging Troy. Agamemnon vows not to surrender a Trojan woman captured by his men: "I won't give up the girl. . . . old age will overtake her in my house, in Argos, far from her fatherland, slaving back and forth at the loom, forced to share my bed!"[18]

In one of the poem's most forceful emotive passages, Homer highlights another role of textiles in his mythical world. When Hector is killed, Achilles refuses to surrender the corpse to the Trojans for a ritual funeral. Zeus, however, decrees that Achilles must return Hector's body after he receives a ransom, and Hector's father selects textile gifts to ransom his son's corpse. Like his wife, Hecuba, the "old and noble" king descends to his treasure chamber, which is "high-ceilinged, paneled, fragrant with cedarwood." He chooses twelve richly brocaded robes, twelve unlined cloaks, and the same number of capes and shirts to go with them, and as many blankets.[19] To the clothing and blankets Priam adds ten bars of gold, two tripods, four cauldrons, and a splendid gold and silver wine cup.

Achilles accepts the ransom and, after Hector's body has been bathed, anointed with oil, and "wrapped round and round in a braided battle-suit and handsome battle-cape," it is returned to his parents.[20] In the *Iliad's* closing lines, Homer honors threadwork once more: Hector's corpse is ritually burned on a pyre; then his white bones are shrouded in soft purple cloth and placed in a golden chest which is lowered into a deep, hollow grave.[21]

The undercurrent of fiber work in this heroic tale is reinforced by Homer's repeated references to each individual's fate, which, he writes, was spun at the moment of birth. He illustrates this theme in Hector's farewell encounter with Andromache, and again in Queen Hecuba's words as she attempts to dissuade King Priam from risking his life endeavoring to ransom Hector's body.

> [T]his is the doom that strong Fate spun out, our son's life line drawn with his first breath—the moment I gave him birth—to

glut the wild dogs, cut off from his parents, crushed by the stronger man.[22]

In this as well as in other Greek myths, each person's destiny is thought of as a thread spun by Fate or the Fates. In our time, as spinning and sewing are experienced firsthand by fewer individuals, this metaphor has slipped out of common use. However, even today "spin" is commonly used as a metaphor to suggest an effort to control the interpretation of information that might affect the fate of an individual.

The *Odyssey*

Homer's epic poem, the *Odyssey*,[23] interweaves the adventures of Odysseus homeward bound after the Trojan War, and the goings-on back at his home on the island of Ithaca. A conventional reading of this story tends to emphasize the adventures that engage the hero during his voyage home. Naval historians with mathematical skills might choose, instead, to focus on distances, supplies, and other strategic factors in this nine-year voyage. But our major interest is Homer's deliberate inclusion of textiles, clothing, and threadworkers in his story. Time and again he creates a colorful and/or decisive role for clothing to play in the *Odyssey*—from the hero's "ripped and filthy rags" to a silky tunic clinging to him "like the skin of a dried onion." The best known and for some the only known example of threadwork in the *Odyssey* is that of the weaving done by Odysseus's wife, Penelope. Even today many schoolchildren are familiar with a simplified version of this episode. Penelope's weaving is, however, only one of many reflections of threadwork in this myth. Over and again, for example, Homer imagines the Bronze Age custom of offering hospitality to strangers, as well as friends, who arrive as guests at one's door: soon after guests arrive, they are provided with a bath, food, and wine as well as a shirt, cloak, or tunic.[24] Penelope's weaving is at the heart of the *Odyssey*.

When Odysseus fails to come home with the other Greek veterans after the Trojan War ends, more than a hundred suitors "swarm like bees" around Penelope and consider themselves guests in Odysseus' house. For years, they devour his store of provisions and give orders to his servants. Telemachus, the son of Odysseus and Penelope, finally

attempts to drive the haughty suitors away. One of them protests, say-
ing the suitors are victims of Penelope, "the matchless queen of cun-
ning." She had told the men she could not marry until she wove an
"exquisitely wrought" shroud for Odysseus' father, the aged Laertes.
The rival suitors' agreed to wait until the weaving was completed and
their waiting month after month suggests they know that making an
exquisitely wrought textile is a time-consuming task. After three years,
however, a disgruntled servant informs the suitors that Penelope by day
would "weave at her great and growing web—and by night, by the light
of torches set beside her, she would unravel all she'd done." The suit-
ors now refuse to leave, so long as Penelope exploits the gifts Athena
gave her, "a skilled hand for elegant work, a fine mind and subtle
wiles."[25]

The men expect Telemachus to rebuke his mother, as he did earlier
in their presence:

> [M]other, go back to your quarters. Tend to your own tasks, the
> distaff and the loom, and keep the women working hard as well.
> As for giving orders, . . . I hold the reins of power in this house.[26]

Yet Telemachus is unwilling to force his mother to marry against her
will. Instead, he secretly leaves for Sparta, hoping to learn news of his
father from the Spartan king, Menelaus, who has returned victorious
from Troy with his wife, Helen. Telemachus and those accompanying
him receive a princely welcome to the royal couple's palace. The travel-
ers climb into burnished tubs; maidservants wash them and rub them
with sweet-smelling oil, dress them in fine tunics, and wrap them in
warm, purple mantles. Afterward, as Telemachus is talking with
Menelaus, Helen comes down from her "scented, lofty chamber"
attended by three servants. One servant arranges a carved, reclining
chair for the queen, another follows with a coverlet of soft wool, and a
third servant brings the queen's work basket which rolls on casters and
is made of "solid silver polished off with rims of gold." The basket is
"heaped to the brim with yarn prepared for weaving; the [golden] spin-
dle swathed in violet wool lay tipped across it."[27]

Outside in the entry porch, servants arrange beds for the guests—
soft, thick purple blankets covered by smoothly woven rugs and wool
cloaks. More threadwork awaits Telemachus! As he prepares to leave for

home, Helen walks to "a storeroom filled with scent" where chests contain "brocaded, beautiful robes her own hands had woven." She selects "the largest, loveliest robe" which is "richly worked and like a star." Holding the robe in her arms, she offers it to Telemachus.

> Here, dear boy, I . . . have a gift to give you, a keepsake of Helen—I wove it with my hands—for your own bride to wear when the blissful day of marriage dawns. . . . Until then, let it rest in your mother's room.[28]

In ancient Greece, a bride's robe traditionally covered the bride and groom on their nuptial bed. The interwoven warp and weft threads of the marriage robe symbolized the creation of bonds of harmony and love necessary for a union of male and female.[29] The principle of unity, obtained by skillfully interweaving separate threads, was widely understood in every Greek household. This traditional meaning of the nuptial bed is likely one reason Homer repeatedly includes bed scenes of Dawn, Zeus, and the mortals (old Nester, King Menelaus, and Odysseus) in the *Iliad* and the *Odyssey*.[30] In the Odyssey, however, Helen's gift of a marriage robe is ironic because she is the woman whom the gods entice to abandon her husband and abscond with another man.

As Telemachus searches for news of his father and faithful Penelope weaves at her loom, Odysseus experiences repeated delays while homeward bound. He is held prisoner on an island for seven years by the beautiful nymph Calypso, who lifts her "breathtaking" voice in song as she glides "back and forth before her loom" inside her cave by the sea. Dressed in a loose robe, a brocaded golden belt at her waist, and a scarf about her head, she weaves with a golden shuttle. In a subsequent adventure, Odysseus encounters another enchantress, the goddess Circe. She, too, wears a glorious robe and brocaded belt, and sings as she glides back and forth at her "great immortal loom, her enchanting web a shimmering glory only a goddess can weave."[31]

Odysseus at last resumes his voyage to Ithaca, but Zeus wrecks the voyager's raft and strands him on the Phaeacian island that is ruled by good King Alcinous and Queen Arete. On the morning Odysseus arrives, the royal couple's daughter, Nausicaa, wakens with the idea of doing the family laundry in a nearby river.[32] Suddenly a wild-looking

man, "without a stitch of clothing," steps out of the bushes and begs the king's daughter to help him get home to his family. Nausicaa responds kindly, telling her frightened maids to give the stranger a cloak, a shirt, and oil so that he can cleanse himself. Next, the princess directs Odysseus to find her mother, Queen Arete, in the nearby palace where she is spinning sea-blue wool beside the hearth.

The goddess Athena, feeling sympathy for Odysseus, disguises herself as a young girl and guides him to the palace, telling him that the king honors the queen

> as no woman is honored on this earth. . . . Such is her pride of place, and always will be so: dear to her loving children, to Alcinous himself and all our people. They gaze on her as a god. . . . She lacks nothing in good sense and judgment. . . . If only our queen will take you to her heart, then there's hope that you will see your loved ones . . . at last.[33]

Queen Arete, like the "capable" woman portrayed in the previous chapter, merits respect rather than scorn. As historian Garry Wills notes: "A principal strength [of Robert Fagles's translation of Homer] is its entry into the psychological subtlety with which Homer presents women."[34]

When Odysseus reaches the palace, he enters a hall where in a long unbroken row, thrones stand backed against the wall, "each draped with a finely spun brocade, women's handsome work." He observes fifty maids at work:

> some weave at their webs or sit and spin their yarn, fingers flickering quick as aspen leaves in the wind and the densely woven woolens dripping oil droplets. Just as Phaeacian men excel the world at sailing . . . so the women excel at all the arts of weaving. That is Athena's gift to them beyond all others—a genius for lovely work, and a fine mind too.[35]

Queen Arete recognizes her own handwork in the fine cloak and shirt that the stranger is wearing, and she promptly advances the aid required to speed the warrior on his way toward home.

Finally, Odysseus reaches the island of Ithaca. He stashes his treasure of gifts from King Alcinous and Queen Arete—finespun robes with

"not a stitch . . . missing from the lot," tripods, cauldrons, and bars of gold—in a cove. Athena, initially disguised as an elegant shepherd boy, "with a well-cut cloak falling in folds across her shoulders," and later as a woman, "beautiful, tall and skilled at weaving lovely things," welcomes him to his native land and warns him of the dangers awaiting him at home.[36] She disguises Odysseus as a beggar in rags, and the erstwhile voyager makes his way to the hut of his old swineherd, who welcomes the stranger but has no spare clothes to offer his guest.[37]

As a cold night comes on, Odysseus, shivering in his rags, invents a story to test the hospitality and wit of his host. He says that once on a freezing night during the Trojan War, he was caught without his cloak when he and his Greek comrades were huddled against the walls of Troy. He feared he would be "done in" by the cold, but his fighting comrade Odysseus devised a way to secure a cloak for him and thereby saved his life. The old swineherd comprehends the point of the stranger's yarn and flings over his guest his own flaring cloak, kept in reserve to wear only in winter's fiercest storms. Outside the hut, under a jutting crag that breaks the north wind's blast, a cloak "stitched tight to block the wind," and the pelt of a shaggy goat become the swineherd's cover.[38]

Here Homer seamlessly transforms clothing into manifestations of courage, unselfishness, hospitality, and vital necessity—each one bonding human to human. Also in this vignette, the masterful poet humanizes his hero, who has been able to outwit the giant Cyclops and other man-eating monsters, yet who, without adequate clothing, shivers in the cold like any other homeless beggar dependent on the kindness of strangers.

The complexity of Penelope's nature, so easily overlooked by those who think only of her weaving ploy, is subtly revealed when Odysseus returns to their house as a ragged old man. In earlier scenes Homer has portrayed Penelope's image primarily through the eyes of other characters. Even the frustrated suitors allow that the goddess Athena has given Penelope a skilled hand for elegant work and a fine mind. Various others speak of her as being wise, self-possessed, circumspect, discreet, shrewd, and cautious. To Odysseus himself she is the soul of loyalty. As the story nears its climax with the return of the voyager, Homer brings the faithful wife center stage to speak for herself.

Lest she be deceived, Penelope tests the rag-clad stranger who claims to have entertained her husband twenty years ago. What clothing, she inquires, was Odysseus wearing when the stranger saw him? The stranger recalls a heavy, woolen, sea-purple cape with a marvelously engraved solid gold brooch to clasp the cape; a silky, soft tunic. Penelope is favorably impressed with this account, for she herself had selected her husband's clothes and fastened the brooch on his cape as he was leaving for Troy. Trusting her guest more, she reveals that a god inspired her to set up a loom when her husband failed to return with others from Troy.[39] By working at the loom, she explains, her thoughts as well as her hands have been occupied. While weaving, she considers her options and spins her strategy, yet she has been unable to reach a decision. Her thoughts have wavered back and forth like the shuttle in her hand. "Do I stay beside my son and keep all things secure . . . true to my husband's bed. . . . Or do I follow . . . the best man who courts me . . . who gives me the greatest gifts?"[40] Once we understand how Homer reinforces Penelope's mental and emotional anguish with the symbols of loom and shuttle, we can easily imagine the lonely wife anxiously weaving by day and unraveling by night, wavering between hope and despair.[41] Anxious and indecisive, yet faithful to her husband and son, Penelope is a character whom Homer's audience can understand.

After he has been bathed and handsomely dressed, the stranger looks for all the world like Odysseus, yet Penelope puts him to a final proof of his identity: she ignores his assumption that they will sleep together. Instead, she makes arrangements for him to sleep alone, asking a maid to remove from the bridal chamber the sturdy bedstead, which "the master built with his own hands." Penelope's words confound Odysseus:

> Woman—your words, they cut me to the core! Who could move my bed? . . . Not a man on earth. . . . I know, I built it myself. . . . There was a branching olive-tree inside our court. . . . I shaped it plumb to the line to make my bedpost. . . . There's our secret sign, I tell you, our life story! . . . Has someone . . . hauled our bedstead off?[42]

This husband-wife scene, in Garry Wills' opinion, "is the greatest picture in all literature of a mature love demanded and bestowed on

both sides equally."[43] Translator Fagles, continues Wills, understands Homer's intention to accord Penelope equality with Odysseus. The skillful weaver, intelligent woman, and faithful wife unmasks the wily raconteur and loving husband. Penelope and Odysseus, like Andromache and Hector, symbolize a husband and wife whose devotion to one another overcomes self-pity, hardship, temptation, and despair.

The preceding episodes focus on three aristocratic women—Penelope, Helen, and Arete—who labor with thread themselves or supervise servants engaged in textile production. In this respect the *Odyssey* mirrors the *Iliad* and its images of Hecuba, Andromache, and Helen. Furthermore, in the *Odyssey*, fifty maids grind corn, spin, and weave in a single palace; in the *Iliad*, servants weave and embroider while kept under close surveillance. And one can easily imagine the scores of other women producing textiles in this mythic world so that kings, queens, and their guests are dressed like Dawn, the goddess of the morning, who flings "her golden robe across the earth" at daybreak as she rises "from the Ocean tides."[44]

Not without good reason Homer is often cited as a source for the assumption that cloth production in Mycenaean Greece was woman-powered. In the *Iliad* and *Odyssey*, threadwork is a unifying theme just as music is frequently an underlying element in contemporary movies. Threadwork has a universal meaning in its unifying role: an individual is a single thread; a family is a number of threads woven into a whole fabric.

Erechtheus

The works of Homer and later classical Greek writers were written originally by hand on scrolls, usually made of the papyrus reed. A papyrus, which once wrapped an Egyptian mummy preserved in the Louvre in Paris, contained some one hundred fifty lines of *Erechtheus*, a drama by the Greek writer Euripides (480?–406 B.C.E.). The play had been lost until information on the papyrus was published in 1967, exposing controversial but significant evidence relating to textiles. This publication led to a reinterpretation of a 528-foot sculpted frieze which originally ran under the roof of the Parthenon on the Acropolis in

Athens. Large portions of the ancient marble sculpture, removed from Athens in the early nineteenth century, are currently displayed in the Duveen Gallery of the British Museum in London. Of the thousands of visitors who annually pass through the gallery, few likely are aware of the richly embroidered peplos (a sleeveless woolen tunic) traditionally associated with the frieze. Even fewer will know of the heroic myth by Euripides and the mysterious folded cloth that is now linked with the monument.

The Greek government's present legal effort to secure the return of the famed marbles to Athens is only the latest development in the uncertainty surrounding the ancient frieze. Scholars agree that the sculpture is a portrayal of a procession of some kind but disagree about the purpose of this grand civic event. Carved figures of men leading animals, of musicians, chariots, and nearly two hundred horsemen converge on a man, a woman, a child holding a large piece of folded fabric, and two young women whose heads support mysterious bundles.

A theory given in 1787 about the meaning of the frieze was widely accepted for nearly two centuries. In this interpretation the frieze portrays the Panathenaic celebration which marked the civic life of Athens every four years; the folded fabric in the child's hands is a peplos, newly woven by the most skilled weavers in Athens and carried in procession to the Acropolis for presentation to a cult statue of Athena, protectress of the city.

Archaeologist Joan Breton Connelly has proposed a new interpretation, based on her reading of the tragedy by Euripides found on the papyrus wrapping the mummy in the Louvre. In the play written at about the time of the creation of the frieze, Erechtheus, the king of Athens, confronts an invasion of his city and is advised by the oracle at Delphi to sacrifice one of his three daughters in order to escape defeat by the enemy. But the daughters have vowed not to be divided by death and all agree to be sacrificed. Their mother, the queen, responds heroically, saying: "The ruin of one person's house is of less consequence and brings less grief than that of the whole city. If there were a harvest of sons in our house rather than daughters and a hostile flame came to the city, would I not have sent my sons into battle, fearing for their death?"[45]

According to Connelly, the five central figures on the Parthenon frieze represent the king, the queen, and the three daughters—the

youngest holding her folded shroud and the older two carrying their shrouds as bundles on their heads. Connelly concludes: "If the central monument of Western culture can be seen, in part, as a monument to the heroism of the three maidens, who, as willing victims, and with the encouragement of their mother, gave their lives to save the polis, so much for misogyny in Greek myth, and welcome to an expanded view of women as heroes in Greek myth and culture as truly celebrated in the Parthenon."[46] The object here is not to enter into the scholarly debate. Whether the traditional interpretation prevails or Connelly's view is accepted by scholars, threadwork remains at the heart of the famous monument's imagery.

Interestingly, Athena, the patron of spinners and weavers, was also the patron deity of architects and sculptors. The work of artisans skilled in both fiber and stone appears on the Parthenon frieze as well as on other surviving sculpture of Classical Greece. Marble figures portray the living body in lifelike images; the sculpted curvilinear folds of drapery reveal an understanding of the anatomical structure of the human body as well as of the alluring softness and seductiveness of the hand crafted fabric.[47] A statue of Athena, sculpted shortly after 480 B.C.E. and exhibited in Washington, D. C., in the 1990s, displays the goddess wearing a sleeveless tunic girded at the waist in a manner revealing her bent leg with the projecting knee barely interrupting her garment's series of thick, vertical pleats. According to notes for the exhibit at The National Gallery of Art: "The figure exemplifies a new interest in allowing the female body, never represented in the nude during the Classical period, to show through the drapery."[48]

Ariadne's Ball of Thread

In a myth attributed to the Roman poet Virgil (70–19 B.C.E.), when Theseus ventures into the Cretan labyrinth to slay the monstrous Minotaur, he depends on a ball of thread paid out by Ariadne to get back out of the maze. Theseus was later honored as the symbol of Athenian democracy. Yet, according to the myth, he could not have succeeded and escaped alive without the help of the Cretan king's daughter, Ariadne. She gambled with her own life when she secretly sought and secured a ball of thread that became the means of escape for her father's enemy. Virgil's story of Ariadne's valor contributes to a view of

women as heroes in Greek myth; it also highlights the importance of threadwork in ancient culture.

The ball of thread is more than a colorful prop. At least two persons trusted their lives to the thread's durability, and thus to the integrity and skill of the worker who had spun the thread. And, while many today may fail to grasp the metaphorical implications of thread's role in this myth, spinsters and weavers of wool, cotton, and flax likely have always understood it: thread matters.

Indeed, to the early Greeks and Romans thread mattered greatly. "It seems," writes Barber, "that the creation of thread symbolized the creation of life and a life-span in Greek mytho-explanatory thought."49 In their cosmology, three mythical sisters—Clotho, Lachesis, and Atropos—controlled the thread of human destiny. Symbolically, Clotho carried the spindle and spun the thread of life; Lachesis held a globe or scroll and determined the length of the thread; Atropos held shears and cut the thread of life. The concept of fate remains in Western culture even though a centuries-old debate has been waged over the respective roles of fate and human responsibility.

The images of women in the myths suggest that to be female in early Greece was to be at work with needle and thread, or distaff, yarn, and shuttle. The ancient literature suggests that threadworkers were variously loved, enslaved, respected, and exploited expressly for their skill and labor. Threadwork is associated in the myths with values that remain sustaining in our own time: artistic beauty, honor, loyalty, faith, family devotion, and work itself.

Notes

1. J. Lesley Fitton, *The Discovery of the Greek Bronze Age* (Cambridge: Harvard University Press, 1996), p. 9.

2. Names and images of the ancient deities are still with us, as in the Apollo space mission and Nike sports shoes. And the goddess Athena (called Minerva by the Romans) has a distinct bond with American women who served in the Women's Army Corps between 1942 and 1978. During those thirty-six years each member of the Women's Army Corps was awarded a medal engraved with the goddess' helmeted profile. Presentation of the distinctive medal was discontinued after women in military service were integrated into the regular United States Army. One of these engraved medals is in the collection of The George C. Marshall Museum in Lexington, Virginia.

3. Textiles were woven from flax and wool fibers in Bronze Age Greece. Silk and cotton arrived in the Mediterranean area during early Classical Greek times (ca. 500 B.C.E.); silk became an established Western industry in late Roman to early Byzantine times (ca. 500 C.E.).

4. Barber, p. 373.

5. Ibid., pp. 100–101.

6. Ibid., p. 372.

7. Ibid., p. 382.

8. Ibid., pp. 365 and 370.

9. The quotes from the *Iliad* cited in this chapter are taken from the translation by Robert Fagles (New York: Viking Penguin of Penguin Books USA Inc., 1990).

10. Book 6: 102–109.

11. Book 6: 349.

12. Book 6: 381–382 and 3: 150–154.

13. Book 6: 539–555.

14. Book 6: 579–589.

15. Barber notes that Andromache is weaving magical flowers, "almost certainly roses . . . that age-old European protective talisman that peasant girls of central Europe still weave and embroider all over their clothes." (see Barber, p. 372).

16. Book 5: 378–379 and 351–353.

17. Book 5: 841–853.

18. Book 1: 33–36.

19. Book 24: 228–230 and 272–275.

20. Book 24: 688–690.

21. Book 24: 944.

22. Book 24: 248–252.

23. The quotes from the *Odyssey* cited in this chapter are taken from the translation by Robert Fagles (New York: Viking Penguin, 1996).

24. The ancient custom of presenting gifts of textiles and clothing has been previously illustrated in biblical sources and can be illustrated in other cultures. In tenth-century central Asia, for example, the caliph in the governing city of Bukhara typically ordered from state-controlled factories and scattered independent workshops two thousand robes of honor as rewards for his favored subjects or guests. Elsewhere, after Galileo dedicated the manual for his military compass to the grand duke of Tuscany in 1606, the nobleman expressed his appreciation by presenting the scientist a bolt of fine satin for an elegant cape. See Kate Fitz Gibbon and Andrew Hale, *IKAT: Splendid Silks of Central Asia from the Guido Goldman Collection* (London: Laurence King Publishing, 1997), p. 31. See also James Reston Jr., *Galileo: A Life* (New York: HarperCollins Publishers, Inc. 1994), p. 77.

25. Fagles tr. *Odyssey,* Book 2: 115–117 and 125–142.

26. Book 1: 409–414.

27. Book 4: 149–150.

28. Book 15: 114–119 and 139–141. Homer provides no description in the *Odyssey* of Helen weaving the brocaded robes and no details to indicate how much time she spent weaving them (just as he provides little in the *Iliad* about her work on the battle scene tapestry). However, his repeated references to spinning and intricate weaving done by hand is consistent with our knowledge that such fiber work requires skill and enormous amounts of time.

29. See Chapter 3, "Aphrodite . . . and Lovers", in John Scheid and Jesper Svenbro, *The Craft of Zeus: Myths of Weaving and Fabric* (Cambridge: Harvard University Press, 1996).

30. See, for example, the *Iliad,* Book 1: 732–735 and 14: 413–421; *Odyssey,* Book 3: 449–450; 4: 341–342; 5: 1.

31. *Odyssey,* Book 5: 68–70 and 10: 240–245. Homer's images of singing weavers suggest a comparison with the spinners, knitters, and lace makers referred to in Shakespeare's *Twelfth Night* and with Navajo weavers who "sing softly to themselves or simply hum" as they weave. See William Shakespeare, *Twelfth Night,* Act II, Scene IV, Lines 43–48; see also Eulalie H. Bonar, ed., *Woven by the Grandmothers: Nineteenth-Century Navajo Textiles from the National Museum of the American Indian* (Washington: Smithsonian Institution Press, 1996), pp. 33–34.

32. Homer's image of Nausicaa and her servants washing clothes in a river and stretching them out to dry on the shore is one that likely would have been familiar to his Greek contemporaries and can still be seen today. In July 1974, for example, I observed women and men washing saris in the shallow Yamuna River which meanders behind the magnificent Taj Mahal. Stretched out to dry

along the riverbank, like a rainbow fallen from the heavens, were yards of vivid-ly colored fabrics.

33. *Odyssey,* Book 7: 78–89.

34. Gary Wills, "Homer's Women," *The New Yorker*, January 27, 1997, p. 75.

35. *Odyssey,* Book 7: 121–128.

36. Book 13: 252–255, and 325–328.

37. Book 14: 66, and 581–582.

38. Book 14: 585–602.

39. Book 19: 153–165. Penelope does not name the god who inspired her "from the blue" to set up the loom, but all of Homer's evidence points to Athena. For example, Book 1: 414–419.

40. Book 19: 592–596.

A twentieth-century variation of Penelope's dilemma has been written for children by Miska Miles: *Annie and the Old One* (Boston: Little, Brown and Company, 1971). In Miles's poignant version, a young Navajo girl learns that her beloved grandmother will "go to Mother Earth" when weaving is completed on a particular rug. Hoping to prolong her grandmother's life, the child slips outside her family's hogan each night, while others are sleeping, and carefully pulls out the yarn woven earlier in the day.

42. *Odyssey,* Book 23: 203–229.

43. Wills, p. 76.

44. *Iliad,* Book 8: 1 and 19: 1.

45. Quoted by Steve Coates, "A Feminist Theory of Greece's Parthenon Frieze," *Wall Street Journal,* January 6, 1994.

46. Ibid.

47. London tailors, imbued with a new sense of the scientific in the early nineteenth century, searched for more sophisticated methods of cutting and tailoring clothes to fit the body. One of their sources of information was a book by German mathematician, Dr. Henry Wampen, a student of the proportions of Greek statues. In 1834 he published *The Mathematical Art of Cutting Garments According to the Different Formation of Men's Bodies.* See Richard Walker, *Savile Row: An Illustrated History* (New York: Rizzoli International Publications, Inc., 1989), p. 38.

48. Quoted from "Notes on the Works of Sculpture," accompany the exhibition, *The Greek Miracle: Classical Sculpture from the Dawn of Democracy, The Fifth Century B.C.,* at The National Gallery of Art, Washington; November 22, 1992–February 7, 1993.

49. Barber, p. 376.

3

Threads 'Twixt Cloister and Crown

The mosaic pavement from Roman Britain and the Sutton Hoo burial treasure in the British Museum are links to textiles that served as symbolic language in early Europe. The central motif of the mosaic pavement is a man's head with the Chi-Rho monogram (the Greek letters for the name of Christ) behind it. It symbolizes the impact of Christianity on the Roman Empire and particularly on Emperor Constantine. The Roman Empire rose in Italy in the centuries before Christ's birth and, by the fourth century C.E., expanded into England, France, Spain, and all the other land bordering the Mediterranean Sea. Early in that century, when a rival threatened the Roman emperor Constantine, he claimed that in a vision he saw a lighted cross in the sky bearing the inscription, "Conquer by this." In a subsequent dream, added the emperor, God appeared to him with the same sign, commanding him to make a likeness of the cross and use it as a standard in all battles.

Constantine's biographer, Eusebius, reports that he himself saw the resulting silk banner. It was made in the shape of a cross, embroidered with a jeweled Chi-Rho monogram and the portraits of Constantine and his two sons; it hung suspended from the standard's crossbar.[1] The rest, as they say, is history: Constantine defeated his rival; he attributed his victory to the Christian God and granted special privileges to the Christian clergy. The emperor, accepted by the clergy as Christ's vice-regent on Earth, "dressed on occasion in raiment which glittered as if

he were a heavenly messenger."[2] His decisions ultimately had the effect of making Christianity a state religion and incorporating the church into the state organization in the waning years of the Roman Empire.[3] By the sixth century the West had ceased to be Roman, pagan, and cosmopolitan. Throughout the area, Christianity replaced Roman classicism as the dominating influence. In the emerging culture, practically every writer, educator, and artist—whether Latin or Orthodox—was a member of the Christian clergy.[4]

The Sutton Hoo burial treasure in the British Museum contains objects from the only royal Anglo-Saxon burial known to survive almost in its entirety. The treasure is believed to be from the burial ship of the Anglo-Saxon king of the East Angles, Redwald, who died about 625 C.E. Excavated at Sutton Hoo in Suffolk in 1939, the treasure consists primarily of metal artifacts such as a helmet and shield, sword fittings set with garnets, gold and silver objects, and coins from the Continent. These metal artifacts, which once glistened in sunlight and by torchlight, are similar to ones described in *Beowulf*, the heroic narrative poem written by an unknown Anglo-Saxon poet some time after Redwald's death. Historic Danish legends interwoven with Roman Christian beliefs form the core of thought in *Beowulf*.

The young warrior Beowulf crosses the sea to rescue neighboring Danes from a man-eating monster and afterward he is entertained in a banquet hall roofed with gold and decorated with banners woven with gold.[5] Fifty years later, in his own homeland in what is now southern Sweden, aging King Beowulf is mortally wounded as he slays a dragon that had laid waste the countryside while hoarding a treasure of gold. The nephew of the dying king finds the treasure hoard hidden in an underground space that is lighted high overhead by a gold-wrought banner "of finest workmanship woven by skillful hand."[6]

According to art historian C. R. Dodwell, the Old English poem reflects the real Anglo-Saxon world. "Its descriptions of the standard, jewellery, helmets, swords and burial rituals are all in line with excavated material—especially that of Sutton Hoo."[7] The epic's prominent references to wall hangings and banners woven with gold threads, like the metal objects, add to the mystique and splendor of Anglo-Saxon mythic history. "If gold-embroidered tapestries are mentioned in *Beowulf*," concludes Dodwell, "we may presume that it was because they existed at the time of its writing."[8]

Constantine's embroidered standard represented the power of textiles to convey authoritative force; the woven banners in *Beowulf* illustrate the use of gold-embroidered textiles to bestow honor and display wealth in early European lands.

Threadwork in Medieval Literature

Threadworkers were less visible in literary works of the medieval period (between 300 and 1300 C.E.) than in the Bible and in Greek and Roman myths. In the early Middle Ages, vernacular literature scarcely existed except as traditional legends of native heroes and gods and as heroic tales chanted by wandering minstrels, whose songs and poems were dominated by military themes. These tales described knights clad in mail shirt and helmet. Peasants almost disappeared from the literature of this period, despite the fact that they were the primary source of subsistence, wealth, and power in the newly rural society that developed in Europe after the fifth century. The French historian Jacques Le Goff suggests a religious explanation for their disappearance: in that church-dominated society, labor was seen as evidence of a failure to trust Providence for the satisfaction of material needs.[9] Even the Benedictine Rule, which required manual labor of its monks, considered labor a form of penitence for original sin.[10] Monastery craftsmen were instructed "to ply their craft in all lowliness of mind. . . . But if any be puffed up by his skill . . . such a one shall be shifted from his handicraft, and not attempt it again until such time as he has learnt a low opinion of himself."[11] In such an environment, the laboring peasants were usually seen as "detestable" subhumans incapable of salvation.[12]

Late medieval poets wove both threadworkers and textiles into their vernacular poetry. In this period, threadwork itself became an important visual language, conveying both religious and secular messages through figural iconography. Thus, medieval threadwork in museums and in church treasuries today offers insights into medieval society, where church and state often competed for the best available threadworkers and textiles.

Even though the Romans in England often dismissed the Anglo-Saxons as "barbarians," surviving literary evidence testifies to the indigenous peoples' sensitivity to beauty, color, and glitter. Surfaces which reflected the play of lights especially attracted the attention of

Anglo-Saxons. Their foremost historian, the eighth-century theologian Bede, reports that one monastery tolerated a monk who preferred alcohol and the "loose life" to prayer and worship because his skills as a goldsmith were essential to the religious community. The creations of jewelers and goldsmiths so hypnotized the Anglo-Saxon poets that they turned to these crafts for their similes and metaphors. Their literature is said to be "shot through with feeling for the lustrous and precious."[13]

Fiber arts also inspired the poets' imagery. Historic records confirm that in the seventh century an Anglo-Saxon king named Oswald presented silk wall hangings interwoven with gold to the churches he founded, and Oswald himself had a gold-enriched banner. The figure of a warrior was said to be interwoven lavishly and skillfully with gold and jewels in King Harold's banner in the eleventh century; also at that time the sails of vessels were embroidered with historic scenes in gold. A Frenchman named Goscelin, who moved to England shortly after the Norman Conquest, reports that he transformed a sordid hovel by placing fabric hangings on the wall, while an inventory made at Ely Cathedral in 1081 lists two hangings of gold threads and forty-three others (probably silk) that depicted Christian themes. Estate wills of the tenth and eleventh centuries bequeathed wall hangings as prized possessions to heirs.[14]

Weaving and the Emperor Charlemagne

Einhard, contemporary biographer of Charlemagne who, from 774 to 814 C.E. ruled what today is France, much of western Germany, northern Italy, and the tip of northern Spain, writes that the emperor never wore the long tunic of Roman fashion unless he was in Rome, calling on the pope. Instead, Charlemagne wore his native Frankish fashions: a linen shirt and linen drawers, a short tunic with a silver border, stockings bound with garters, and he "was always girt with his sword."[15] In winter he added a vest made of otter and sable skins covered by a blue cloak. The concubines of his court found silks "ravishing,"[16] thus it is probable that Charlemagne's tunics were made of silk bordered with silver thread embroidery. The wealthy in the West had imported silk from the East for centuries, their demand for the fabric creating at times a severe trade imbalance for the Roman Empire.

Peasants, who comprised ninety-five percent of those who lived in

Charlemagne's empire, covered themselves in homespun wool or leather and, if lucky, had wooden clogs for shoes.[17] Despite an enormously inequitable distribution of wealth and privilege in society, peasants of all ages labored to provide the food, cloth, and other items needed for their own households, as well as for the rulers and defenders of the empire.

Historian Eileen Power, drawing from a ninth-century book prepared to aid with the management of an abbey near Paris, imagines a day in the life of two peasants, Bodo and Ermentrude, and their three children during the rule of Charlemagne.[18] Like all peasants, they were bound to the soil and remained attached to the estate if it changed owners. On a fine spring day, while Bodo is out plowing with one son who uses a large stick to break up clods left by the plow, Ermentrude is busy, too. Trusting her second son, aged nine, to look after the baby, Ermentrude goes up to the master's house to pay the chicken-rent. In the women's workshop she finds about a dozen women spinning and dyeing cloth and sewing garments. [19] Ermentrude delivers the tax owed today, a fat pullet, and five eggs, then hurries back to her dwelling where she works in a little vineyard for an hour or two, prepares the children's meal, and spends the remainder of the day weaving warm woolen clothes for her family.

Peasant women, reports Power, work as hard as the men. Ermentrude and her neighbors, living in mud-and-wattle huts, paid some of their taxes to Charlemagne with small pieces of cloth that they had woven on narrow, vertical warp-weighted, or two-beam looms. The emperor ordered each family in his realm to learn to process, spin, and weave flax, not only for trade, but also because he recognized the sanitary value of linen garments for himself and others with wealth.[20] Linen clothing could be laundered more quickly than woolen, which often remained unwashed and became a breeding ground for lice. Power reports that Charlemagne himself addressed the following instructions to stewards of his estates:

> For our women's work they are to give at the proper time the materials, that is linen, wool, woad, vermilion, madder, wool combs, teasels, soap, grease, vessels, and other objects which are necessary.[21]

In the medieval era the nouns "hackle" and "heckler" were associated with the preparation of flax fibers for spinning. A hackle was the

tool with steel pins used to split and comb the flax; a dresser of flax was known as a heckler. Since the early nineteenth century a person who interrupts a public speaker in an abusive or aggressive manner has also been referred to as a heckler.

By the fourteenth century, the growth of a market economy had narrowed a rural woman's domestic chores and encouraged her to purchase such commodities as poultry, bread, ale, and cloth. Nonetheless, a woman spent most of her time in the production of food in the acre or two surrounding the house in which she and her family lived, or in the fields with her husband when additional labor was needed there.[22] The production of textiles remained a task for medieval Englishwomen of all ranks, and the wife of a knight spun thread as readily as the wife of a plowman.[23]

Piers Plowman and His Host of Pilgrims

Another view of medieval threadworkers and clothing appears in an allegory, *The Vision of Piers Plowman*, attributed to English poet William Langland (c.1330–c.1400). The poem is set in the Vale of Berkley and Malvern Hills areas of the Cotswolds. The cloth industry brought more wealth into this region of England than did anything else in Langland's day and continued to do so until 1840.[24]

As the poem opens, clothing "to keep out the cold" is the first of three blessings bestowed to all by the allegorical character Truth.[25] Covetousness, another character, is described as wearing a hood on his head with a lousy hat above it, and a "tawny tabard of twelve years' service, / Tattered and dirty, and full of lice creeping. / Unless a louse were a good leaper / He could never have crawled on a cloth so threadbare."[26] Covetousness confesses that during his apprenticeship to a party of drapers (cloth merchants) he learned:

> . . . to stretch the selvage so that it looked longer.
> With striped silks I studied a lesson.
> I pierced them with a packneedle and plaited them together,
> And put them in a press and pinned them fast,
> Till ten yards or twelve told thirteen in the total.[27]

He also boasts:

> My wife was a webster and wove woollens.

> She spoke to the spinners to spin it thinner.
> But the pound that she payed by passed by a quarter
> My own weight, if you weighed rightly.[28]

The narrator mentions the clothing of numerous other characters: hundreds in silk hoods; a lovely lady in linen garments; a woman wonderfully apparelled, the finest of furs affixed to her garments; a man clothed in a coarse suit; a traveller dressed like a pilgrim in pagan garb. When Piers Plowman, the leader of this host of pilgrims in search of Saint Truth, is delayed by his need to plow a half acre, a lady in a wimple asks what the women will do while they wait. Piers Plowman answers:

> Some must sow the sack . . . to keep the seed from spilling.
> And you lovely ladies with your long fingers,
> Who have silk and sendal to sow when you are able,
> Make chasubles for chaplains and for the church's honour.
> Wives and widows, spin wool and linen;
> Make cloth, I counsel you, and instruct your daughters.
> Note how the needy and the naked are lying.
> Get them some clothing, for truth commands it.[29]

The plowman turns to religious allegory when he describes the coat of Haukyn the Active Man; it was a coat of Christendom but covered with many patches—a patch from pride, from mad speaking, scorning and scoffing, from arrogance, from "showing himself otherwise than his heart warrants."[30] When Haukyn turns around, more evil covers the back of the coat—wrath, wilfullness, envy, and lying. "He told all that he heard of evil in any, / And blamed men behind their backs and prayed for their misfortune." [31]

Peasants hearing recitations of the poem would have understood its language combining the practical and the allegorical:

> Cloth that comes from the weaver is not good for wearing
> Until it is trod under foot or taken in the stretcher,
> Washed well with water, wiped with teasels,
> Tucked, and given to the tenter hooks, and to the tailor's
> finishing.
> The same belongs to the babe born of woman.
> Till it is christened in Christ's name and confirmed by the bishop.
> It is an heathen towards heaven, and helpless in the spirit.[32]

When Thread and Faith Were Wed

The Christian faith was a prominent influence in the artistic work of Anglo-Saxon threadworkers. When missionaries came to England from Rome in 597 C.E., they arrived with a variety of altar linen, priestly vestments, and relics of the holy apostles. Within a hundred years Christianity spread to all parts of England, and the decorative art skills of local textile crafters helped the Church teach lessons from biblical stories to the mostly illiterate population.

What lay behind this marriage between religion and threadwork? A short but reasonable answer is that medieval Christians joined Scripture found in the Hebrew Bible to a verse in the Gospel. They united the splendor of adornments in the Book of Exodus with miraculous healings found in the Book of Acts:

> And through Paul God worked singular miracles; when handkerchiefs and scarves which had contact with his skin were carried to the sick, they were rid of their diseases and the evil spirits came out of them.[33]

They compared themselves with the Israelites and determined to have ecclesiastical adornments in their churches as "splendid and glorious" as those specified for the early tabernacle and for the temple built by Solomon with its golden altar, golden lamps, golden censers, and golden candlesticks.[34] A medieval priest celebrating holy mass before an altar flaming with gold, altar vessels gleaming with gold or glistening with precious stones, and a cross lustrous with gold and gems had no need to apologize for his own attire's displaying equal brilliance. As the whole of England became Christianized—as monasteries and abbeys were constructed in the byways of that entire land, as kings and bishops traveled between their island and the pope's residence in distant Rome—the clergy endlessly desired, if they did not always need, richly embroidered priestly vestments and altar cloths.

Goscelin compared nuns, stitching on sacred vestments, to Aaron's sister Miriam who supposedly embroidered vestments for her brother and other Old Testament priests.[35] The nuns were models for every Anglo-Saxon Christian lady, who, in the later words of George Eliot, might nurture "the care of her soul over her embroidery in her own

boudoir."[36] While religious houses were centers of needlework produc-
tion, embroidery was widespread among all classes of people. For
queens and other noble ladies it was not merely a pastime but a serious
occupation, an organized domestic activity in which they directed the
work of servants and slaves.[37] Most contemporary reports refer to
embroidery workers as female, yet the reports also include some refer-
ences to members of both sexes—broiderers and broideresses.

The needleworkers' handwork could not be understated after the
twelfth century; priests' vestments now were competing for attention
with enormous and brilliantly colored stained-glass windows, elaborate-
ly carved wood-and-ivory screens, gold candlesticks that were four or
five feet tall, and other engraved vessels. The priests' choreographed
movements during the mass drew the viewer's eyes and thoughts into
the ritual. Vestments, heavy with gold thread and sparkling jewels, sug-
gested the riches reserved in heaven for worshippers, who expected to
walk around heaven someday, dressed in their own gold-embroidered
robes.

Medieval needleworkers apparently accepted a sort of quid pro quo
arrangement with God: they would make Him beautiful vestments and
textiles worthy of becoming sacred; He would bless them with miracles.
Somewhat like the ancient Greeks, who linked their gifts to Athena and
other gods with anticipated divine favors, early Christians placed great
faith in the continuance of miracles after the death of the apostles. By
156 C.E., the mortal remains of a saint—and also all the textile objects
that had been in contact with the saint's bones or tomb—became sanc-
tified as relics through which God could work miracles.[38]

Pilgrims seeking healing or blessing began traveling long distances
to visit the Holy Land. "The trickle of pilgrims to Palestine in the third
century grew into a stream in the fourth century," states John Adair in
The Pilgrims' Way.[39] Soon Europe had its own pilgrimage destination,
Rome, which reportedly possessed the bones of the chief apostles, Peter
and Paul. Believers quickly realized that their pilgrimages could be sim-
plified: all they needed were neighborhood saints and relics to bring
miracles closer to home. The honorary title "saint" began to designate
not only martyrs but also "those who had witnessed to the faith by suf-
ferings short of death or by the self-imposed cross of a holy and blame-
less life." By the fifth century shrines of lesser saints and martyrs
appeared, to use Adair's words, "like mushrooms after rain all over

Europe. . . . The test usually lay in the efficacy of their relics to work miracles. If miracles occurred which could be directly associated with a dead person or his relics, then he was acclaimed a saint by his neighbors, and sometimes his fame would spread throughout the region."[40] Of course, the mushrooming of all these saints and martyrs led to a wholesale demand for textile relics that were as splendid as vestments being worn by priests.

In the Middle Ages, a few threads of a saint's robes became as valuable for a relic as a splinter of his or her bones. Thus a needleworker could dream that the very garment on which she stitched for a priest or nun or for a noble lord or lady might someday in the future become sanctified as a holy relic.

St. Benedict taught his followers in the sixth century that "to labor is to pray," and a medieval needleworker surely had more than one reason to pray as she sewed. In addition to praying for her religious salvation, she could also pray for good eyesight in rooms that were dark more often than not. And she could pray for warmth in rooms that were generally damp and chilly. She could pray to be cured from stomach disorders and arthritis in her hands or back—disorders which are still all too common for workers who earn their bread with a needle. If she sewed for wages, she might pray to be paid before she died. But whether or not she prayed as she labored, she and others stitched storied vestments that took their place in the splendid pageantry of Latin and Orthodox church ritual.[41] Storied vestments had recognizable biblical scenes and/or figures embroidered on them or woven in them just as Helen's tapestry had Trojan War battle scenes woven into it. Embroidered threads are stitched on pre-woven fabric; tapestry threads are woven into the web of the fabric itself.

Faith in miracles and in sacred textiles only increased among Christians as the years passed and as the church named many additional saints. Furthermore, the Book of Acts mentioned only Paul's handkerchiefs and scarves, but medieval Christians exalted other textiles to a position of sanctity.[42]

Threadwork in Chartres Cathedral

In 858 C.E. Vikings burned a cathedral dedicated to the Virgin Mary in France at Chartres. After the people of Chartres rebuilt the cathedral

in 876 C.E., Charlemagne's grandson, Charles the Bald, gave the cathedral a piece of cloth believed to be from the garment worn by Mary as she gave birth to Christ. Soon the cathedral became one of the most popular pilgrimage shrines in Europe. Citizens of Chartres knew not only that the *Sancta Camisia* protected them and their city but also that this particular relic constituted a considerable source of income for them.

When fire severely damaged the cathedral in 1194, the people feared that the blaze had destroyed the relic protecting their city. A papal legate told them three days after the fire that the relic had been preserved in the crypt of the cathedral. Today the famous holy relic and several examples of medieval ecclesiastical embroidery are on display in the cathedral treasury. A visitor walking along the cathedral's south ambulatory can find among the scenes sculpted in the marble choir screen a delicately carved statue of Mary, her head bowed over needle-work. She is dressed in a medieval robe bordered with embroidered flowers; beneath her needlework is an open book, perhaps an illuminated manuscript of prayers.

The cathedral's thirteenth-century stained-glass windows contain images of thousands of human figures clothed in bright colors. Most of these windows were gifts of tradesmen—shoemakers, farriers, armorers, and money changers.[43] Three windows are particularly rich with thread-work narratives. In the upper half of a window in the south aisle, one finds the story of Adam and Eve. An illiterate peasant who had heard the Creation story could have followed the action depicted in the brilliantly colored glass, from the naked Adam and bare-breasted Eve under the apple tree, to the couple with scanty fig leaves covering their genitals, to a scene in which Eve, still bare breasted, sits spinning, and Adam, in a short tunic, pushes a plow.

The window's lower half tells the story of the man bound for Jericho who is attacked by thieves. The robbers strip a vivid green tunic off the man's back, leaving him only in his white drawers. A priest and a Levite, identifiable by their clothing, pass without stopping; finally the Samaritan mercifully clothes the victim and takes him by donkey to an inn.

The Joseph window in the north aisle not only spotlights the coat of many colors but also the cloak dropped by Joseph when he flees from sexual entrapment by Potiphar's wife. Butter yellows and willow greens complement the multitude of lavender and purple hues in this window. The final thirteenth-century stained-glass artwork particularly linked to

threadwork is the Prodigal Son window in the north transept. The father is shown in the opening panel giving his son a handful of coins. The well-dressed son sets out on a horse accompanied by a dog and a servant who is wearing a traditional medieval short tunic. Two seductively robed women await the youth in town and soon join him at a table laid out with a fine white cloth. One woman kisses her host while male and female servants (women in long robes, men in short tunics) bring food to the guests. A bed scene follows in which some heavy touching is suggested; but luck runs out for our hero soon after, as he sits forlornly with his chin in hand while playing a game of dice. Gone, next, are the clothes off his back as two burly men yank off his tunic. Reduced finally to wearing a peasant's smock and knocking acorns from trees, he scrounges food for swine. Subsequently, he walks toward home, humbly dressed now in a peasant's smock with a peaked hood. In the final scene, the father presents a new robe to his returning son. The theme of gifted clothing representing paternal love is recognizable whether encountered in Eden, in battle-weary Troy, or in the stories of Joseph and the Prodigal Son. Conversely, here, as in the Good Samaritan window/story, the loss of clothing is a metaphor for the loss of identity, dignity, and possibly of life itself.

Outside, on the left bay of the North Porch, stonecrafters left other evidence of contemporary medieval peasant life. Among the statues are two of seated women, each clothed in a flowing dress covering her from head to toe. Both are engaged in textile-related tasks, their tools clearly sculpted in stone; one woman is heckling flax and one is carding wool. Chartres Cathedral's glass, stone, and reliquary references to the role of threadwork and clothing in medieval theology and daily life are indispensable to the cathedral's story and place in history.

opus Anglicanum

England ranked preeminent among its neighbors during the Middle Ages in only one art: embroidery. Cathedral inventories and wills of the wealthy, as well as early historians, bestowed praise on this stitchery, called *opus Anglicanum* (English work).[44] Papal records indicate that popes from the twelfth to the fourteenth centuries either ordered embroidered vestments from England or received them as gifts, as in this anecdote from 1246:

> About the same time my Lord Pope, having noticed that the ecclesiastical ornaments of certain English priests . . . were embroidered in gold thread after a most desirable fashion, asked whence came this work. From England they told him. . . . Thereupon the same Lord Pope, allured by the desire of the eye, sent letters, blessed and sealed, to well nigh all the Abbots of the Cistercian order established in England, desiring that they should send to him without delay, these embroideries of gold which he preferred above all others . . . as if these acquisitions would cost him nothing. This command of my Lord Pope did not displease the London merchants who traded in these embroideries and sold them at their own price.[45]

English embroiderers apparently worked from designs taken from sketchbooks that were prepared by monks or others with access to drawings in manuscripts. They depicted specific biblical characters—Christ, the Virgin, the Apostles, Adam, and Eve—in exactly the same way on the storied textiles. For example, Saint Peter was and is recognizable because embroiderers always portrayed him with a tonsured head that is round with short gray hair; they identified Saint Paul with a long, narrow head and a high forehead, bare except for a prominent forelock of dark hair.[46] Such language in symbols enabled a largely illiterate population to understand the Bible and other stories of mythology, chivalry, and romance.

For over a hundred years the lines of stitching on faces and on garments followed the same directions. One scholar suggests that this formality of technical procedure allowed needleworkers to concentrate on expressing ideas as they worked instead of being distracted by the need to decide how to produce desired effects.[47] Perhaps so, but adept workers added their own creations of angels, foliated devices, birds and animals, armorial shields, and other ornaments to identifiable figures in the embroideries.

Surviving Medieval Embroidery

Of the many thousand English embroideries produced before the fourteenth century, barely a hundred important pieces are known still to exist. The earliest needlework surviving in northwestern Europe appears to be an Anglo-Saxon panel made early in the ninth century.[48] It is now

in Masseik, a small Belgian town near the Ardennes. The oldest known pieces of embroidery in England are a stole and maniple made in the tenth century for the tomb of Saint Cuthbert, who died in 687 C.E. Preserved in the library of Durham Cathedral, the threads on the fragments of these silk relics are "extraordinarily fine; sixteen of them couched closely side by side cover about an eighth of an inch."[49] Although it is probable that this stitchery was the handwork of women, medieval monks required all women who visited Saint Cuthbert's tomb to remain a measured distance away from the relics. A dark line across the cathedral floor, near the west end of the nave, still marks the boundary medieval women could not cross.[50] The tomb lay in the floor at the opposite end of the nave; above it rose a shrine covered with articles that might heal or pardon the sins of male worshipers allowed to touch the relics. The annual Feast of St. Cuthbert attracted thousands of pilgrims in the fourteenth century, yet the pilgrims at the tomb would have been only men.

Surviving ecclesiastical embroideries are stitched in gold, silver, and colored silk threads usually on fabrics of either linen or silk. The silks are often lined with linen foundations. When linens are used alone, they invariably are of two thicknesses, with a fine upper layer and a stouter one below, the needlework almost always being stitched through both layers. The silk floss used in stitchery is divided into strands of varying thickness, with the finest possible separation of strands made for faces and hands. Dyes have proved fast over the centuries, revealing even now beautiful tones of indigo, green shaded with yellow, and reddish fawn along with black and other less frequently used colors.[51]

While medieval Christians credited sacred textiles, such as a banner made from part of Saint Cuthbert's shroud, with helping them win battles against pagan Vikings, Muslim soldiers in Spain and elsewhere believed silk textiles woven or embroidered with holy writing to be their safeguards in battle. Sacred textiles covered Islamic sanctuaries and were ritually cut up and distributed to pilgrims. And, particularly beautiful silks captured by Muslims in battle were cut into fragments and divided up as war booty.[52]

A Closer Look at the Bayeux Tapestry

Over nine hundred years ago needleworkers documented a singular

military engagement with handwork that survives on display in Bayeux, a small village in the Normandy coast area of France. The needlework narrates the story of the Norman invasion of England on September 27, 1066, and the defeat of the English by William the Conqueror at the Battle of Hastings. Known as the Bayeux Tapestry, scholars generally acknowledge it to be English needlework even though it celebrates the invasion and conquest of England by a Norman king. Although it is known as a tapestry, it is actually embroidery.[53] Originally it was made in eight sections, but needleworkers later sewed it into a single panel which today is over two hundred feet long. It is only twenty inches high and is mounted behind glass that is an arm's length or more beyond the metal railing along which visitors walk as they read the narrative needlework.

The Bayeux Tapestry is rich as a historical representation of eleventh-century military equipment and action. On display are more than six hundred soldiers in mail armor, 202 horses, forty-one ships, and activities such as horse riding, shipbuilding, hunting, and even cooking as well as fighting with swords, bows and arrows, and battle-axes.[54]

Of the hundreds of individuals shown on the tapestry, only six are women.[55] The tapestry shows three of them in what are all too likely typical experiences of medieval women in wartime. In the first scene (depicted in the border running along the textile's lower edge) a nude male with outstretched arms and erect penis moves toward a nude woman. The woman has lifted her right hand to her head and turned her face away from the man; with her left hand she shields her genitals. The tapestry may suggest rape.

In the second scene (included in the narrative story itself) a tonsured cleric clothed in a short tunic and knee-length cape touches, possibly caresses, the face of a woman dressed in a floor-length robe. Mysteriously stitched above the two figures are the words "WHERE A CLERK AND AELFGYVA" but nothing more. Some scholars suggest that this vignette probably alludes to a contemporary sexual scandal that was "so well known in the circles where the idea of the Tapestry was first envisaged that the designer could not venture to omit it, however irrelevant it might be to the story he was telling."[56] In the third scene (also in the main narrative), a robed, presumably Saxon (English) woman grasps the hand of a small child. They stand inside a house, ready to flee as it is being torched from outside by enemy Norman soldiers.

Imaginative needleworkers and/or designers may have slipped all three figures of the women onto the tapestry. Perhaps they thought that this document of raw history should include at least some accurate reporting of real-life experiences of women in war. In the main narrative one also finds Queen Edith, attended by what appears to be a lady-in-waiting; they are sitting at the foot of King Edward's bed as he lies dying in his palace at Westminster.

Using woolen threads of eight different colors, the needleworkers embroidered on linen that in various places is now stained and repaired. The embroiderers used two embroidery techniques: outline or stem stitch for single lines, and laid and couched work on larger spaces. Their needles were probably bronze, like ones found on the site of the Saxon monastery at Whitby Abbey, but possibly were of an imported, harder alloy, steel.[57]

Authorities for many years thought the tapestry was the work of William the Conqueror's wife, Queen Matilda, and the ladies of her court. They credited Matilda, like a medieval Penelope, with spending lonely hours embroidering this memorial to her husband. David J. Bernstein, in *The Mystery of the Bayeux Tapestry,* observes, however, that more recent scholarship attributes the needlework to English craftspersons, probably all women, who did the embroidering on a carefully thought-out design. Rather than dismissing the designer as a charming folk artist, Bernstein credits the designer for translating a century of manuscript illumination into a spirited embroidery.[58]

The museum that houses the centuries-old tapestry also displays life-size models of medieval soldiers in their mail armor and robed monks working at manuscripts. But the museum has no life-size figures, or even drawings, of embroiderers (male or female) even though a sizable work force must have toiled for many months on the canvas.

The surviving tapestry in Bayeux ends abruptly in a ragged edge, with the English flight from the Battle of Hastings. In 1997, a panel recreating the lost ending of the original masterpiece went on display in Harrogate, England. It shows William the Conqueror being crowned king. For the panel, English embroiderer Jan Messent used yarn and plant dyes such as those employed a thousand years ago.[59]

A Bayeux Tapestry in Reverse

In 1990 Lord Dulverton commissioned twenty-five women at England's Royal School of Needlework to make "a Bayeux Tapestry in reverse" that would document a second cross-Channel invasion—the British and American landing on the Normandy coast of France on D-Day, June 6, 1944.[60] Working from paintings by Sandra Lawrence, a young English artist, the embroiderers completed in four years their 225 x 3-foot record of the World War II invasion, code named Operation Overlord. The Overlord Embroidery, as the needlework is called, is now displayed in a museum built around it in Portsmouth, England. Living memory of that day in 1944 when 176,000 men, 9,500 warplanes, 600 fighting ships, and 4,000 transports and landing craft set out from England across the English Channel, will soon slip away. Already the reinforced cement pillbox defenses topping the Normandy coast are starting to crumble. Remarkably the fragile object made of cloth and thread in the 1990s may last for a thousand years to bear testimony to this second successful cross-Channel invasion.

The Bayeux Tapestry's art inspired a representation of the Allies' D-Day invasion on the cover of *The New Yorker* July 14, 1944. A half-century later, the magazine reprinted the drawing in celebration of the fiftieth anniversary of D-Day.[61] The resonance between the medieval and modern art and between the two Channel crossings, separated by nine hundred years of time and technology, was happily apparent despite the passing of time.

A Roster of Medieval Needleworkers

A twelfth-century record indicates that the Spanish city of Almeria had eight hundred textile workshops in which silks and brocades were produced. And the medieval French tale, *The Knight of the Lion*, includes an imagined scene of three hundred young girls making various things with gold thread and silk.[62] Such concentrations of craftspeople working at spinning, weaving and embroidering propelled the economy in many medieval towns. In eleventh-century London, craftsmen lived and worked in distinctive neighborhoods with names identi-

fying each trade. Threadneedle Street marked the place where tailors set up shop; today the Bank of England, known as "the Old Lady of Threadneedle Street," is located there.

Contemporary documents preserve the names of few threadworkers and, not surprisingly, the names of noblewomen are among the few that are known today. Early English documents also cite the names of a few craftswomen associated with some kind of payment for their work. Denbert, Bishop of Worcester, granted Eanswitha, a ninth-century embroideress at Hereford, a lifetime lease of a two hundred-acre farm "on condition that she was to renew and scour, and from time to time add to the dresses of the priests who served in the cathedral church."[63] During the eleventh-century reign of Edward the Confessor, the sheriff Godric granted Alwid the Maid a small parcel of land which she could hold as long as he was sheriff, "on condition of her teaching his daughter embroidery work." The will of Matilda, queen of William the Conqueror, refers to a chasuble which "is being embroidered at Winchester by Alderet's wife."[64]

Royal accounts concerning payments for embroideries between 1239 and 1245 refer at least twenty-four times to Mabel of Bury St. Edmunds who executed many commissions for Henry III. In 1256 Henry made a pilgrimage to Bury St. Edmunds and during his stay presented a gift of warm clothing to Mabel. His order stated that because the "broideress" had served the king and queen well, making ecclesiastical ornaments, he would give her "six ells of cloth, appropriate to her [status], and the lining of a robe of rabbit fur."[65]

Jacques Le Goff believes that the image of a society that appears in its records "is related in a complex way to the global society from which it stems. . . . This image is at once an expression, a reflection, and a sublimation or camouflage of the real society."[66] An Anglo-Saxon proverb proclaimed: "A woman's place is at her needlework,"[67] and in medieval society all women were expected to have textile skills. Thus it is understandable that few names of threadworkers would stand out in the records of that era. If a needleworker did become an exception to this typical invisibility, it was because of his or her outstanding skills in needlework, marketing, or management; some of these entrepreneurs rose to become merchants of wealth. But far more numerous were the unnamed peasants weaving in damp cellars and darkened hovels behind the camouflage of cathedrals, castles, and jeweled crowns.

Notes

1. Kenneth Scott Latourette, *A History of the Expansion of Christianity,* vol. 1, *The First Five Centuries* (New York: Harper & Brothers Publishers, 1937), p 158; Arthur E. R. Boak, *A History of Rome to 565 A.D.* (New York: Macmillan, 1947), p. 429.

2. William H. McNeill, *The Rise of the West* (Chicago: The University of Chicago Press, 1963), note, p. 399.

3. Boak, p. 491.

4. Loren Carey Mckinney, *The Medieval World* (New York: Rinehart & Company, 1955), pp. 264–65.

5. Mary E. Waterhouse, *Beowulf in Modern English* (Cambridge: Bowes and Bowes, 1949), p. 37.

6. Ibid., p. 95.

7. C.R. Dodwell, *Anglo-Saxon Art: A New Perspective* (Ithaca: Cornell University Press, 1982), p. 134.

8. Ibid.

9. Jacques Le Goff, *Time, Work, & Culture in the Middle Ages,* tr. by Arthur Goldhammer (Chicago: The University of Chicago Press, 1980), p. 90.

10. Ibid.

11. Dodwell, p. 50.

12. Le Goff, p. 91.

13. Dodwell, pp. 27, 29, 35, 50.

14. Ibid., pp. 30, 129–32.

15. Norman F. Cantor, *The Medieval Reader* (New York: Harper Collins Publishers, 1994), p. 101.

16. J.H. Plumb, *The Italian Renaissance* (New York: American Heritage, 1985), p. 10.

17. Carl Stephenson, *Medieval History: Europe from the Second to the Sixteenth Century* (New York: Harper & Brothers, 1943), p. 270.

18. Eileen Power, *Medieval People* (New York: Barnes & Noble Books, 1963, paperback edition), pp. 19, 23–28. First published in London by Methuen & Co., 1924.

19. Ibid., p. 25.

20. Wilson, p. 15.

21. Power, p. 25.

22. Judith M. Bennett, *Women in the Medieval English Countryside: Gender*

and Household in Brigstock Before the Plague (New York: Oxford University Press, 1987), pp. 117 and 119.

23. Ibid., p. 186.

24. David Daniell, *William Tyndale, A Biography* (New Haven: Yale University Press, 1994), p. 15.

25. William Langland, *The Vision of Piers Plowman,* tr. by Henry W. Wells (New York: Sheed & Ward, 1945), I: lines 20–23.

26. Ibid., V: lines 308–311.

27. Ibid., V: lines 322–26.

28. Ibid., V: lines 327–330.

29. Ibid., VI: lines 9–16.

30. Ibid., XIII: lines 290–297.

31. Ibid., XIII: lines 339–343.

32. Ibid, XV: lines 482–489.

33. The Book of Acts, 19:11.

34. Dodwell, p. 33.

35. Ibid., pp. 31, 33.

36. George Eliot, *Middlemarch,* Chapter 3. (New York: Book-of-the-Month Club, 1992), p. 29.

37. A. G. I. Christie, *English Medieval Embroidery* (New York: Oxford University Press, 1938), pp. 2, 17–18.

38. John Adair, *The Pilgrims' Way: Shrines and Saints in Britain and Ireland* (London: Thames and Hudson, 1978) p. 9.

39. Ibid, p. 9.

40. Ibid., pp. 10-12.

41. See Athanasios A. Karakatsanis, *Treasures of Mount Athos* (Thessaloniki: Holy Community of Mount Athos, 1997), pp. 443–89, for examples of medieval liturgical vestments in the Orthodox Church.

42. Pilgrims seeking divine blessings flocked to Constantinople after the sixth century and to Rome after the thirteenth to view the Mandylion and the Vernoica, two textiles on which, according to legend, the "true likeness" of Christ had been miraculously imprinted when he used each of them to wipe his face. See Gabriele Finaldi, Alexander Sturgis, et al., *The Image of Christ* (London: National Gallery Company Limited, 2000), pp. 74-101.

43. Malcolm Miller, *Chartres Cathedral* (Andover, Hants.: Pitkin Pictorials, 1985), p. 10.

44. Christie, p. 2; Philippa Scott, *The Book of Silk* (London/New York: Thames and Hudson, 1993), p. 194.

45. Christie, p. 2.

46. Ibid., p. 10.

47. Ibid., p. 21.

48. Scott, p. 194.

49. Christie, p. 18.

50. Adair, pp. 145, 149.

51. Christie, p. 20.

52. Scott, pp. 94, 95.

53. George W. Digby, formerly Keeper of Textiles at The Victoria and Albert Museum, writes that although "the word 'tapestry' derives from the Latin *tapesium,* meaning a covering in general (and so the use of the word to include needlework on canvas is perhaps fully justified), it is very useful to reserve the word exclusively for the woven fabric whose different-coloured wefts combine with the warp to make up a figured material, the wefts not being thrown in a shuttle from selvage to selvage. In this sense tapestry is a precise technical term, distinct from shuttle-woven fabrics and brocades on the one hand, and from embroidery and canvas work on the other." Sir Frank Stenton, General Editor, *The Bayeux Tapestry: A Comprehensive Survey* (New York: Phaidon Publishers, Inc., 1957), p. 38.

54. Stenton, p. 42; David J. Bernstein, *The Mystery of the Bayeux Tapestry* (Chicago: The University of Chicago Press, 1986), p. 16.

55. Bernstein, p. 16. I myself have located and found specific identifications of only five of the six women referred to by Bernstein.

56. Stenton, p. 10, and fig. 19; Bernstein, p. 238.

57. Stenton, pp. 40, 42; Bernstein, pp. 14–15.

58. Bernstein, pp. 7, 15.

59. Russell Jenkins, "Stitches in Time," *London Times* (August 28, 1997).

60. Timothy Foote, "Tapestried Tales of Two Rough Channel Crossings," *Smithsonian Magazine,* May 1944, p. 71.

61. *The New Yorker,* June 13, 1994, p. 83.

62. Scott, pp. 108, 172. Looking at the geometric patterns on decorative tiles in medieval palaces built by the Spanish Moors in Cordoba, Seville, and Granada, I recognized immediately their similarity to certain geometric patterns on American quilts. Ironically, some of the tile designs are reported to have come from antique textiles.

63. Christie, p. 31.

64. Ibid., pp. 31, 32.

65. Kay Staniland, *Medieval Craftsmen: Embroiderers* (Toronto: University of Toronto Press, 1991), p. 10.

66. Le Goff, p. 88.

67. Dodwell, p. 72.

Art of the Loom

4

Germany's oldest museum for folk arts and crafts is located in the Jägerhof, a building in Dresden that served as a menagerie for exotic animals in the eighteenth century. Inside the Jägerhof's stone walls today are hundreds of exhibits that reflect the traditional culture of Saxon peasants and craftspeople. Among the exhibits of looms and spinning wheels on display in 1997 was a small glass bottle containing a miniature weaving workshop complete with three Lilliputian workers. A woman sat spinning yarn, a man wove at a treadle loom, and another woman, no more than two inches tall, stencilled designs on a length of fabric. In Germany and elsewhere in Europe from the thirteenth into the nineteenth century, women and men, whether in their own homes or in workshops, produced textiles at treadle looms not only for their own clothing but also for an extensive commercial trade. For the merchants who controlled the trade, textiles became a source of considerable wealth. In cities such as Florence the production of woolen cloth by skilled workers was the main factor in their economic growth in the thirteenth century on the eve of the Italian Renaissance.[1]

Europe's Leading Export

The Crusades of the eleventh and twelfth centuries stimulated an economic revival in Europe and the Levant countries bordering on the

Mediterranean and an interdependence between the former enemies. Soon textiles led Europe's exports and dominated the complex economic system linking the two areas. Shepherds from England's Cotswold and Yorkshire hills, Belgian weavers, traders at fairs in the French trading center of Champagne, and Italian merchants, dyers, finishers, and navigators were all involved in the expanding textile economy.[2] The voyages of Columbus illustrate the importance of textiles to Europe during the high medieval and early Renaissance period. The son of an Italian weaving family, Christopher Columbus reached the Americas while looking for the source of spices and coveted silks being woven in China. Profits from Spanish wool interests financed his ventures. The cotton he found growing in the West Indies ultimately became the raw material for weavers back in England, France, and Spain.[3]

From the thirteenth century onward, rival European rulers and merchants sought to increase their power and profits by extending their control over the expanding textile market. England's Edward III (1327–77) launched an attempt to produce wool cloth domestically by promising to lavish favors on weavers who brought their craft from Flanders to England. Capitalizing on political unrest in the Low Countries, Edward granted letters of protection in 1331 to all Flemish weavers who immigrated to England "to ply their trade."[4] The king apparently sent secret agents to promise the weavers beef and mutton on English soil instead of the few herrings and moldy cheese that they lived on in Flanders. Eventually, England and Flanders were "married by wool and cloth," and England offered whatever was necessary to lure weavers away from other areas on the continent competing for the limited pool of skilled weavers.[5]

In 1337 an act of parliament promised "lavish favours" and "fair treating" to alien settlers. "All the cloth-workers of strange lands . . . shall be in the king's protection and safe conduct to dwell . . . where they choose" in England, Ireland, Wales, and Scotland.[6] As a result of this enticement, a large influx of immigrant weavers, dyers, and fullers came and took up residence in English towns and in the countryside. (The fullers shrank cloth to increase its weight and bulk.) Guild members in the towns resented the arrival of the immigrants, who refused to pay annual dues to the guilds. Friction between the native English and the alien textile workers lasted into the fifteenth century, but Edward's

initiative succeeded well enough to establish cloth manufacture as England's pillar of revenue by the early seventeenth century.[7]

Trade in wool and woolen textiles also sustained trade of other products such as wine and spices. According to historian William H. McNeill, Italian merchants discovered that northern Europeans delighted in a sweet dark wine with unusually high alcoholic content made from grapes that grew in Cyprus and the Greek Peloponnesus. The English called the wine "malmsey" and exchanged their high quality wool for barrels of it. Highly specialized artisans in Flanders and Italy worked the raw English wool into finished textiles. Italian merchants exchanged the fabrics in the Levant for wine, spices, and the chemical alum, which was used as a mordant in dyeing textiles. Custom-designed vessels, larger than any wooden ships built before or after, carried alum from its source in Asia Minor to Flanders, where workers combined it with dyes to make colors that would be insoluble when the woolen textiles were worn and washed. "The far-flung integration of skills and resources that went into Europe's fourteenth-century textile trade was the single most important achievement of the Italian city state economy," concludes McNeill.[8] In Florence, Italy's greatest center of textile manufacture, one observer in the 1330s used the evidence of bread needed daily for "the mouths of men, women and children" to estimate that the wool craft supported more than thirty thousand persons, or at least one third of the city's population.[9] The lot of such workers in the fifteenth century inspired artists Michelangelo and Botticelli. The art and Florentine architectural monuments that have for centuries delighted visitors "were built by the profits accumulated from sale of Florentine cloth and from the transactions of Florentine merchants and bankers."[10]

The Importance of Spinning

Philippe V, the new king of France in 1317, was given a beautifully illuminated manuscript. It recounted the life of the first bishop of Paris, St. Denis, who had been beheaded circa 250 C.E. outside the city gates at the instigation of the Roman emperor. Miniature drawings in the manuscript featured thirty contemporary scenes of everyday life on two bridges crossing the Seine River. The bridges dated to Roman times

and, after being damaged by fire and flood in the course of the centuries, had been rebuilt again and again, sometimes of wood, sometimes of stone. The miniature drawings were reproduced in 1974 in a book by Virginia Wylie Egbert, who wrote that any visitor to medieval Paris soon would have discovered that commercial activity was centered on the two bridges—the Grand Pont and the Petit Pont—connecting the island of the *Cité* with the Right and Left Banks.[11]

Within the bustling activity illustrated in the drawings, one finds blacksmiths replacing shoes on a horse, men pulling in a net of good-sized fish, and money changers and goldsmiths at work. A young man who is carrying his falcon into the congested city follows a porter staggering under a heavy sack slung over his shoulder. A ragman walks away from a woman who spins as she sits in the doorway of her house or shop.[12] In her left hand she holds a tall distaff, its base pressed against a belt at her waist. The top of the distaff holds unspun fiber, which the woman is steadily drawing out under tension and twisting into a thread attached to the spindle she is turning in her right hand. Another drawing depicts a woman skillfully winding thread from a spindle to a thread-winder as she sits in a fashionably styled chair and observes the passing scene.[13] And in still another doorway a woman is spinning thread on a long distaff held under her left arm; a large basket at her feet appears to contain balls of thread while a pet monkey crouches nearby.[14] From a peddler with two baskets of bread balanced over his shoulders to men pulling carts laden with sacks or stones, the drawings continue in delightful sequence illustrating the variety of trade in progress on the bridge and below in the river.

The drawings suggest that the time-consuming practice of spinning thread by hand was ubiquitous in fourteenth-century Paris and that thread was spun primarily by females (spinsters). Such gender-based hand spinning remained for four more centuries crucial to the production of cloth in Europe. Historian Merry E. Wiesner indicates, for example, that in 1577 in one German center of textile production, Augsburg, the city council responded to complaints from the weavers' guild by enacting a series of harsh ordinances designed to force more single women to work as spin-maids in the weavers' households. The demand for thread was so great, however, that the regulations were impossible to enforce. Two decades later young women "were saying openly that they were not so dumb as to work as spin-maids for the

weavers when they could earn three times as much spinning on their own." Wiesner also reports that seventeenth-century Württemberg authorities exercised tight control over women who earned their own bread, forbidding them to accept any work other than spinning and imposing fines on residents who provided other employment to single women.[15] As late as 1718 it was said that there were not enough spinners in all of England to spin the wool that was needed there in cloth manufacture. Spinning schools existed as part of poor relief, and English children as young as six were paid a pittance to spin up to twelve hours a day.[16]

The St. Denis manuscript presented to Philippe V had been intended for his father, Philippe IV, who died before work on the *Life of St. Denis* was completed. In 1302 Philippe IV had gained control of Flanders, northern Europe's greatest textile region, and for a brief time the French king reaped a rich financial harvest from the hands of peasant weavers. After two years of his tyrannical exploitation, the Flemish townsfolk in Brugge revolted against the French monarch. When Philippe IV sent armored knights on horseback to suppress the rebellion, they were disgraced at Courtrai in a battle with an improvised army of Flemish textile workers, artisans, and other peasant pikemen led by a weaver, Peiter de Coninck. The peasants and workers carried so many of the knights' golden spurs—one for each knight killed—from the battlefield as trophies that the victory came to be known as the Battle of the Golden Spurs. The spurs were hung in the Courtrai cathedral as an offering of thanks. The Flemish people of Belgium still celebrate the battle's anniversary each July in memory of those who fought victoriously for their rights at Courtrai.[17]

In 1358, a half-century after the Flemish revolt, peasants (many of them cloth workers) in the city of Paris briefly ended the tranquility suggested by the drawings in the *Life of St. Denis.* Called the "Jacques," the laborers united in mobs that looted, plundered, and tortured their perceived enemies. Unlike the victorious peasant pikemen in Flanders, however, the Parisian rebels were unable to overpower those in control.

The Apocalypse Tapestry

During this period the powerful and wealthy commissioned artists to draw large cartoons, or illustrated stories, as patterns for woven tap-

estries to cover dark, cold walls in massive stone castles.[18] European nobility often wanted to see themselves portrayed in heroic splendor in these larger-than-life scenes. And they wanted to be amused, inspired, or instructed by stories written in threads, picturing familiar biblical and mythical characters on the walls surrounding them. About 1373, Louis I, the Duke of Anjou and brother of Charles V of France, commissioned a tapestry of extraordinary size. Seven to ten years later *The Apocalypse Tapestry,* longer than an American football field and twenty feet high, was delivered to the duke, who lived to enjoy it for only a brief time at Saumur Castle, his massive fortress on a hill overlooking the city of Angers.[19]

Jean Bandol of Brugge, court painter of Charles V, is credited with designing the life-sized cartoons from which weavers worked. The artist is thought to have based his design more on traditional apocalyptic iconography than on the biblical text found in the Book of Revelation, yet he is credited with being the first person to transcribe the prophecy in wool. On highly detailed tapestries such as this, one weaver, weaving daily except Sunday, from daylight to dark, could complete about one square yard per month. An unknown number of weavers worked, apparently at vertical, high-warp looms, in several workshops under the direction of Nicolas Bataille, a merchant-weaver of Paris. They wove the tapestry in six sections, each section measuring seventy-eight feet by twenty feet (the latter measurement being the width of the looms on which several weavers worked side by side). Each of the six sections contained fourteen scenes; a final section of six scenes completed the series.[20] Today seventy-five of the tapestry's original ninety scenes are hung in two rows, one above the other, their blue, red, and ivory colors in wool thread still discernible, yet in places very pale.

The Apocalypse Tapestry, woven by now-nameless weavers a hundred years before Columbus reached the New World, is the largest known set of tapestries anywhere; it is also the oldest French tapestry to have survived to our time.[21] Displayed since 1954 in a gallery designed for it within the thirteenth-century ramparts of Saumur Castle, the tapestry is like a book in mural form. Its narrative is based on the enigmatic yet dramatic story written at the end of the first century C.E. by John the apostle and evangelist and recounted in the Book of Revelation. The surviving seventy-five scenes of the drama contain representations of God, Christ, and John as well as the Beasts and Elders, the Seven

Churches, the Four Seals, the trumpets, angels, demons, prophets, horses, Satan, Babylon, and Jerusalem the Celestial. The larger-than-life figures are woven between upper and lower borders that signify the heavens and earth. Angels playing trumpets, violas, and drums fill the heavens; trees, flowers, grass, and various animals, including a rabbit, which is shown going in and out of its burrow throughout the story, cover the earth. A taped guide helps visitors to Saumur Castle comprehend the tapestry's message.

Obviously, textiles that have survived for centuries are the exception. Indeed, some have had very brief lives. Records from the city of London in 1374, the year after *The Apocalypse Tapestry* was commissioned, include an order of the mayor and aldermen granting permission to "reputable men" of the tapestry guild to burn a tapestry made by Katherine Duchewoman in her house at Fynkeslane. Katherine was charged with "deceit of the people" because her work was made of "linen beneath, but covered with wool above."[22]

Hints to a Young Wife in Paris

A book of deportment written between 1392 and 1394 by an older man who had recently married a young woman of higher birth than himself contains further evidence of the role fiber workers played in Paris a half century after the Renaissance had taken form in Italy.[23] Thinking that he might die before his wife, he wrote at length offering advice in the event that she married again after his death.

> Fair sister, if you have another husband after me, know that you should think much of his comfort. . . . I pray you, keep him in clean linen, for 'tis your business. And because the care of outside affairs lieth with men, so must a husband take heed, and go and come and journey hither and thither, in rain and wind, in snow and hail, now drenched, now dry, now sweating, now shivering, ill-fed, ill-lodged, ill-warmed, and ill-bedded; and nothing harms him because he is upheld by the hope that he has of his wife's care of him on his return.[24]

The good care that this traveling businessman anticipates on reaching home includes having his feet washed and having fresh shoes and stockings along with good food and drink waiting for him. When bed-

time arrives, he will expect to be "well bedded in white sheets and night-caps, well covered with good furs, and assuaged with other joys and amusements, privities, loves, and secrets concerning which I am silent, and on the next day fresh shirts and garments. . . . [S]uch services maketh a man love and desire to return to his home and see his goodwife and to be distant with other women."[25] This Parisian's advice to his wife echoes that of Hector to his wife, Andromache: "Attend to your work, the loom and the spindle, and see that the maidservants get on with theirs."

Silk, Chivalry, and Slaves

Silk textiles played a prominent role in the high medieval and early Renaissance centuries, particularly when embroidered silks were used to advertise the wealth of kings and nobles in the age of chivalry. Monumental brasses preserved primarily in English churches reveal knights wearing silk *joupons* (rich tunics embroidered with heraldic devices) over their armor.[26] And contemporary reports tell of tournaments bedecked with silk-hung tents and banners and with horses covered in rich silks. In one fifteenth-century report, a young Englishman, attending the continental wedding of Margaret of York and Charles the Bold of Flanders, wrote home that the gold-embroidered textiles and tapestries lining the processional route almost blinded him. (Less than ten years later, after a disastrous battle, the naked body of Charles was found stripped of his clothes and armor on the edge of a frozen pool.)[27] In the sixteenth century the builder of Fontainebleau Palace, Francis I, met England's King Henry VIII at the Field of the Cloth of Gold near Calais in France. The rival kings set up vast tents hung with gold and silver silk brocades and changed their richly woven silk garments several times a day.[28] Ironically, perhaps the most famous event in the two-week parade of extravagance was a wrestling match in which Francis threw Henry to the ground.

Wealthy merchants and bankers could also afford to dress their family members fashionably. From Nuremberg in 1591, Magdalena Paumgartner wrote to her husband on one of his business trips to Lucca: "Dear treasure, I ask you not to forget about my Italian coat, one like the one Wilhelm Imhoff brought his wife from Venice. . . . Do not think ill of me because I always try to wheedle something out of you

in every letter. I especially ask that you bring some red and saffron-coloured satin, if you can find an inexpensive measure or two."[29]

Rich silks had traveled from China to the West for centuries before the Silk Road "opened" in the second century B.C.E. during the time of the Romans. After the fall of Rome in the fifth century, rare samples of richly embroidered textiles began turning up in Germany, France, and even England. Eastern sheiks gave silks to Western rulers such as Charlemagne. Christian pilgrims traveling to the Holy Land often returned home with rare silk textiles which they might have worn until their death, then bequeathed to the church to wrap the mortal remains of a saint such as Cuthbert.

After Arab and Berber forces crossed the Strait of Gibraltar from North Africa into Spain in 711 C.E., they rapidly established Muslim control over much of the Iberian Peninsula.[30] In this relatively isolated part of the West, Muslim merchants from Egypt, Iran, and Byzantium introduced fine textiles and textile workers. By 1060 Spanish workers in Córdoba and Almería had begun to produce beautiful silks that local officials presented to ambassadors from France, Italy, and elsewhere.[31]

In the twelfth century the Norman King Roger II (1103–1154) returned to Sicily with silk weavers captured from the Byzantine lands of the Peloponnese and Ionian islands,[32] just as Muslim victors in earlier centuries had forcibly taken Chinese silk weavers to lands we know today as Iraq, Iran, and Turkey. "Slaves," writes historian William H. McNeill, "played a far greater role in trade than scholars recognized until recently."[33] During violent struggles for control of Sicily after the death of Roger II, colonies of these weavers migrated to Naples, Lucca, Venice, and other Italian cities where they introduced their textile art; thus silk manufacturing began in Europe beyond the Iberian Peninsula. The silk business was highly competitive, as the Lucca statutes of 1308 concerning silk weavers illustrate. The statutes ordered the strangling of any man and the burning of any woman from Lucca who engaged in the silk industry outside the precinct of the town. Shortly after the announcement of these statutes, an enemy sacked Lucca and many of her textile workers fled in haste to Venice, where the destitute refugees were given loans which had to be repaid in silks woven in the new city.[34] The crafty Venetians knew that once the Luccan immigrants wove in Venice, they would not dare return to their native city.

Females dominated only seven out of more than one hundred guilds

in late thirteenth-century Paris. They specialized in spinning silk, weaving silk ribbons, and producing luxury products decorated with silk, gold thread, and pearls. Female-dominated guilds in Rouen and Cologne at this time also focused on luxury textiles, including silk fabrics. In London and most medieval cities and towns, however, females working with silk and at other highly skilled crafts never formed guilds.[35]

European merchants and weavers, aided by political woes in the older silk-weaving centers of the Middle East, developed silk weaving to a spectacular degree and controlled the silk trade within much of Europe from the fourteenth to the sixteenth centuries. By 1531 the city of Genoa listed some two thousand silk weavers among its craftspersons.[36]

Italian High Fashion

At the highest economic level in Italian Renaissance society lived two women who came from one of the most ancient dynasties in Italy: Isabella d'Este and her younger sister, Beatrice, the daughters of an Italian duke. When Isabella married, at sixteen, in February 1490, her elegant trousseau was packed in thirteen hand-painted chests and transported in a triumphal carriage from her home in Ferrara to the groom's castle in Mantua. The following year, as Beatrice prepared for marriage, royal ministers recommended that she take "many embroidered and bejeweled gowns" to her new home. After her marriage, however, critics protested that her eighty-four dresses, heavily embroidered with gold thread, jewels, and pearls, were "excessive" and "verging on the satanic." Six years later Beatrice died in childbirth at age twenty-two; she was "robed in gold upon her bier" in a cathedral brilliantly lighted by a thousand flaming torches and thousands of wax tapers.[37]

How many persons labored over all the weaving, embroidering, and sewing for Isabella and Beatrice during their lifetimes remains unknown. Far better documented is the era's widespread violence and brutality which are illustrated in the fates of the men who married the Este sisters. Isabella's husband, Francesco Gonzaga, marquis of Mantua, survived three years in a Venetian prison; Beatrice's husband was less fortunate. Three years after her funeral, her husband, Il Moro, the duke of Milan, was captured by a French king and imprisoned for eight years in a windowless cell at the castle of Loches. He died at the moment he was released, perhaps from the shock of sunlight.[38]

The ninth-century peasant, Ermentrude, the unnamed young wife in Paris, and the two Este sisters in Renaissance Italy are women from different centuries who cut across the socioeconomic spectrum, but all appear to have had considerable threadwork tasks to perform or to supervise. Each woman's situation sheds partial light on the roles and daily lives of threadworkers in early Europe.

Developments in Technology

Between the eleventh and the fifteenth centuries cloth-making technology in the West began evolving after having remained virtually static for centuries. Larger, more sophisticated looms, spinning wheels, and new sources of power became available to textile workers. The treadle loom, which weavers had used perhaps as early as 2000 B.C.E. in China, made its way into Europe in the eleventh and twelfth centuries.[39] At this type of loom, a weaver's feet operate a pedal that raises and lowers alternate warp threads, thereby freeing the weaver's hands to propel the shuttle through the warp threads and beat the successive weft threads against the cloth already woven. Men in the West initially worked the new looms and were able to sit while they wove. These looms, larger and initially more expensive than vertical looms, enabled entrepreneurs to organize weaving in workshops or weaving sheds. Over time, however, handmade treadle looms became ubiquitous in ordinary households.

The *Domesday Book* of 1086 records that five thousand water wheels were in use for grinding grain in England.[40] By the twelfth century, water wheels were supplying power for other labor-saving functions, including fulling cloth in dozens of European towns.[41] Before the introduction of water wheels, fulling required an extensive system of vats, a water supply, a strong solution of animal urine, mineral alkali, and an absorbent clay known as fuller's earth. Men called fullers trampled newly woven cloth underfoot until it was shrunk sufficiently. The fuller was sometimes called a walker. The surnames Fuller, Walker, Weaver, Webster, and Tailor are among those probably derived from tasks associated with threadwork. Rural households that made their own wool cloth skipped the fulling, dyeing, and finishing of their textiles, and perhaps the coarse wool cloth worn by peasants caused some of the skin afflictions common in the Middle Ages.

The use of wind power developed rapidly in Europe after technicians in Normandy conceived of the vertical-sail, horizonal-shaft windmill near the close of the twelfth century. The windy flat lands of northwest Europe, although impractical for water mills, were ideal for windmills. Prosperous towns soon developed in this region, and over a hundred windmills were in use in the town of Ypres by the thirteenth century.[42]

The first belt transmission of power occurred circa 1280 when imaginative workers applied it to spinning wheels in Speyer, Germany.[43] At the time twenty or more spinners working at traditional spinning wheels were needed to supply thread for one weaver; after the introduction of the belt-driven spinning wheel, four to six spinners were able to keep one weaver supplied with yarn. Weavers in Speyer naively accepted the new, belt-powered spinning wheel on the condition that it be prohibited in the spinning of warp threads. These threads, they maintained, needed to be stronger and could be better made by the old hand method.[44] Only later, when nothing could be done to stop "progress," did textile workers comprehend how they would suffer when belt-driven spinning wheels began producing more yarn than they could weave and belt-driven looms began replacing tens of thousands of hand weavers.

Measuring the Working Day

In the church-dominated society of the Middle Ages, labor meant rural labor, and labor time was measured by the amount of land that could be plowed from sunrise to sunset. This concept of a day's labor echoed the biblical definition, "God called the light Day." As towns developed, church bells ringing at sunrise and sunset signaled the beginning and end of the urban working day. Urban cloth workers, including weavers sitting at the new treadle looms in workhouses, were among the first laborers to attempt to lengthen the working day and thereby increase their wages. In 1315 the fullers' assistants in Arras, citing the increase in the weight and size of fabrics with which they worked following the invention of fulling mills, demanded longer working days and higher wages. Owners of the mills granted their request and authorized night work, a practice considered heresy by rural laborers. Within seven years, night work had become standard practice.

Soon afterward, employers began charging that cloth workers were

cheating on their hours and, in place after place across Italy, France, and the Low Countries, governing officials authorized bells in workhouses. Philip VI granted permission, in 1335, to the mayor and aldermen at Amiens to ring a bell in the city belfry, authorizing the time when cloth workers should begin work, when they should eat, and when they should quit work for the day. In other towns officials also granted employers the right to construct a belfry with a special bell that would regulate the work hours of the cloth trade.

In the *Divina Commedia,* written by the poet Dante (1265–1321), church bells that rang at the beginning and end of the working day symbolized the underlying economic, social, and mental structures of Florentine society during the eleventh to thirteenth centuries. The introduction of a mechanical clock in the town belfry in 1354 silenced the ancient church bells in Florence while in other villages and towns church bells were also being silenced. This silence marked a major revolution in the rhythms of time that occurred in the West during the fourteenth century as urban/secular concepts of time replaced rural/ecclesiastical ones. "Labor time," writes historian Le Goff, "was transformed along with most other social conditions; it was made more precise and efficient, but the change was not a painless one . . . in the cloth manufacturing cities, the town was burdened with a new time, the time of the cloth makers."[45]

The new time symbolized new masters who were secular rather than ecclesiastical, and although workers may have wanted more pay and hence asked for longer hours, they did not want their work hours ruled by bells. In town after town, employers fired or fined workers who defied the bells. The workers responded with uprisings and strikes, and in return, the authorities merely stiffened the penalties. Lest work bells be seized and used to call workers to assemble in revolt, city authorities in Paris proclaimed the death penalty in 1361 "for anyone who should ring the bell to call for revolt against the king, the aldermen, or the officer in charge of the bell."[46]

These regulations ultimately snared urban workers in a web of fixed hours. Time ceased to be linked to special events like festivals or cataclysms; instead, it became linked to daily life. The invention and spread of mechanical clocks led to the building of clock towers opposite church towers in most towns. By the end of the fourteenth century, the sixty-minute hour became the standard in much of France and Italy, where

the textile industry prevailed.[47] Handsome clock towers surviving in medieval market squares in cities such as Prague and Gouda are reminders today of this cultural evolution as the control of workers' time slipped from the bells in church steeples to mechanical clocks in secular towers.

Blue Nails and Cottage Weavers

Along with the secularization of daily time came challenges to society's hierarchy. Between the ninth and eleventh centuries a tripartite social order, consisting of the clergy, the nobility, and the peasantry, prevailed. The notion that God permanently assigned persons to the rank into which they were born sustained that social hierarchy for generations. Convenient as this structure may have been for those with power, by the fourteenth century it was anathema to cloth workers and others, struggling to survive, who heard conflicting ideas from social critics such as England's John Wycliffe (d. 1384) and Bohemia's John Hus (d. 1415). These nonconforming priests and others like the Florentine firebrand monk Savonarola (d. 1498) harked back to pre-Augustinian interpretations of the Creation story in Genesis: all persons were created equal as children of the same parents, Adam and Eve. "[T]hings cannot go well in England," warned another radical priest, John Ball, "nor ever will, until everything shall be in common; when there shall be neither vassal nor lord . . . when the lords shall be no more masters than ourselves."[48]

When aroused by sermons proclaiming the equality of all persons, cloth workers—contemptuously called "blue thumbs"[49] or "blue nails"[50] because of their dye-stained hands—were among the masses who revolted against this tripartite social order. "Order" included, among much else, the law that all peasants wear only black or brown clothing. Secular authorities and leaders of the Church, who were by and large in alliance with the newly emerging entrepreneurs, hastened to oppose revolt whenever it occurred. In Florence, Savonarola's bailiwick, a bishop's pastoral letter declared that spinners could be excommunicated for wasting their wool. The authorities of that city in 1345 hanged ten woolcarders as agitators for organizing opposition to their employers' right to flog, imprison, or cut off the hand of a worker who resisted working conditions.

In addition to the technological and societal changes noted above, cloth workers experienced modifications in the organization of their systems of work during these centuries. Perhaps to get around the powers of urban guilds that regulated textile and clothing production after the tenth century, some employers reversed the earlier trend of congregating workers in towns; they began seeking weavers who worked in their homes outside towns, where no guilds existed.

The putting-out or domestic system of cloth production resulted and grew into an industry centered in cities of the Low Countries. In the putting-out system, the capitalist manufacturers furnished or sold wool to peasants and also rented or sold them treadle looms, thereby increasing the workers' dependence on the capitalist for income to pay for supplies and/or equipment. Workers spun yarn and wove cloth in their cottages; the manufacturers then collected the cloth, had it finished elsewhere, and marketed the finished product. The individual capitalist controlled the flow of work and the price paid to the weaver for the cloth. Weavers soon discovered that what had begun as a source of additional income turned into a nightmare of indebtedness to the manufacturers. It is not surprising, according to technology historians Kranzberg and Gies, that history's first strike took place in 1245 in one of the principal cloth weaving centers of northern France.[51]

By the late fifteenth century, the putting-out system was well under way in England, where rural cotters spun wool fibers left at their cottages by entrepreneurs from neighboring towns. To maintain safe control of their investments, the entrepreneurs typically separated their materials by household, leaving wool for carding and spinning in one cottage and yarn for weaving in another. They had the cloth finished in a third location. The black sheep queried in the nursery rhyme "Baa-baa Black Sheep" is said to be the suspect outsider delivering bags of wool to cottage weavers in the putting-out system.

New managerial skills were essential for the evolving textile industry. Both historian William H. McNeill and textile scholar Agnes Geijer highlight the capitalist system that underlies the successful development of procedures for organizing the production and coordination of the growing cloth industry.[52] The quality of textile production rested on the sorting and standardization of raw materials for the yarns as well as on the manual skills of individual spinners and weavers. Finally, the ability to sell the finished product at a profit was a necessity. "All this," states

Geijer, "would have been impossible without many generations of professional training coupled with a suitable economic and social background, in short, a developed capitalist system."[53]

Well into the nineteenth century, thousands of weavers in various areas of Europe worked in their own homes on treadle looms similar to the one modeled inside the glass bottle in Dresden's arts and crafts museum. New generations of weavers, like their ancestors, remained dependent on local entrepreneurs to market their woven cloth. From time to time, mobs of rebellious textile workers in Florence, Paris, Flanders, and elsewhere protested against their powerlessness and poverty. Because desperate circumstances endured for many into the modern era, late nineteenth-century works by playwright Gerhart Hauptmann and artist Käthe Kollwitz portray living conditions similar to those of countless late medieval and Renaissance spinners and weavers.

The Weavers

A spontaneous rebellion in 1844 among the impoverished weavers of Silesia, an area east of modern Dresden, inspired Gerhart Hauptmann (1862–1946) to write *The Weavers* in the late 1890s. Hauptmann, considered by some to be Germany's most important modern writer, was born in Silesia where his paternal great-grandfather had been a weaver. For at least three centuries, Silesian weavers had worked in their huts and lived in a state of poverty. Hauptmann's ancestor escaped from his loom by becoming a waiter and then a hotel owner; his descendants benefited from his rise in the world. When Hauptmann was born, his father was the owner of a fashionable hotel in a small resort town where Gerhart, as a child, played with the children of weavers and miners who worked in the area. As a young man, Hauptmann studied at the University of Zurich, the first university in Europe to allow women to sit in lecture rooms. Shortly after the production of his first play in 1889, he returned to the village of his boyhood to interview eyewitnesses of the 1844 rebellion, and after reading historical accounts of the revolt, he returned to Zurich and wrote *The Weavers.*

This play, according to literary scholar Warren Maurer, quickly became the subject of "the most spectacular political censorship trial in the history of German literature," and the government temporarily banned it as subversive. Some critics warned that it was "a dangerous

incitement to revolution."[54] Indeed, Lenin's sister translated *The Weavers* into Russian, and it is said to have had an impact on the Russian Revolution.[55]

A Weavers' Rebellion

The artist Käthe Kollwitz (1867–1945) attended a private opening performance of Hauptmann's play on February 26,1893, in Berlin. She was so moved by it that she abandoned another graphic series to work on a series of etchings, which she titled *A Weavers' Rebellion*. Her "choice of this infamous work guaranteed her an audience and established her reputation as an advocate for the downtrodden."[56] She apparently began to think as did Hauptmann: art could be a means to communicate everyday life rather than simply art for art's sake.

In Hauptmann's 1844 characters Kollwitz recognized members of the industrial proletariat who came as patients to her husband's medical clinic in Berlin. While the drama formed the basis for her six images, Kollwitz wanted her etchings to go beyond a single rebellion. She hoped that her art would portray the unchanging circumstances of the working class and the continual nature of their protest against such intolerable conditions.

At the Women Artists' Exhibition in Berlin in 1898, five years after starting work on *A Weavers' Rebellion,* Kollwitz exhibited the series: "Poverty," "Death," "Council," "March of the Weavers," "Storming the Gate," and "End." In these etchings she linked the difficult themes of poverty, infant mortality, violent rebellion, and retaliatory slaughter. Her first proof of "Poverty" depicts a small room with a low ceiling. In the forefront a gaunt woman, old before her time, bends helplessly over the bed of a starved, dying child. The clutter of two weaving looms and a thread winder hems in their figures. In the background another woman stands silently holding a child in her arms, her oily-looking hair severely parted and pulled back from her deeply lined face. The looms strung with thread suggest these women would be capable and willing to work; their immobile figures convey the hopelessness of production when supply overruns demand.

The story unfolds in "Death." In a darkened room the light from a single candle falls on a woman in an ankle-length dress, her hands,

enlarged and misshapen from weaving, hang lifeless. She has collapsed on a bench or seat we cannot see, her head and right shoulder resting against the bare plank wall. Death's skeletal hand reaches toward the woman, whose eyes are already closed as if for the last time. A wide-eyed child in the center background silently reaches out to restrain Death's hand. With his own large hands folded helplessly behind his back, a man stands with bowed head in the scene's right foreground. We see the Holy Family in Hell.

The heavy stillness and silence of the first two scenes contrast with the movement and sound of scuffling feet in the "March of the Weavers." Poor working-class men of all ages, walking shoulder to shoulder in their tattered clothes, fill the etching. They march determined in purpose, but their hands contain no weapons. In the forefront a young woman carries a sleeping child on her back. Desperation and anger scream out in the fifth scene, "Storming the Gate," in which shirt-sleeved men are shouting, their arms upraised in protest outside an ornate iron gate and stone wall that surround a mansion. In the center of the scene, a worker with a derby capping his head reaches back to get "weapons" from a man and woman who are pulling cobblestones from the street. Again a child is present; in the right corner a small, frightened girl turns away from the crowd. She is trying to run from danger, yet a woman who stares fiercely at the mansion behind the locked gate grips her wrist tightly. All the suppressed anger and despair conveyed earlier in the series explode in this scene. One imagines the crack of stones against the closed shutters of the splendid house beyond the gate and the terror of the family members clinging to one another behind the walls.

An enormous hand-crafted treadle loom occupies half of the room depicted in the final drawing in the series, "End." Two corpses lie on the bare dirt floor in the foreground; a woman sits beside them in a conventional long dress, her head buried in her lap. Two men carrying another man, injured or dead, rush in through the open doorway in the rear of the room; a woman stands alone inside the door, her arms hanging at her sides, her fists clenched against her legs. This gesture, according to art historian Elizabeth Prelinger, conveys militant anger and a resolve that the weavers' deaths not go unavenged.[57]

Touched by Fire

For centuries anonymous weavers, embroiderers, and lacemakers created garments, tapestries, liturgical accessories, laces, and other textile objects that now are treasured in museum collections around the world. A visitor's experience on first seeing some of these rare creations—whether the fourteenth century's mysterious *Apocalypse Tapestry,* the delicately beautiful fifteenth-century *Unicorn Tapestries* at the Cluny Museum in Paris, the Flemish needle lace collection at the Royal Museum of Art and History in Brussels, or some other exceptional work of art—is to be touched by fire, awed into silence, and filled with disbelief that anything so remarkable could have been made by human hands. Ironically, the artwork itself is so overwhelming it easily transcends thoughts about the hands and minds that produced it. In scholarly studies of antique textiles, one may read today about various kinds of remarkable work which threadworkers in our society have lost the ability to replicate. The working of thousands of stitches into a single inch of some antique textiles defies rational comprehension, and conceiving of the slow, persistent, amazingly skilled labor of the earlier needleworker may be unfathomable.

Notes

1. Gene A. Brucker, *Renaissance Florence* (Berkeley: University of California Press, 1983), pp. 52–56.

2. Kranzberg & Gies, p. 71.

3. Wilson, p. 17.

4. Ephraim Lipson, *A Short History of Wool and its Manufacture (Mainly in England)* (Chicago: The University of Chicago Press, 1953), p. 58.

5. Le Goff, pp. 8–9.

6. Lipson, pp. 57–58.

7. Ibid., p. 59.

8. William H. McNeill, *Venice: The Hinge of Europe, 1081–1797* (Chicago: The University of Chicago Press, 1974), pp. 52–53.

9. Cantor, p. 71.

10. Brucker, p. 56 and Plumb, p. 63.

11. Virginia Wylie Egbert, *On The Bridges of Medieval Paris: A Record of Fourteenth-Century Life* (Princeton: Princeton University Press, 1974), pp. 9, 21.

12. Ibid., p. 35.

13. Ibid., p. 59.

14. Ibid., p. 69.

15. See Merry E. Wiesner, "Employment and Independence in Germany," in *Singlewomen in the European Past, 1250–1800*, eds. Judith H. Bennett and Amy M. Froide (Philadelphia: University of Pennsylvania Press, 1999), pp. 197–98.

16. Lipson, pp. 85–86.

17. Baron Joseph van der Elst, *The Last Flowering of the Middle Ages* (New York: Doubleday, 1946), p. 13.

18. The design of a true tapestry is built up in the course of the weaving and the fabric has no existence independent of the design. In tapestry weaving, the warp yarns are coarse, undyed, and widely spaced; the wefts are fine and colored. This definition is taken from *Five Centuries of Tapestry*, edited by Anna G. Bennet (San Francisco: The Fine Arts Museum, 1976), p. 7.

19. Claire Giraud-Labalte, *The Apocalypse Tapestry* (Caisse Nationale des Monuments Historiques et des Sites, Ministere de la Culture, 1992), pp. 3, 7.

20. Ibid., p. 7.

21. Ibid., p. 3.

22. Emilie Amt, ed., *Women's Lives in Medieval Europe* (New York: Routledge, 1993), p. 205.

23. Power, p. 96.

24. Ibid., pp. 105–06.

25. Ibid.

26. Muriel Clayton, *Catalogue of Rubbings of Brasses and Incised Slabs* (London: Victoria & Albert Museum, 1968), p. 16.

27. van der Elst, pp. 18–19, 22.

28. Scott, p. 184.

29. Quoted in John Hale, *The Civilization of Europe in the Renaissance* (New York: Atheneum, 1994), p. 173.

30. See Oleg Grabar, "Islamic Spain, The First Four Centuries," in *Al-Andalus: The Art of Islamic Spain*, ed. by Jerrilynn D. Dodds (New York: The Metropolitan Museum of Art, 1992), p. 3.

31. See Renata Holod, "Luxury Arts of the Caliphal Period," in *Al-Andalus: The Art of Islamic Spain*, pp. 42, 44.

32. Scott, p. 150 and p. 24.

33. McNeill, p. 54.

34. Scott, p. 152.

35. See Maryanne Kowaleski and Judith M. Bennett, "Crafts, Guilds, and Women in the Middle Ages," in Judith M. Bennett, et. al., *Sisters and Workers in the Middle Ages* (Chicago and London: The University of Chicago Press, 1989), pp. 18–20.

36. Scott, p. 167.

37. See Maria Bellonci, "Beatrice and Isabella d'Este," in Plumb, *The Italian Renaissance,* pp. 288, 290, 294–95.

38. Ina Caro, *The Road From the Past: Traveling Through History in France* (New York: Harcourt Brace & Company,1994), p. 181.

39. The treadle loom is still widely used. For example, Mennonite and Amish women in the United States continue to weave on treadle looms in their homes at the beginning of the twenty-first century.

40. Kranzberg and Gies, p. 72.

41. Ibid., p. 71.

42. Ibid., p. 72.

43. Kranzberg and Pursell, p. 78.

44. Kranzberg and Gies, p. 72.

45. Le Goff, pp. 44–47.

46. Ibid., p. 47.

47. Ibid., p. 49.

48. W. E. Lunt, *History of England* (New York: Harper & Brothers, 1957), p. 242.

49. Le Goff, p. 59.

50. Lipson, p. 50.

51. Kranzberg and Gies, p. 70.

52. McNeill, Venice, pp. 52–53; Agnes Geijer, *A History of Textile Art*

(London: Philip Wilson Publishers Ltd., 1979), pp. 73–74.

53. Geijer, p. 74.

54. Warren R. Maurer, *Gerhart Hauptmann* (Boston: Twayne Publishers, 1982), p. 46. See also Margaret Sinden, *Gerhart Hauptmann: The Prose Plays* (New York: Russell & Russell, 1957), p. 72.

55. Maurer, p. 47.

56. Elizabeth Prelinger, *Käthe Kollwitz* (Washington, D. C.: National Gallery of Art, 1992), pp. 20–21.

57. Ibid., p. 26.

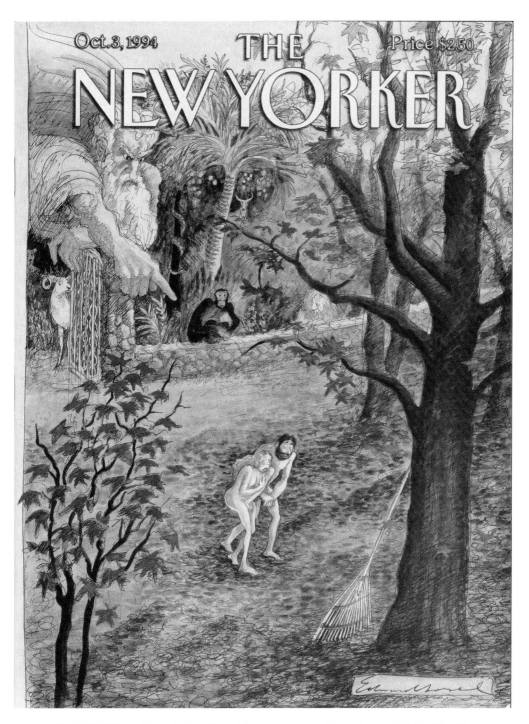

The Fall, Edward Sorel. Reprinted by permission Copyright © 1994 *The New Yorker* Magazine, Inc. All rights reserved.

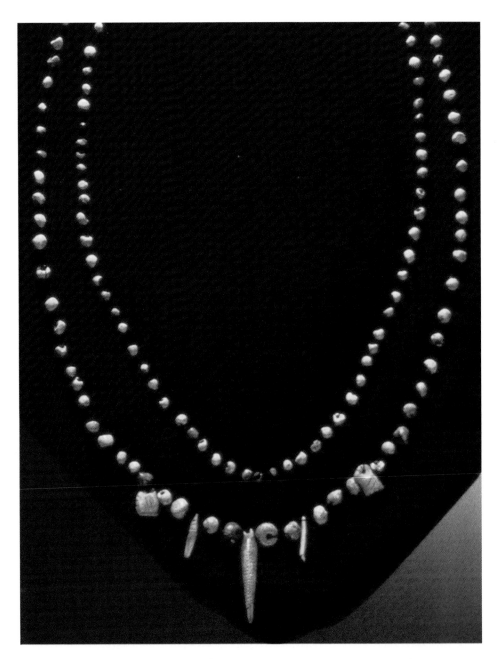

The World's Oldest Necklace. Found at a site in Dordogne, France, these 30,000-year-old beads and pendants, made of soapstone and ivory, were possibly worn as a necklace or sewn onto a garment. Courtesy Beloit College, Logan Museum of Anthropology, Beloit, Wisconsin.

This Hellenistic statue honoring Nike, messenger of Zeus and Athena, is draped in folds of fabric, likely representing silk, which arrived in the Mediterranean area during early Classical Greek times. Victorie de Samothrace *(Winged Victory)*. Courtesy Musée de Louvre. (Photo RMN – Gérard Blot.)

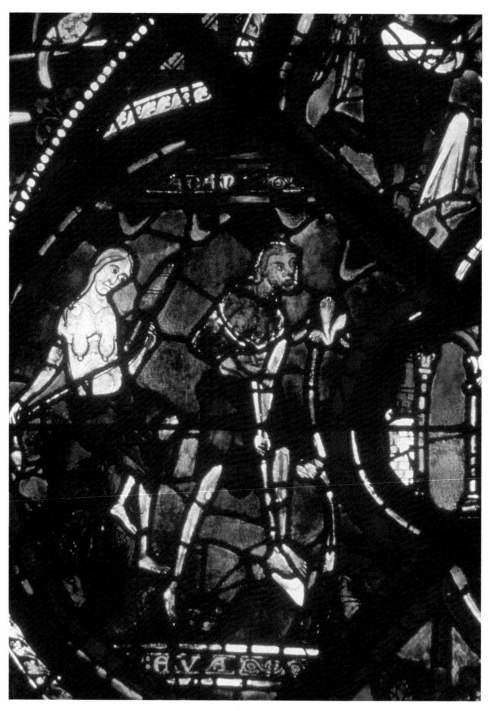

Eve spinning and Adam delving. Detail from Chartres Cathedral's early thirteenth-century stained glass window donated by medieval shoemakers. Courtesy Chartres Cathedral.

Mary sewing. The Virgin, emblematic in the Middle Ages as spinner of the thread of life, was sculpted about 1520 by Jean Soulas for Chartres Cathedral's choir screen. Detail courtesy Chartres Cathedral.

The Bayeux Tapestry—11th Century. Figures of a woman and child inside a burning house are among hundreds of other figures on the medieval embroidery that records the Norman invasion of England in 1066. By special permission of the City of Bayeux.

David's wife, Michael, is depicted in this detail from one of the series of ten *David and Bathsheba* tapestries believed to have been woven in Brussels workshops between 1510 and 1513. Courtesy Musée National de la Renaissance. (Photo-RMN.)

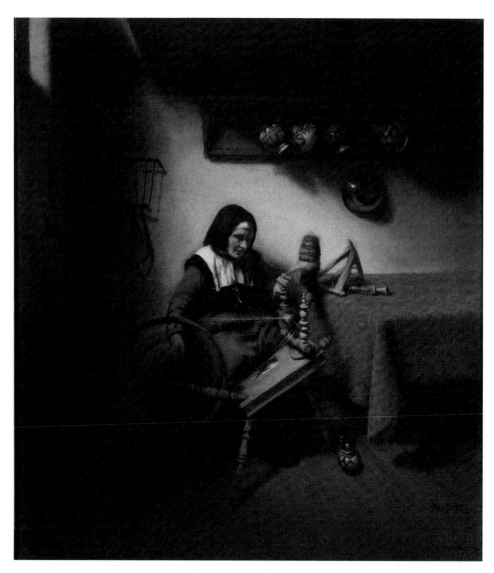

Spinning, weaving, and sewing in seventeenth-century portraits such as this indicated a woman's virtuous character rather than her profession. *De spinster*, Nicolaes Maes. Courtesy Rijksmuseum, Amsterdam.

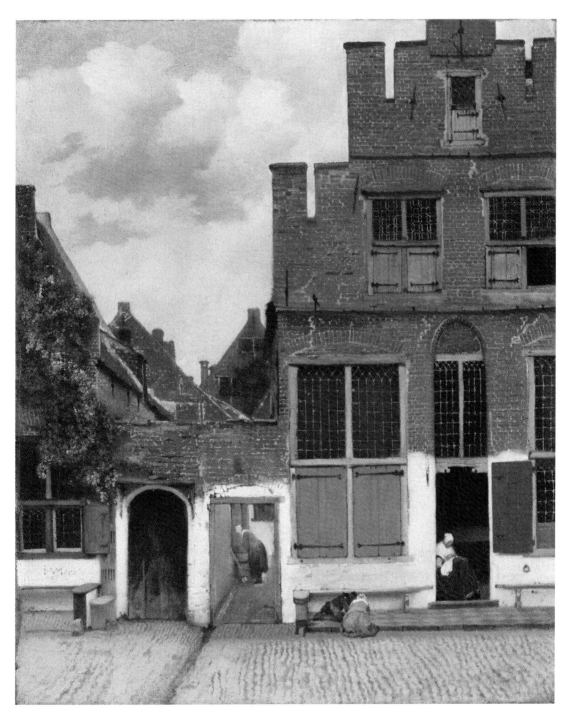

A woman is absorbed in her handwork, another is engaged in a task in a passageway, and two children are engrossed in play at the street's edge. *The Little Street,* Vermeer de Delft (1632–1675). Courtesy Rijksmuseum, Amsterdam.

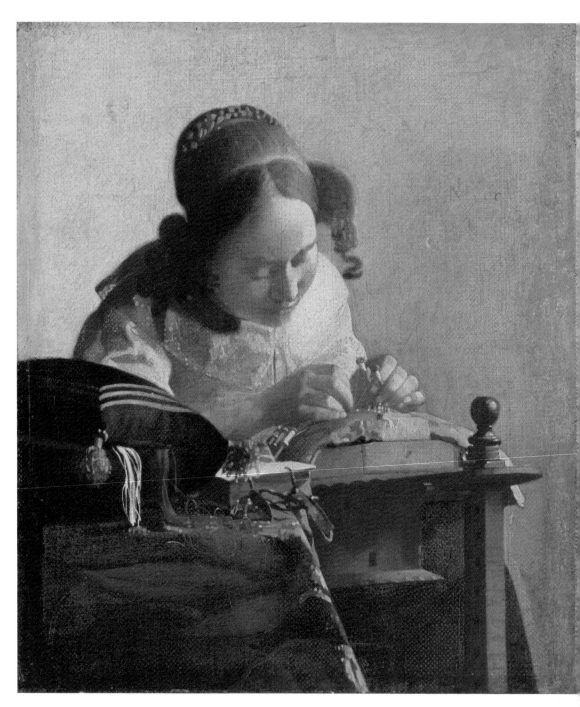

A lacemaker concentrates on her needlework; in the seventeenth century, needlework was believed to preserve a lady's virtue by occupying her leisure hours. *La dentilliere*, Vermeer de Delft (1632–1675). Courtesy Musée de Louvre. (Photo RMN—Jean Schormans)

Shoe Fitting. Shoe fitters handstitching linings of women's shoes are illustrated in an 1868 engraving from *Harper's Bazaar.*

A mass of predominately male figures in ill-assorted clothes, some carrying makeshift weapons, presses forward in this etching. *The Weavers' March,* from the series, *A Weavers' Rebellion,* Käthe Kollwitz. Gift of Grant and Virginia Green, (2000 Board of Trustees, National Gallery of Art, Washington, 1897, etching and aquatint [printed 1931]: plate. .216 x 300 (8 ½ x 11 ¾).

Nineteenth-century Frenchwomen frequently socialized while doing hand-work, whether indoors in winter or outside when possible. *Portraits à la campagne (Portraits in the Country)*, Gustav Caillebotte. Courtesy Musée Baron Gérard, Bayeux.

Ellen Day Hale (American, 1855-1940) *June,* ca. 1905, Oil on canvas 24 x
18 ⅛ in. The National Museum of Women in the Arts, Washington, D.C.
Gift of Wallace and Wilhelmina Holladay

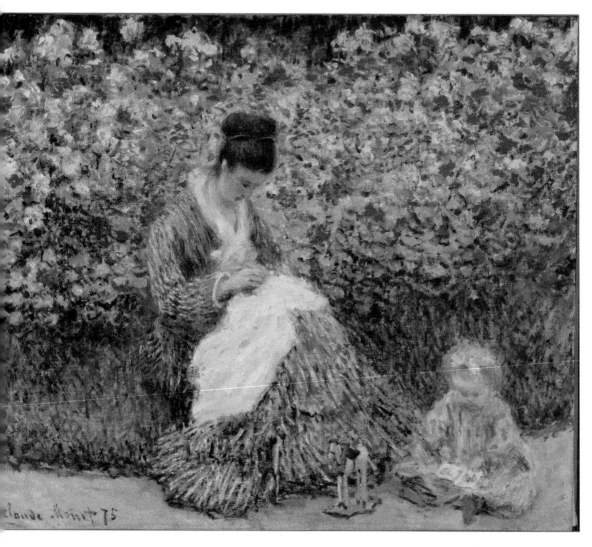

Camille Monet and a Child in the Artist's Garden in Argenteuil, 1875;
Claude Monet, French (1840–1926) Oil on canvas; 55.3 x 64.7 cm (21 $^{13}/_{16}$ x
25 ½ in.) Anonymous gift in memory of Mr. and Mrs. Edwin S. Webster,
1976. Courtesy, Museum of Fine Arts, Boston. Reproduced with permission.
(Museum of Fine Arts, Boston. All Rights Reserved.)

Author Edith Wharton seated at her desk. Charles Scribner's Sons Archives, Manuscript Division, Princeton University Library. Courtesy Princeton University Library.

This quilt from Kansas, perhaps made to raise war funds, survives from World War I and includes names of two men who served in that war; later, names of two men who served in World War II were stitched on the quilt. *Red Cross.* Privately owned. Courtesy the author.

Emblems of U.S. Army divisions border a commemorative quilt made by Luxembourg women to honor American soldiers who liberated their country from enemy occupation in World War II. *Liberation of Luxembourg*. Privately owned. Courtesy Le Rowell.

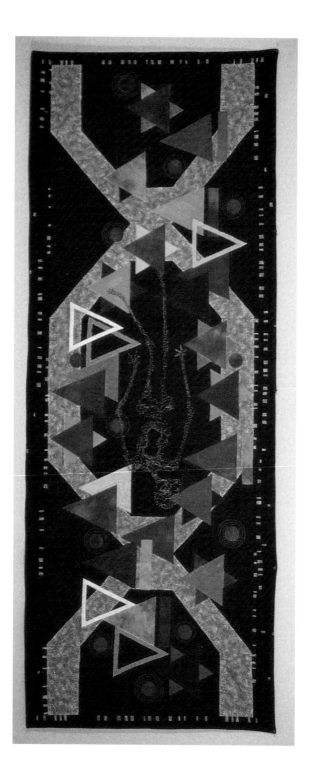

A memorial crafted in metal at the site of the German concentration camp at Dachau inspired a fiber artist to design and quilt this wall hanging. "Dachau Memorial." 1994. Privately owned. Courtesy Sharon Walton.

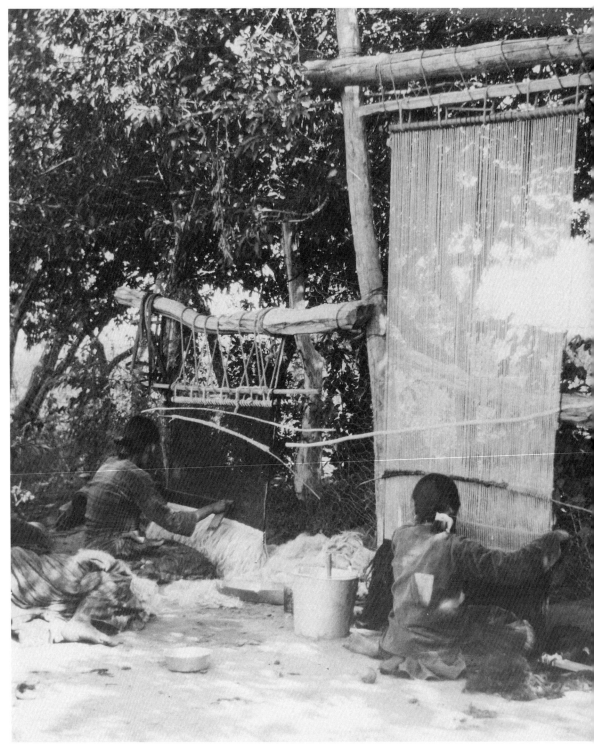

Detail from *Navajo woman weaving under summer shade. 1907. Tuba City, Arizona*. Churchill Collection. Courtesy National Museum of the American Indian, Smithsonian Institution (N26609).

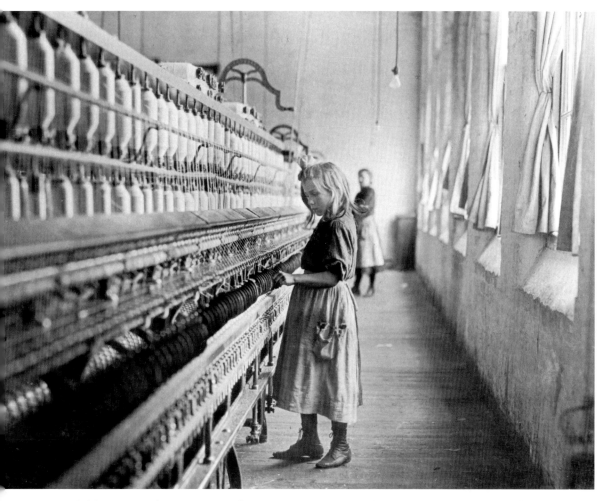

Child in a Carolina Cotton Mill. Lewis Hine. 1908. Gelatin-silver print on masonite. 10 ½ x 13 ½ (26.67 x 34.29 cm.) Museum of Modern Art, New York.

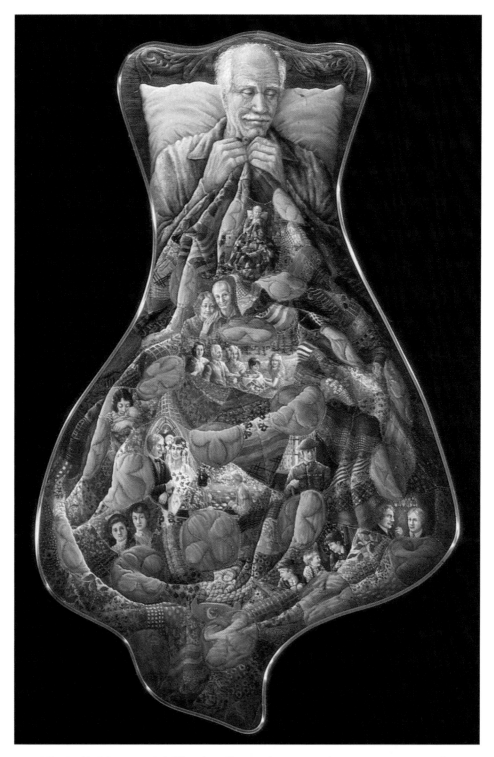

The Quilt. Margaret Schillie. A quilt reverberates with warm memories of individuals and events that have shaped the elderly man's life. Courtesy the artist.

Ballads of Harp Weavers

5

An unknown poet protested changes in the environment surrounding him in sixteenth-century England:

> Sheep have eaten up our meadows and our downs,
> Our corn, our wood, whole villages and towns.[1]

By 1769, half or more of all peasant families had lost their rural landholdings and cottages and were totally dependent on sporadic wages they received for working twelve to fifteen hours on days when work was available in mills owned by others. This gradual demographic transformation was the unintended consequence of Edward III's successful efforts in the fourteenth century to bring Flemish weavers into England. As the quality of domestic woolens improved after the arrival of the immigrant weavers, the better the textiles sold abroad and the louder English merchants called for additional wool. Landowners, facing a greater demand for wool, sought larger estates on which to raise additional sheep.

The only lands available were small lots of thirty or fewer acres that had been used for hundreds of years by each tenant or cotter in the countryside and the acres of commons and woods used by everyone for pasture and fuel. Consequently, landowners began to demand rents from their tenants and to evict those who could not afford to pay. The landowners began enclosing, with hedges and ditches, large ranges for

sheep grazing. They gradually replaced the traditional open-field system of landholding with a new system termed enclosure.

According to centuries of conventional wisdom, nothing had endured longer than open fields and the divinely ordained labor intended for humankind. Like the Creation story window in Chartres Cathedral, a perennially popular rhyme reinforced this belief among the peasantry:

> When Adam delv'd and Eve span
> Who was then a gentleman?[2]

The couplet also served as an implicit threat to the prevailing rigid class structure during the era of enclosure, when it seemed to the poor that their divinely ordained way of life was disappearing.

Country squires who profited in the sixteenth century from the enclosure movement boasted, "The foot of the sheep turns sand into gold." William Tyndale (1494–1536), the Bible translator and a defender of cloth workers, responded: "God gave the earth to men to inhabit, and not unto sheep."[3] Tyndale was born and reared in the Vale of Berkely area of Cotswold; in his lifetime half of the area's population worked in the rural cloth-making industry. His brothers, Edward and John, organized the production of cloth in the Vale and its sale in London. After William Tyndale translated the Greek and Hebrew Bible into the English language understandable by the masses, he was exiled from his homeland. Living in Cologne, he used the trade routes of cloth merchants to get his books, smuggled in bales of cloth, into England. Thus, "clothmen" carried sheets of printed Bibles or whole Testaments as well as cloth from village to village in cloth-making counties. They also went into craft halls and wool marts where ideas as well as products were exchanged.[4] (Tyndale's biographer, David Daniell, notes that from the middle of the seventeenth century the phrase "man of the cloth" signified a clergyman or minister. Daniell acknowledges that the phrase refers to a clergyman's distinctive dress, but he wonders if there might be a residual sense of the historic link between cloth working and religious faith.[5])

Hugh Latimer, sixteenth-century religious reformer and martyr, also spoke out against forcing peasants off their ancestral landholdings: "Where have been a great many householders and inhabitants, there is

now but a shepherd and his dog."[6] Enclosures continued despite growing protests. From 1700 to 1760 over three hundred thousand acres were enclosed; by 1801, over three million acres had been enclosed, and during the next half century nearly as many more. In 1696 approximately four out of five people in England still lived in rural areas; seventy-three years later, in 1769, half of the population lived in towns.[7]

A Favorable Spin

Ironically, during this time when agrarian textile workers were being driven from their own looms and lands, the development of water-powered machinery and the assembling of workers in town factories facilitated a massive increase in textile production. As early as the sixteenth century, at least one poet, Thomas Deloney (1543?–?1600), heralded a weaving shed owned by a certain John Winchcomb, who employed a host of weavers and other workers:

> Within one room being large and long
> There stood two hundred Looms full strong.
> Two hundred men the truth is so
> Wrought in these Looms all in a row.
> By every one a pretty boy
> Sate making quills with mickle joy.
> And in another place hard by
> An hundred women merrily
> Were carding hard with joyful cheer
> Who singing sate with voices clear.
> And in a chamber close beside
> Two hundred maidens . . . all day did spin.
> Then to another room came they
> Where children were in poor array
> And everyone sate picking wool
> The finest from the coarse to cull.[8]

A century and a half later, another English poet, John Dyer (1699–1757), endeavored to put a favorable spin on factory work in his lengthy blank-verse poem, "The Fleece" (1757). Contemporary critics valued the poem not for its literary quality but for its accurate descriptions. Book I describes sheep pastures and sheep raising; Book II focuses on wool as the best material for clothing; Book III describes

the manufacture of wool textiles; Book IV treats wool's role in England's world trade.

In the following lines from Book III, the poem's narrator calls the "village nymphs" to begin combing, carding, and spinning the fleece:

> . . . Come, ye village nymphs!
> The scatter'd mists reveal the dusky hills;
> Gray dawn appears; the golden morn ascends,
> . . . Arise, begin your toils;
> Behold the fleece beneath the spiky comb
> Drop its long locks, or from the mingling card
> Spread in soft flakes, and swell the whiten'd floor.

After taking a visitor through each step of textile fabrication underway in the factory, the poet ends Book III on a reassuring note:

> . . . Nor hence, ye nymphs! let anger cloud your brows;
> The more is wrought, the more is still required;
> Blithe o'er your toils, with wonted song, proceed:
> Fear not surcharge; your hands will ever find
> Ample employment. . . .[9]

Weaving a Rebellion

War with the American colonies and conflict with France added to the misery enclosures caused for many in England in the late eighteenth century. The scarcity and high price of food in 1792 provoked riots in several towns populated largely by landless peasants. In these conditions talk of government reform became equated with revolutionary propaganda, and the prime minister, William Pitt, issued a proclamation urging local authorities to prosecute authors of seditious writings. When failures of crops led to food shortages and acute distress among the poor in 1794 and 1795, officials attributed the resulting riots to political propaganda rather than to the need for economic and political reform. Consequently, they passed even harsher repressive acts, threatening arrest and imprisonment without trial of any person speaking derogatorily of the king, the government, or the constitution.

At the time, grain was so scarce that Parliament forbade its use in the making of spirits, and flour was in such short supply that the gov-

ment forbade its use by the wealthy for hair powder.[10] But as the
ern impoverished masses continued rioting, one government spokesman
argued that hair powder enabled members of the upper class to main-
tain their "distinction of dress and external appearance."[11] Inattention
to this distinction, he claimed, would threaten law and order.

Because the defenders of the realm in this era of empire building
and war were recruited from the ranks of the yeomanry, some in the
English government feared that if the depopulation of the country-
side went unchecked, the country "might be a prey to our ene-
mies."[12] Yet the rulers knew that the nation's security also depended
on the strength of its economy; while some feared the depopulation
of large areas of the country, others saw it as necessary for economic
growth.

Reform-minded poets, like liberty advocates Thomas Paine and
Mary Wollstonecraft, opposed repressive government policies and sym-
pathized with the plight of the underprivileged. They attempted to sway
popular opinion through ballads or other verse that the elite could read
and ordinary people could understand in recitations at public gather-
ings. Not surprisingly, their efforts threatened those whose privileges
might be stripped from them if the government introduced reform. Any
reform was like a loose thread; if the thread were pulled, it might unrav-
el the entire social fabric.

In this charged atmosphere the artist and poet William Blake
(1757–1827) made and exhibited fourteen watercolor drawings to
illustrate a poem against tyranny which Thomas Gray (1716–1771)
had written nearly forty years earlier.[13] Gray was one of the first English
poets in the eighteenth century to link the power of ballads with pop-
ular forces that were attempting to overthrow a tyrant. In 1755 he
began writing an ode, which he left unfinished until two years later
when the visit to Cambridge of a blind Welsh harpist, John Parry,
inspired Gray to complete his poem, "The Bard." Gray indicated that
he based his ode on a legend concerning the resistance of the Welsh
five centuries earlier to the conquest and occupation of their lands by
England's king Edward I (1272–1307). According to the legend,
Edward I ordered the execution of all Welsh bards to prevent their
keeping alive the spirit of resistance to his establishment of English set-
tlers in lands which had always been in Welsh hands. A solitary bard
escapes execution and confronts the king with his army on horseback,

homeward bound along a mountainous path running beside the river Conway. From a rock high above the river, the bard strikes his harp to warn that the slain bards survive as ghosts and to predict the king's ruin:

> On yonder cliffs, a grisly band,
> I see them sit; they linger yet,
> Avengers of their native land. . . .
> With me in dreadful harmony they join,
> And weave with bloody hands the tissue of thy line.
>
> Weave the warp, and weave the woof,
> The winding-sheet of Edward's race. . . .
>
> Now, brothers, bending o'er the accursed loom,
> Stamp we our vengeance deep, and ratify his doom. . . .
> "Weave we the woof: the thread is spun. . . .
>
> The web is wove, The work is done.[14]

Blake's illustrations for this poem advocated government reform; they expressed the artist's belief in "the moral and social power of the inspired bard (both the Welsh bard and the living poet Thomas Gray) to overwhelm evil rulers and summon together patriots."[15] The fearless bard, weaving in oversized harp strings, dominates one of the drawings. Blake's visionary watercolors appeared when George III (1760–1820) and his ministers feared the power of critics as much or more than had Edward I.

Economic forces too complex for the masses to comprehend lay behind the ongoing social upheaval and industrial mechanization, and even decision makers sitting in London had little understanding of the magnitude of the transformations going on in the countryside.[16] Because wages and prices had not varied for generations, the government ministers believed that stability could be maintained without additional government intervention as laborers left farming and cottage weaving to work in new textile mills and coal mines. When inflation began in the eighteenth century, prices doubled and wages decreased; fear slowly replaced complacency in government policy, and suppression of those in opposition grew.

The Harp Weavers

Poets who opposed the status quo, such as Gray and Blake, attempted to give voice to what they sensed or observed about the complex forces of change. They expressed their views more in sadness than with fiery zeal, hoping to gain reform rather than to incite revolution. In "Elegy Written in a Country Churchyard" (1751), Gray laments what is happening before his very eyes. While pausing in a churchyard as darkness envelops him, the poem's narrator observes a ploughman homeward bound. The narrator imagines sounds which the humble ancestors of the ploughman heard daily: the cock's shrill clarion and the hunter's horn at dawn, the housewife's stirring about the blazing hearth and the children's joyous greetings at day's end when the father returns home. Greed, laments the poet, is threatening to destroy the lifestyle of the ploughman, his family, and others like them.

> Let not Ambition mock their useful toil,
> Their homely joys, and destiny obscure;
> Nor Grandeur hear with a disdainful smile,
> The short and simple annals of the poor.[17]

The ongoing destruction of rural villages where only one "master grasps the whole domain" was also protested by Oliver Goldsmith (1731–1774), the Irish-born son of an Anglican cleric. In his poem "The Deserted Village" (1770), Goldsmith remembers a place that once had sheltered cottages and farms as well as a church that topped the neighboring hill, and he warns of dangers to the nation in the swelling movement of people from the land.

> Ill fares the land, to hastening ills a prey,
> Where wealth accumulates, and men decay;
> Princes and lords may flourish, or may fade;
> A breath can make them, as a breath has made;
> But a bold peasantry, their country's pride,
> When once destroyed, can never be supplied.[18]

The popularity of Goldsmith's poem endured for decades. Recitations of it were well received at gatherings of mostly illiterate handloom weavers and other displaced craftsmen during their move-

ment, known as Chartism, which demanded universal suffrage and government reform in the 1830s and 1840s.[19]

Ironically, in his famous elegy, Gray praises the ploughman at length but only briefly mentions the ploughman's wife. Yet his own father is said to have been a worthless person who was cruel to his wife, and Gray's mother is credited with supporting her son through Eton College with her earnings from a small millinery shop. Likewise, in "The Deserted Village," Goldsmith's images are almost uniformly male in character. Among his few references to women is a cautionary one to "a poor houseless shivering female" who was betrayed by her lover when "she left her [spinning] wheel and robes of country brown" to pursue ambition in the town.

The Scottish poet Robert Burns (1756–1796) offers advice to young spinsters[20] in his mischievous ballad "To the Weavers Gin Ye Go" (1788). In this song, a lass sent off to town to spin warp thread loses her heart and perhaps her virginity to a young weaver.

> My heart was ance as blythe and free
> As simmer days were lang;
> But a bonie, westlin weaver lad [west-country]
> Has gart me change my sang. [made me] (Chorus)
>
> My mither sent me to the town,
> To warp a plaiden wab; [a web for a coarse woolen cloth]
> But the weary, weary warpin o't
> Has gart me sigh and sab. [got me sighing and crying] (Chorus)
>
> A bonie, westlin weaver lad
> Sat working at his loom;
> He took my heart as wi a net,
> In every knot and thrum. [thread] (Chorus)
>
> I sat beside my warpin-wheel,
> And ay I ca'd it roun'; [as I turned it]
> But every shot and every knock,
> My heart it gae a stoun. [gave a sharp pain] (Chorus)
>
> The moon was sinking in the west,
> Wi' visage pale and wan,
> As my bonie, westlin weaver lad
> Convoy'd me thro' the glen. (Chorus)

And here Robert Burns has his fun.

> But what was said, or what was done,
> Shame fa' me gin I tell; [should I tell]
> Bot Oh! I fear the kintra soon [country]
> Will ken as weel's mysel! [know as well as] (Chorus)
>
> To the weaver's gin ye go, fair maids, [if you go]
> To the weaver's gin ye go;
> I rede you right, gang ne'er at night, [advise you, go never]
> To the weaver's gin ye go.[21]

Burns praises the spinster's domestic craft in "Bessy and Her Spinnin-Wheel" (1792) as a maiden spins beneath lofty oaks beside the flowing stream outside her cottage:

> O leeze me on my spinnin-wheel, [commend me to]
> And leeze me on my rock and reel; [distaff wheel]
> Frae tap to tae that cleeds me bien, [That clothes me comfort-
> ably from head to toe]
> And haps me fiel and warm at e'en! [And wraps me cozy and
> warm at evening]
> I'll set me down and sing and spin,
> While laigh descends the simmer sun, [low]
> Blest wi' content and milk and meal,
> O leeze me on my spinnin-wheel!

Even as Burns published this and other early poems, the world of his youth was disappearing. As if attempting to stem this disappearance, he concludes "Bessy and Her Spinnin-Wheel" on a serious note:

> Wi' sma' to sell and less to buy, [With little to sell]
> Aboon distress, below envy, [Above distress]
> O wha wad leave this humble state [O who would]
> For a' the pride of a' the great?
> Amid their flairing, idle toys, [their gaudy]
> Amid their cumbrous, dinsome joys, [noisy joys]
> Can they the peace and pleasure feel
>
> Of Bessy at her spinnin-wheel?[22]

Despite differences of opinion, the enclosure process continued. In

the eighteenth century improved agricultural methods, such as crop rotation, reinforced landowners' desire for more land. The push of better farming methods in combination with the pull of water-powered spinning mills forced ever increasing numbers of peasant families from rural areas into towns where they quickly had to establish a whole new culture or be crushed by the harsh realities of poverty, crime, and increasingly brutal laws. These people and their ancestors had long attributed a death in the family or a poor harvest to divine will; separated from their rural roots, they replaced theological explanations for disasters with secular causes. The masses now held the wealthy and those in authority responsible for their hunger during increasingly frequent food shortages. Thus the secularization of society, which some say had already begun in Italy in the Renaissance, spread with industrialization in the new urban culture.

Weaving on the Windy Coast of France

Changes occurring in the lives of English peasants at this time were similar to ones that soon got underway in France, Germany, and elsewhere in Europe. The Caux, an area surrounding Rouen in Normandy, had long been populated by peasants whose men primarily performed agricultural tasks and wove cloth, while women and children in their cottages spun thread, wove ribbons, made hats, or knit stockings for the merchants of the nearby towns. By the mid-eighteenth century, here in one of the most fertile grain-producing regions in France, the enclosure of lands had made little progress, and the putting-out system of cloth production still thrived in conjunction with farmwork. Historian Gay Gullickson[23] has carefully documented peasant life in the Caux between 1750 and 1850 as workers there adjusted to changes in their traditional patterns of living.

Winters lasted from October to May when cold, wet winds swept in continuously from the ocean, driving person and beast to seek shelter. Life was difficult, yet the availability of seasonal day labor in agriculture combined with the cottage industry enabled most families not only to stay above the subsistence level but also in good years to have some money to spend on alcohol and entertainment at village fairs, cafes, and taverns.

Most families, writes Gullickson, lived in small, damp, dark, and

poorly ventilated houses with bare earth floors and roofs thatched with straw. During winter rains, the roofs leaked, and the earth floors turned into mud. Peasant houses in Normandy typically had two rooms: a kitchen and a sleeping chamber. If there was a third room, it contained the weaving equipment consisting usually of two looms, one operated by the husband and one by a son or nephew. No women were listed in tax roles or parish registers as weavers, but they probably took turns at the looms when men worked in the fields or were unable to weave because of illness or age.

Spinning, as we have seen at other times and places, was women's work, yet mothers taught both boys and girls to spin because six to ten spinners were needed to supply one weaver. Some continued to spin with the distaff, but most spinners used a large spinning wheel that they turned by hand while a few used a foot-powered spinning wheel. After sundown, women and girls gathered in each other's houses to spin and talk during the long winter evenings. Men, on the other hand, gathered in local cafes in the evenings to drink and bet small sums on dominoes or went to taverns, as they did in playwright Gerhart Hauptmann's imagined German village and in most real villages throughout Europe.

Twice a week spinners rose in the middle of the night to carry their skeins of yarn in leather backpacks to the textile market in nearby Bacqueville, where trading began at dawn. The seven-mile walk was exclusively for women; neither men nor children were allowed to go along. Perhaps this was the women's choice, the equivalent of their "night out." Gullickson reports that women also exercised power in the family by controlling how family earnings were spent, allowing some to the men for their pleasure in the cafes and taverns.

Boys began to learn weaving between the ages of twelve and fifteen and usually were taught by their fathers. As soon as they had minimal weaving skills they were set to work at the family's second loom, per-haps weaving cloth for family use. They used treadle looms with foot pedals to raise and lower combinations of warp threads, and after each passage of the shuttle, they used a wooden bar to beat the new weft thread against the edge of the cloth already woven. If a weaver did not push the foot pedals firmly, the weft threads could not be properly beat-en into place; if he beat the threads too hard, the fabric would be brit-tle, but if he beat too lightly, it would be flimsy. The average weaver, according to Gullickson, beat the weft threads between fifteen and

twenty thousand times a day. Weaving required strong arms and legs; weavers' strength peaked in their early- to mid-adult years, and after forty the quality of their work and health declined. Universally they suffered from chest and neck ailments, varicose veins, and leg pains.

In 1782 there were reportedly 188,000 spinners and weavers working in their cottages within a forty-five-mile radius of Rouen. By the winter of 1788–89, these workers were caught up in the turmoil of the French Revolution and in the market disruption caused by the arrival from England of machine-made cloth that was higher in quality and lower in price than cloth made locally. Merchants in France soon found it necessary either to introduce machines or abandon textile production; some built mills with water-powered spinning machines along low-flowing rivers in and around Rouen. The decline in cottage spinning followed.

By spring 1789, the poor roamed the area in bands, stopped grain shipments on the roads, rioted in marketplaces, and raided more prosperous peasants' homes at night. The poor outnumbered local mounted police who were powerless to prevent the increasing chaos. Women as well as men participated in bread riots and in demonstrations to protest high grain prices. By 1805 cotton spinning was no longer a viable home occupation for women of the Caux, yet here, as in England, spinning mills increased thread production and thus increased the need for cottage weavers. But the increase in cottage weaving was temporary; eventually water-powered looms in mills silenced treadle looms in cottages here as they had in England.

To the south of Rouen, in Nantes, mill manufacture of textiles flourished in the late eighteenth century. The opening of colonial markets for slaves and manufactured goods encouraged French cloth merchants at Nantes and elsewhere in France to meet the expanding demand for cotton fabrics by increasing their employment of displaced rural weavers. In the eighteenth and early nineteenth centuries, traders and merchants in Nantes launched some 1,800 expeditions to buy African captives, transporting more than 500,000 men and women to the Americas[24] and returning to Europe with sugar, tobacco, coffee, cacao, and other tropical produce. Textiles, guns, alcohol, and beads shipped to Africa were bartered for the slaves. Textiles to pay for slaves became so important that in 1780 Nantes had more than ten textile mills, employing 4,500 workers.[25]

Refugee Entrepreneurs on the Rhine

Foreign and domestic events during the eighteenth century also altered the lives of textile workers in the Lower Rhine area of Germany. The region had benefited a hundred years earlier from an influx of Mennonites (Anabaptists) fleeing persecution from Catholics in the Netherlands. The Dutch refugees, leaving successful cloth production enterprises behind, moved to the Krefeld area of Germany.[26] Many of the Mennonite refugees who had arrived from Holland were men of substance and business experience. It took the Mennonites about a half century to build a successful financial empire based on textile production in Germany and to dislodge the established elite from power in Krefeld. By 1768, a single prominent family owned "155 looms for producing silken handkerchiefs; 257 looms for the manufacture of silken fabrics; 97 narrow looms for making figured and brocaded velvets and ribbons; 197 large ribbon looms to manufacture all types of ribbons; 18 large silk throwing machines preparing raw silk of foreign provenance; two dye shops." A total of over three thousand employees worked at these assorted looms and shops.[27]

Machines Replace Human Hands

Early defenders of power machinery maintained that the various inventions rescued the uprooted, landless population of peasants in England and elsewhere in Europe by providing employment in factories to thousands of children and adults who might otherwise have starved. The inventions occurred one by one, between about 1733 and 1823, leading eventually to the end of the putting-out or domestic system of textile production.

As noted earlier, the treadle loom and water-powered fulling mill were introduced in the West in the eleventh and twelfth centuries, and the water-powered spinning wheel in the thirteenth century. By the fifteenth century, the drawloom had also been introduced in France after having been used in the East for more than a thousand years. Until it was replaced in 1804 by the French-developed Jacquard loom, named for Joseph Marie Jacquard (1752–1834), the drawloom enabled weavers to produce some of the most elaborate textiles ever known.[28] In

the sixteenth century, an unknown person developed the flyer, a U-shaped device that improved the spinning wheel; this enabled yarn to be twisted at the same time it was being wound on the spindle and thereby increased a spinner's production.

Several mechanical inventions in the eighteenth century further eroded the production of textiles by spinsters and handloom weavers. The transfer of production to power-driven factories followed, first in England where the inventions were made, and ultimately in other European countries. John Kay's flying shuttle (1733) doubled or tripled the speed of cotton weavers, in some cases enabling each of them to weave up to twenty yards in one day; James Hargreaves' spinning jenny (1767) enabled one spinner to produce an amount of yarn that had previously taken twelve to fifteen spinners to produce; and Richard Arkwright's water-frame (1769) improved Lewis Paul's method (1738) of using rollers rather than wheels and spindles to spin yarn.[29]

Because the flying shuttle greatly increased a weavers' speed and need for thread, still being slowly spun by hand, the invention some thirty years later of the spinning jenny and water frame revolutionized the spinning of thread and marked the beginning of the transfer of cloth manufacture from human hands to water-powered factory equipment. Spinning was the first process in textile production to move from cottages; spinning mills began to be constructed beside sources of flowing water where the water frame, rather than human hands, rapidly spun thread. Lewis Paul's second invention, the carding machine, soon followed; it supplanted the laborious process of preparing cotton for spinning by hand. All of these machines were in use in England before the end of the eighteenth century and enabled a large-scale export of cotton yarn to Europe.

As the speed of spinning increased, the slowness of handweaving became apparent. In 1787, Edmund Cartwright built the first English powerloom shed; an ox powered its twenty looms during its first two years of operation; then a steam engine was installed. The following year twenty-four of Cartwright's patent looms were in use in a factory in Manchester. Irate handloom weavers burned the factory two years later.[30] Within thirty years, however, the reluctance of entrepreneurs to invest in newfangled machinery had passed, and clergymen, poets, and weavers knew that the powerloom had come to stay.

The early twentieth-century historian Eileen Power affirmed that "the greatness of England was built up . . . upon the wool which generation after generation [was] grown on the backs of her black-faced sheep."[31] She noted further:

> The visitor of the House of Lords, looking respectfully upon that august assembly, cannot fail to be struck by a stout and ungainly object facing the throne—an ungainly object upon which in full session of Parliament, he will observe seated the Lord Chancellor of England. The object is a woolsack, and it is stuffed as full of pure history as the office of Lord Chancellor itself.[32]

Historian Jacob Bronowski reinforces Power's assessment. "England's wealth was made in cottages," he writes. The country's "empire was begun on the bottom of village industry; on this rested her liberal dissenters, her society of moneyed men. . . . To the end of the eighteenth century, the woollen cloth made up one third of England's exports, and of her whole output. But cotton, the new staple of factory industry, was gaining fast; and overtook wool as soon as the century turned."[33]

The Dark Side of the Fabric

Poets such as Gray, Goldsmith, and Burns, and clerics such as Tyndale and Latimer were prescient in forecasting hardship for peasants driven from their village industry. Fewer than fifty years after Burns wrote his imagined "Cotter's Saturday Night" (1786), much textile production in England had shifted from cottages to mills in factory towns such as Spitalfields, one of the new centers of cotton and silk textile production. Women and children who had always prepared fiber and done their spinning at home now went off to the mills where half the workers were children and two-thirds of the other half were women. Mill owners preferred women and children who worked for less money than men, and therefore they soon outnumbered men in textile manufacturing.[34] They worked fifteen-hour days during which they walked twenty miles among the moving machines.[35]

In *A History of Textiles,* historian Kax Wilson quotes a short passage from a British Parliamentary report on the conditions of the weavers at Spitalfields around 1836. When questioning a weaver about his earnings

and those of his wife, the government examiner asked if the couple had any children, perhaps expecting to be able to include their wages in the family's total income. "No; I had two, but they are both dead, thanks be to God!" answered the impoverished weaver. Shocked by this reply, the investigator inquired: "Do you express satisfaction at the death of your children?" "I do," admitted the weaver. "I thank God for it. I am relieved from the burden of maintaining them, and they, poor dear creatures, are relieved from the troubles of this mortal life."[36] According to historian Duncan Bythell, any parliament in the early nineteenth century would have lacked the means, even if it had the will, to intervene in the unregulated introduction of machinery in the cotton hand-weaving industry which then provided the largest manufacturing employment in the country. Bythell concludes: "The suffering entailed in the elimination of the handloom weavers as an element in economic organization is still the most disquieting aspect of the English industrial revolution." [37]

Today the textile collections of London's Victoria & Albert Museum preserve the designs of Spitalfields' nineteenth-century woven textiles, particularly of its silk designs. Looking at reproductions of the astonishing designs and at examples of the exquisite textiles themselves, we know they represent the talents, skills, and hopes of generations of amateur and professional craftspersons. The museum's records acknowledge the dark side of the history of this remarkable woven art. These historical records include, for example, the report of a letter sent to a newspaper in 1765 in which the writer explained "with pride that children from three years old could be employed in silk mills."[38] Because silk was thrown (the equivalent of spinning in other industries), the public considered silk processing less unhealthy than cotton spinning. Only boys could be apprenticed as silk weavers, and the Weavers Company, one of the oldest of the medieval guilds, carefully controlled entry into an apprenticeship.[39]

In 1801 the House of Lords threw out a bill requiring that all children be taught reading, writing, and arithmetic. One member, in agreement with the Archbishop of Canterbury, argued:

> However specious in theory the project might be, of giving education to the labouring classes of the poor, it would in effect be found to be prejudicial to their morals and happiness; it would teach them to despise their lot in life, instead of making them good servants in agriculture, and other laborious

employments to which their rank in society had destined them; instead of teaching them subordination, it would render them factious and refractory, as was evident in the manufacturing counties; it would enable them to read seditious pamphlets, vicious books, and publications against Christianity; it would render them insolent to their superiors; and in a few years the result would be that the legislature would find it necessary to direct the strong arm of power towards them, and to furnish the executive magistrate with much more vigorous laws than were now in force.[40]

Instead of teaching poor children to read and learn math, authorities encouraged them to learn trades such as the spinning of worsted yarn. Reformers, however, believed that children "could rise from their station" only if they were taught above it.[41]

It was in this social and economic environment that poet/artist William Blake scorned the London custom of annually marching some six thousand children from London's charity schools into St. Paul's Cathedral "for a compulsory exhibition of their piety and gratitude to their patrons." In 1789 he etched plates to illustrate a collection of his early poems, one of which—"Holy Thursday"—portrays satirically the children's compulsory annual march to St. Paul's.

> 'Twas on a Holy Thursday their innocent faces clean
> The children walking two & two in red & blue & green
> Grey headed beadles walkd before with wands as white as snow
> Till into the high dome of Pauls they like Thames waters flow.
>
> O what a multitude they seemd these flowers of London
> town. . . .
> Beneath them sit the aged men wise guardians of the poor
> Then cherish pity; lest you drive an angel from your door.[42]

Another Century, Another Bard

Nearly a century after Thomas Gray sought to link the power of the Welsh bard with forces opposing political tyranny, another English poet, Thomas Hood (1799–1845), continued the effort to arouse opposition to the exploitation of labor. His poem, "The Song of the Shirt" (1843), paints a picture consistent with the grim Parliamentary report of 1836 cited above and sharply different from Dyer's mid-eighteenth century

poetic scene of factory bliss. In his angry, dolorous composition, Hood focuses entirely on the threadworker as hand seamstress, a laborer direly needed before the invention of sewing machines. As cloth became widely available, larger segments of the population desired better wardrobes made from the newly available cotton fabrics as well as from linen, silk, or wool. In England, France, Germany, and elsewhere, before the invention of the sewing machine, hundreds of thousands and perhaps millions of women sewed by hand. Hood rallied the public to take notice of these invisible human beings.

> With fingers weary and worn,
> With eyelids heavy and red,
> A woman sat, in unwomanly rags,
> Plying her needle and thread—
> Stitch! stitch! stitch!
> In poverty, hunger, and dirt,
> And still with a voice of dolorous pitch
> She sang the "Song of the Shirt."

Having drawn this portrait of an exhausted seamstress, Hood addresses the men who heedlessly wear the garments on which the worker slaves:

> Oh, Men, with Sisters dear!
> Oh, Men, with Mothers and Wives!
> It is not linen you're wearing out,
> But human creatures' lives![43]

Hood's repetitive line "work—work—work" has the rhythm of a needle rocking left and right in the hands of a veteran seamstress as she pushes it through layers of fabric. His tone is shrill and relentless. Today one may be repulsed by his scene or dismiss it as sentimental and sensational; in Hood's day, however, the poem became widely popular.

Echoes of the Harp Weavers

The political and technological transformations of earlier centuries continue. Yet as modes of communication, production, and trade change, human emotional and physical needs are not radically different

from those which existed when Blake, Gray, Dyer, and others wrote their verses. While the ongoing secularization of society has caused fewer people to have faith in the miraculous powers of textiles, weaving as metaphor continues to have a spiritual meaning in our culture.

As if aware of the timeless web connecting the spiritual and the material, Queen Elizabeth II began her 1997 Christmas Day broadcast to the British people by saying, "Joy and sadness are part of all our lives." She then quoted William Blake:

> Joy & Woe are woven fine / A Clothing for the Soul divine
> Under every grief & pine / Runs a joy with silken twine.[44]

With Blake's threads of joy and woe, the queen proceeded to weave highlights from the year into her message.[45] She spoke of the "almost unbearable" sadness at the death of Diana, former princess of Wales, and the joy of celebrating fifty years of marriage to Prince Philip. She referred also to the terrible fire that had destroyed Windsor Castle five years earlier, yet which "brought opportunities for all sorts of people to display their range of craftsmanship and skills, their love of history and their faith in the future" as they worked to restore the castle.

Blake and other harp weavers share a place with the embroiderers of the Bayeux Tapestry, the weavers of *The Apocalypse Tapestry,* the artist Käthe Kollwitz, and others in the threadwork legacy of our culture, a legacy which strengthens the fabric of society in our own time.

Notes

1. Lipson, p. 12.
2. Lunt, p. 242. In Old English, span meant to draw out and twist wool into yarn or thread. Spinning involves both drawing out and twisting, although we often think of it as only twisting or twirling as in spinning a top.
3. Lipson, pp. 11–12.
4. Daniell, pp. 15–16.
5. Ibid., p. 393.
6. Lipson, p.12.
7. Lunt, pp. 568–69.
8. Lipson, pp. 74–75.
9. John Dyer, *The Fleece*, Book III, pp. 78–90. Excerpts taken from The Chadwyck–Healey English Poetry Database at the Electronic Text Center, University of Virginia, Charlottesville.
10. Jacob Bronowski, *William Blake and the Age of Revolution* (New York: Harper & Row, 1965), p. 43.
11. Ibid., p. 104.
12. Lipson, p. 13.
13. David V. Erdman, *Blake, Prophet Against Empire: A Poet's Interpretation of the History of His Own Times* (Princeton: Princeton University Press, 1969), p. 348.
14. Frank Kermode, John Hollander, et.al., (editors), *The Oxford Anthology of English Literature,* vol. 1 (London: Oxford University Press, 1973), pp. 2211–2215.
15. Erdman, p. 49.
16. Bronowski, p. 101.
17. Kermode, Hollander, et. al., (ed.), *Oxford Anthology,* vol. I, p. 2208.
18. Ibid., p. 2237.
19. Duncan Bythell, *The Handloom Weavers: A Study in the English Cotton Industry During the Industrial Revolution* (Cambridge: Cambridge University Press, 1969), p. 223.
20. Spinsters were females, particularly unmarried ones, who spun thread. Their numbers were so great that eventually the word "spinster" became synonymous with all unmarried women.
21. Robert Burns, *The Complete Works of Robert Burns* (Philadelphia: Gebbie & Co. Publishers, 1886), vol. II, pp. 148–49.
22. Ibid., vol. IV, pp. 117–18.

23. The material in these pages on the Caux area of Normandy is drawn from Gay L. Gullickson, *Spinners and Weavers of Auffay: Rural Industry and the Sexual Division of Labor in a French Village, 1750–1850* (Cambridge: Cambridge University Press, 1986).

24. The identities and backgrounds of more than 100,000 African captives brought from France and Spain to Louisiana in the 18th and 19th centuries have been compiled in a searchable database by the Louisiana State University Press. See David Firestone, "Anonymous Louisiana Slaves Regain Identity," *The New York Times,* July 30, 2000.

25. Marlise Simons, "Unhappily, Port Confronts Its Past: Slave Trader," *New York Times International,* December 17, 1993.

26. Historian Herbert Kisch reports that because of a shortage of housing around Krefeld, thirteen families left in 1693 for the colony of Pennsylvania, where they helped found Germantown. William Estep indicates that Mennonites founded their first permanent settlement in the New World in Germantown in 1683. It is reasonable to think that the families from Krefeld joined the earlier settlers. Their descendents in America are still known for their entrepreneurial and needlework skills. See Herbert Kisch, *From Domestic Manufacture to Industrial Revolution: The Case of the Rhineland Textile Districts* (New York: Oxford University Press, 1989), p. 66, and William R. Estep, *The Anabaptist Story* (Grand Rapids, Michigan: William B. Eerdmans Publishing Company, 1975), p. 203.

27. Kisch, p. 66.

28. Jennifer Harris, ed. *Textiles, 5000 Years: An International History and Illustrated Survey.* (London: British Museum Press, 1993), p. 19.

29. Wilson, p. 200; Gullickson, p. 97.

30. Bythell, pp. 74–75.

31. Power, p. 120.

32. Ibid. The large red woolsack on which the presiding officer in the House of Lords sits remained visible in its official place in 1999, when Parliament voted to end the six-hundred-year-old right of the landed aristocracy to sit in the House of Lords. See John Cassidy, "The Blair Project," *The New Yorker,* December 6, 1999, p. 120.

33. Bronowski, pp. 44–45.

34. Ibid., p. 97.

35. Ibid.

36. Wilson, pp. 199–200.

37. Bythell, p. 139.

38. Natalie Rothstein, *Woven Textile Design in Britain to 1750: The Victoria & Albert Museum's Textile Collection* (New York: Canopy Books, A Division of Abbeville Publishing Group, 1994), p. 9.

39. Ibid.

40. Bronowski, p. 149.

41. Ibid., p. 148.

42. William Blake, *Songs of Innocence and of Experience* (New York: The Orion Press, 1967), Pl. 18.

43. Thomas Hood, *The Complete Poetical Works.* Walter Jerrold, ed. (Westport, Connecticut: Greenwood Press, 1980; reprint of Oxford University Press, 1920 edition), pp. 518-519.

44. William Blake, "Auguries of Innocence," *Selected Poems* (London: John Westhouse Publishers Ltd., 1947), p. 42.

45. Carol Midgley, "Queen speaks of sadness over the death of Princess," *The London Times,* December 26, 1997.

With Passion and Thread

6

When early English crafters pierced a piece of cloth, leather, or metal with a sharp tool, they called the resulting small hole a prick. Eventually, they used the same five-letter word when speaking of a thin, tapering piece of wood or metal that served as a fastener or pin on their clothing. By the late sixteenth century, prick commonly referred to the male genital organ, while prick-stitch denoted the stabbing stitch needle crafters employed in glove making and embroidery. In various locales, the public began to associate ordinary threadwork with sexual activity. Popular metaphors for copulation in seventeenth-century Dutch society "included the needle piercing a hole in cloth and the loom's shuttle driving the woof threads through the warp."[1]

Today threadwork as an erotic metaphor may exist only in the imagination of an individual. Yet it is reasonable to think that threadwork and/or threadworkers arouse a variety of strong feelings, including erotic passion, in characters created by two well-known American novelists and a provocative British novelist.

The Scarlet Letter: Interweaving Good and Evil

Employed as a measurer of coal and salt for the Boston Custom House in 1839, Nathaniel Hawthorne (1804–1864) recorded in his journal seeing on a wharf "a huge pile of cotton bales, from a New

Orleans ship, twenty or thirty feet high, as high as a house."[2] Ten years later when he began writing *The Scarlet Letter,* factory smokestacks and water-powered engines were invading the green hills and dales outside Boston and his hometown of Salem. In the textile mills of nearby Lowell, Massachusetts, a labor force of young girls, recruited from the farms of New England, spun natural fibers into thread and wove cotton and wool textiles for a young nation striving for economic independence.

Some say that the theme of Hawthorne's novel is the sense of guilt that lingered in the author's mind long after his ancestors had participated in colonial America's Salem witch trials. Whatever his inspiration, the author used pen and ink to turn the calendar back two hundred years to a world where inhabitants believed good and evil were clearly recognizable opposites. But Hawthorne saw that appearances are often deceptive; he believed good and evil are interwoven in human nature. In Hawthorne's imagination, the courage, wisdom, and sewing skills of a "sinful" woman, employing in her own hands the simplest of tools— a slender, tapering piece of steel—overcomes the cruelty and self-righteousness of her outraged, pious neighbors.

The plot of *The Scarlet Letter* is timeless. A powerful but cowardly man betrays a beautiful, proud young woman; the community shuns her, but its scorn does not destroy her; she slowly regains the respect she deserves. Into the web of this ordinary fabric, the author weaves a variety of complicated ethical themes which have not faded since the novel's publication in 1850. As Hawthorne introduces his story, he knows that morally ambiguous territory lies ahead, and he warns his readers that he will be "dressing up the tale, and imagining the motives and modes of passion that influenced the characters who figure in it." Textile imagery begins with the narrator's discovery, in the old customhouse in Salem, of a tattered rag with "traces about it of gold embroidery . . . greatly frayed and defaced. . . . wrought, as was easy to perceive, with wonderful skill of needlework"(31). Thus Hawthorne introduces the provocative, central symbol in his tale:

> This rag of scarlet cloth, for time and wear and a sacrilegious moth had reduced it to little other than a rag, on careful examination, assumed the shape of a letter. It was the capital letter A. . . . It had been intended, there could be no doubt, as an ornamental article of dress; but how it was to be worn, or what rank, honor, and dignity, in by-past times, were signified by it,

was a riddle which . . . I saw little hope of solving. And yet it strangely interested me. My eyes fastened themselves upon the old scarlet letter.(31)

With this mysterious scrap of red cloth, Hawthorne snares the reader's attention and proceeds to reveal how a token of intended shame paradoxically arouses fantasies of erotic pleasure. He adroitly sews sin and sex together in one bold letter.

The Accused Hester Prynne

Men's and women's fashions color the setting of Hawthorne's tale, once he moves from the old customhouse to a seventeenth-century town near the village of Cornhill where on a summer morning a "throng of bearded men, in sad-colored garments, and gray, steeple-crowned hats, intermixed with women, some wearing hoods and others bareheaded, was assembled"(47). These townsfolk are standing around a scaffold in the marketplace, awaiting the "outing" of the scandalous fallen woman whose sinful conduct is a threat to their welfare.

As they wait, Hawthorne provides more textile imagery: women wearing petticoat and farthingale are elbowing one another for the best view of the fight to come. With well-developed busts above their hoop skirts, these "self-constituted judges" buzz with opinions regarding the "malefactress" expected at any moment to stand exposed before them. Their conflicting adjectives—brazen, bold, brave—suggest a certain uneasiness about the possible threat that the accused Hester Prynne poses in their midst. Their own uncertainty begins to unnerve them.

"Little will she care what the magistrates order her to put upon the bodice of her gown," one of the women protests before adding with a note of envy, "She may cover it with a brooch . . . and so walk the streets as brave as ever"(51)! The speaker's words relating to Hester's style of dress and demeanor reveal the heroine's character: determined self-control dominates her clothing as it does most of her life.

Near the end of his story, when Hawthorne portrays the final gathering of villagers in the marketplace, he dwells again on their costumes. The English immigrants have not yet enlivened their sad gray, brown, or black colors with other hues, while a party of Indians wears finery of embroidered deerskin robes. The Puritan elders are in black cloaks,

starched bands, and steeple-crowned hats. The crew of a vessel from the Spanish main attends in short trousers and broad-brimmed hats of palmleaf. Old Roger Chillingworth—Hester's estranged husband—wears a profusion of ribbons on his garment; gold lace and a gold chain encircle his hat.

When Hester finally steps through the prison doorway into the bright sunlight of the marketplace, the author rivets his readers' attention on the ornamental needlework pinned erotically on Hester's bosom.

> On the breast of her gown, in fine red cloth, surrounded with an elaborate embroidery and fantastic flourishes of gold-thread, appeared the letter A. It was so artistically done, and with so much fertility and gorgeous luxuriance of fancy, that it had all the effect of a last and fitting decoration to the apparel which she wore; and which was of a splendor in accordance with the taste of the age, but greatly beyond what was allowed by the sumptuary regulations of the colony.(53)

Hawthorne's image of the accused adulteress, Hester Prynne, is as complex as his threadwork symbol of the A-word. Behind her marble passiveness is a will of steel, and in a sense, Hawthorne's "genteel" adulteress is the original steel magnolia or iron butterfly in American literature. A thread of subliminal eroticism runs through his description of this woman charged with being guilty of "the deepest sin in the most sacred area of human life."

> The young woman was tall, with a figure of perfect elegance, on the large scale. She had dark and abundant hair, so glossy that it threw off the sunshine with a gleam, a face which, besides being beautiful from regularity of feature and richness of complexion, had the impressiveness belonging to a marked brow and deep black eyes. She was lady-like, too, after the manner of the feminine gentility of those days . . . her beauty shone out, and made a halo of the misfortune and ignominy in which she was enveloped.(53)

With her infant in her arms and the symbol of adultery on her bosom, Hester is both "the image of Divine Maternity" and the incarnation of Mary Magdalene. The fantastically embroidered letter, exposed prominently on Hester Prynne's "figure of perfect elegance,"

transfixes the spectators in the crowd. The license granted to them by the magistrates to gape at a beautiful woman's bosom astounds them. One of the female spectators finds her voice and says: "She hath good skill at her needle, that's certain, but did ever a woman, before this brazen hussy, contrive such a way of showing it!" This clever observer recognizes that Hester has made a joke of the magistrates: she has made "a pride out of what they meant for a punishment"(54).

Another woman wishes it were possible to strip the rich gown off Hester and clothe her in a rag of rheumatic flannel, a recurrence of the association of shame with nakedness. The youngest woman in the group allows that there's "not a stitch in that embroidered letter" but what Hester has felt in her heart, a fleeting reminder of the Augustinian association of sex, guilt, and sewing. Hawthorne mocks the hypocrisy of the pompous crowd with the grim cry of the beadle: "A blessing on the righteous Colony of the Massachusetts, where iniquity is dragged out into the sunshine! Come along, Madam Hester, and show your scarlet letter in the marketplace"(54).

Hester Prynne walks to a scaffold, a penal machine embodying the ideal of ignominy, where she has been sentenced to stand for three hours under the "heavy weight of a thousand unrelenting eyes . . . concentrated at her bosom."

> the point which drew all eyes . . .was that SCARLET LETTER, so fantastically embroidered and illuminated upon her bosom. It had the effect of a spell.(55)

Not unlike some twentieth-century person shackled helplessly before a mob of television cameras, Hester feels that she may go mad. Moments later her thoughts turn to tranquil childhood memories, and her feelings of panic gradually subside. At length her mind returns to the scene before her, and she recognizes her erstwhile, elderly husband standing on the outskirts of the crowd. Here Hawthorne uses erotic Edenic imagery: "A writhing horror twisted itself across his features, like a snake gliding swiftly over them"(60).

Hester's three hours of exposure on the scaffold are only one torment to survive. She faces more severe punishment: for the remainder of her natural life she must wear the scarlet mark of shame—not on her sleeve or skirt or cap, but upon her bosom. She also confronts the necessity of providing economically for herself and her "sin-born" child

through the coming years. Perhaps more painful than either of these is having to endure being abandoned by a man, highly respected in her community, who lacks the integrity and moral courage to "drag out into the sunshine" his singular responsibility for her public humiliation. Hester considers herself "connected in a union" with this man, and a secret feeling struggles out of her heart, "like a serpent from its hole," that their marriage will be recognized "before the bar of final judgment" (80). The tempter of souls, writes Hawthorne, "laughed at the passionate and desperate joy" with which Hester seized this idea and then compelled herself to "bar it in its dungeon"(80).

The Art of Needlework

After Hester's exposure in shame on the scaffold, she takes up her abode with her infant child in a "little lonesome dwelling, with some slender means that she possessed," and by the license of the magistrates, establishes herself as a seamstress in her cottage. "She possessed an art that sufficed, even in a land that afforded comparatively little scope for its exercise, to supply food for her thriving infant and herself. It was the art—then, as now, almost the only one within a woman's grasp—of needlework"(81). Curiosity draws children, too young to comprehend the scandal occupying their elders, to Hester's isolated dwelling. They peek at "the poor, sinful woman" who is "plying her needle at the cottage-window.(81)"

Hester has readily available advertisement for her needle skills; "in the curiously embroidered letter" on her breast is a permanent specimen of her delicate and imaginative threadwork skill. With some irony, Hawthorne observes that the simplicity of Puritanical dress might logically have led to an infrequent call for the finer productions of Hester's handiwork, but these stern progenitors of his generation find it harder to dispense with "certain finery" than with many things that others might consider more important.

> Public ceremonies . . . were, as a matter of policy, marked by a stately and well-conducted ceremonial, and a sombre, but yet a studied magnificence. Deep ruffs, painfully wrought bands, and gorgeously embroidered gloves, were all deemed necessary to the official state of men assuming the reins of power. . . . In the array of funerals, too . . . there was a frequent and characteristic

demand for such labor as Hester Prynne could supply. Baby-linen—for babies then wore robes of state—afforded still another possibility of toil and emolument.(82)

With time, it becomes fashionable in the community for individuals who have denounced this woman as "a living sermon against sin" to employ her for as many hours as she sees fit to work with her needle. "Her needlework was seen on the ruff of the Governor; military men wore it on their scarfs, and the minister on his band; it decked the baby's little cap; it was shut up to be mildewed and molder away, in the coffins of the dead"(83). But heaven forbid that anyone should employ Hester's "sinful hands" to embroider the white veil which would cover the pure blushes of a bride! Brilliantly, Hawthorne's thread of subliminal eroticism persists; the blushes of a virgin bride contrast with the unmentionable dalliance of the adulterous threadworker.

The single mother sews elaborately for others to support herself and her child, "the effluence of her mother's lawless passion"(165). For her own clothing, however, Hester chooses the coarsest materials and the most somber hue, the gloomy effect highlighted only by the glistening scarlet letter. Yet with her needle and determined will, she finds ways to outflank her public adversaries and to express her own inner passions of guilt and bitter anger.

Hester's Shield and Companion

From Pearl's earliest days in the thatched cottage outside of Cornhill, Hester creates attire of fantastic ingenuity for this "lovely child" whom God had given "as a direct consequence" of the mother's sin (89). For Pearl, Hester buys the richest fabrics available in her village and elaborately designs and decorates the dresses the child wears in public. "So magnificent was the small figure, when thus arrayed, and such was the splendor of Pearl's own proper beauty, shining through the gorgeous robes which might have extinguished a paler loveliness, that there was an absolute circle of radiance around her"(90). The mother allows "the gorgeous tendencies of her imagination their full play" with her daughter, arraying Pearl on one occasion "in a crimson velvet tunic of a peculiar cut, abundantly embroidered with fantasies and flourishes of gold thread"(102).

Despite all her masterful self-control, Hester is unable to suppress her maddening desire to shock her enemies with the finery she fashions for this child who is both hers and not hers, whom she both loves and fears, who is both her closest companion and the person to whom she dares not reveal her soul. The needle, Hester's shield and only other companion, is her means for expressing the contradictions in her mind and soul, and she uses it to release the wildness in her passion and the ecstasy in her sadness. Yet Hester's thwarted emotions and needlework talents have a dark side: the conspicuous clothes that Pearl wears reinforce the child's isolation from her peers. Other "sombre little urchins" of the village often pursue Hester and Pearl from a distance with taunts and shrill cries; when they see Pearl arrayed in her crimson velvet tunic, they fling mud at the mother and the child (85,102). One can reasonably conclude that Pearl, like most individuals, is aware of her clothing and the impressions it creates. In Pearl's case, however, clothing is a particularly meaningful language because of her mother's constant occupation with needle and thread as well as because of the embroidered accessory on her mother's dress which is synonymous in Pearl's mind with her mother's identity. Thus the needle which becomes Hester's instrument for slowly purging her own anger and gaining psychological and spiritual freedom is ironically the weapon with which she unwittingly almost destroys her young daughter's independence and selfhood. Conspicious apparel calls out the "fire" in Pearl and suggests to others that the child's "nature had something wrong in it"(165).

No sooner does the author bring Pearl into the sewing room than he proceeds to make the workshop a goodwill center for the community. Instead of spending all her sewing time creating fine articles to sell or for Pearl to wear, Hester voluntarily works on garments that she gives to poor wretches, some of whom consider themselves morally superior to her and do not hesitate to communicate their feelings of moral superiority to their benefactress (84). Her motive for the charity sewing perhaps is penance, suggests Hawthorne. He goes on to hint, however, at another possible motive: sewing for the unfortunate may be Hester's means of reassuring herself that she is not entirely cut off from the moral life of her community despite the fact that the rest of humankind cuts her off day after day in a thousand ways. Needle and thread are her blessed link to the outside world, her anchor in sanity, her salvation from self-destruction.

Whether sewing for gain or for charity, Hester is no mindless seamstress. Hawthorne offers repeated evidence to the contrary, such as her schooling herself to resist responding to words of exhortation that her female clients or others direct at her when they pass her in the street. Further, she steels herself to forgo praying for her enemies, "lest in spite of her forgiving aspirations," each prayer twists itself into a curse (85). Had she been of a "softer moral and intellectual fibre," she might have been bereft of all reason to live and to provide for little Pearl. But with her needle in hand, she has a defender and companion as steadfast as any knight's sword.

Finally, by refusing to identify her partner in sin, Hester outwits her self-righteous judges and paradoxically turns the tables on them. No woman in Cornhill knows whether her own husband has taken pleasure in the "glossy-haired beauty" with "deep dark eyes." And no man in the village knows which of his neighbors is privy to something he himself desires.

One of Hawthorne's most vivid images of the shunned-woman-turned-seamstress reverberates with the language of passionate, strong feelings:

> She had in her nature a rich, voluptuous, Oriental characteristic, a taste for the gorgeously beautiful, which, save in the exquisite productions of her needle, found nothing else, in all the possibilities of her life, to exercise itself upon.(83)

Artists express rich, voluptuous feelings with color and paintbrush; composers pour deep emotion and indescribable passion into musical compositions. Hester expresses the "gorgeously beautiful" with "the exquisite productions" of her needle art, yet she rejects using her needle to express "the passion of her life."

> Women derive a pleasure, incomprehensible to the other sex, from the delicate toil of the needle. To Hester Prynne it might have been a mode of expressing, and therefore soothing, the passion of her life. Like all other joys, she rejected it as sin.(83)

In these two passages Hawthorne portrays the needle as Hester's alter ego, as her temptation and salvation. There is a wrestling match in progress. Hester is determined to sew beautifully but not to enjoy the

act of sewing. To create but not to take satisfaction in creating. To keep her eye constantly on the firm, round needle plunging up and down through tiny holes separating the fine threads in her hands but never to think of the firm, round taper that once penetrated her own body. Never to recall her joy in that one unguarded moment of lawless passion.

Hawthorne creates an atmosphere of high emotional tension in Hester's isolation. A reader can imagine that in the near silence of her cottage, Hester hears no sound but that of the needle quietly puncturing the fabric stretched tight in the embroidery frame, the scissors now and then snipping a thread, and new thread being pulled through the needle's eye. Will the tiny needle snap, one wonders, because Hester angrily pushes it through too many layers of cloth? Will tears falling down her cheeks stain the expensive silk someone has left with her for a new dress? Is that a blood stain darkening the ruff on which she carefully loops her thread? What would Hester do if *he* should suddenly appear at her isolated door? This tempting thought, "like a serpent from its hole," surely must have struggled out of her heart.

The needle mediates between the shunned and those who shun, between Hester's denial and her desire, between her needs to repress joy and to be ecstatic, between her longing to be loved and her compulsion to endure punishment. It mediates between her urge to release the passion awakened in her loins by her experience and her buttoned-up denial of this unspeakable desire. Over the world outside her door, Hester has little power, but in the realm of needle and thread, she is sovereign. The two worlds collide in Hester's scarlet letter and in her soul. Her protracted dilemma reflects that of Penelope, shuttling back and forth at her loom on Ithaca, struggling to remain loyal to the missing loved one and to maintain the hope he will return.

Finally, Hawthorne's allegory returns to the biblical theme which links sewing and clothing to life and redemption. In the initial scene at the scaffold, the village folk know and understand little about Hester Prynne, yet over the course of the following seven years they slowly come to recognize undeniable qualities about the wearer of the scarlet letter. No one is as ready as she to give of her little substance to every demand of poverty (161). Her fingers, which could have embroidered a monarch's robe, have instead stitched garments for some bitter-hearted pauper who thanks her with a gibe. The folk of Cornhill repeatedly

see Hester devote herself to those in trouble, and with the passage of time, the badge of shame on her breast becomes the symbol to them of her calling to be a sister of mercy. The red letter imparts "to the wearer a kind of sacredness" enabling her "to walk securely amid all peril" (163). In contrast, her "partner in sin," whose scarlet letter is stitched secretly and agonizingly upon his heart, lacks moral strength and inner serenity to the end of his days (75).

Hawthorne's Own Fantasies

Literary critic James R. Mellow notes, of a sketch Hawthorne published anonymously in the *New England Magazine* in December 1835 and again in the 1854 edition of *Mosses from an Old Manse,* that Hawthorne writes "with that mounting attention to incidental detail that figures in the most ardent sexual fantasies."[4] It is a sketch, continues Mellow, written "by a man with healthy instincts who feels some cause for complaint with strait-laced American mores in his encounters with the opposite sex." A strong erotic undercurrent persists in Hawthorne's love letters to his fiancée, Sophia Peabody, in the journals husband and wife kept after they married in 1842, and in their correspondence when they were apart. Hawthorne was clearly a man who could weave his own erotic experience and fantasy into a novel such as *The Scarlet Letter* with its intimations of sexual repression and desire.

Ethan Frome: A Mirror Image of Hester Prynne

A little over a half century after *The Scarlet Letter* was published, another American novelist, Edith Wharton (1862–1937), created a mirror image of Hester Prynne in the isolated yet dogged Ethan Frome who, like Hawthorne's heroine, is trapped in a net of contradictory emotional and physical passions.[5] The setting in each novel is a New England village in a bygone era and in both, a solitary narrator imagines the unknown circumstances behind a mystery that occurred before he arrives on the scene. Finally, both Wharton and Hawthorne suggest that cloth, which has been held and stitched by a woman's hands, can conduct the warmth of erotic passion to a man's hands or imagination.[6] Needlework is not a major theme in Edith Wharton's brief novel, yet in

one scene in which the air is charged with erotic passion, hand sewing—that universal symbol of feminine virtue—plays a worthy supporting role.

A love triangle in *Ethan Frome* provides the background for the plot: the younger husband of an older, invalid woman struggles to restrain his emotional and physical attraction to his wife's youthful cousin, a live-in helper with the housework and nursing chores. *Ethan Frome* appeared serially in *Scribner's Monthly* from August to October 1911. Before publication of the series ended, many readers must have wondered how the author would resolve this intriguing yet melancholy story of repressed passion.

A Man's Dreams

Ethan Frome's ailing wife, Zeena, recognizes her husband's increasing attraction to Mattie Silver, who for a year has been living and working in their isolated farmhouse. When Zeena improves enough to pay a visit to her relatives in another village, Ethan and Mattie are suddenly left alone. After they finish supper on a winter evening, Ethan goes out to look at the cows and to take a last turn about the house. When he returns to the kitchen, he finds his own chair pushed up to the stove and Mattie sitting at a table near the lamp "with a bit of sewing" in her hands (64). Through her hair, she has run a streak of crimson ribbon.

Ethan sits down, draws his pipe from his pocket, and stretches his feet to the glow of the stove. This is the world as he has dreamed it: being alone with Mattie, free to gaze on her light figure and dark hair without fear of Zeena's noticing the joy and longing in his eyes. Yet even now, Mattie is sitting where he can not readily observe her at work. His wife's empty rocking chair—symbol of her cold denials and harsh demands—faces Ethan, and he asks Mattie to sit in it, to fulfill his fantasy that he is married to a responsive, loving woman. As Mattie moves to the empty chair, both she and Ethan seem spooked by this invasion of Zeena's space. Mattie retreats to her place by the lamp, tactfully saying, "I can't see to sew"(65).

Ethan, determined to enjoy his momentary fantasy, pushes his chair sideways "that he might get a view of her profile and of the lamplight falling on her hands" (65). He takes his pipe from his mouth and draws

his chair up to the table where Mattie is working, her soft hands moving skillfully and rhythmically, her eyelids lowered over her work. Ethan cautiously leans forward, touches "the farther end of the strip of brown stuff" that Mattie is hemming and attempts to speak casually:

> "What do you think I saw under the Varnum spruces, coming home just now? I saw a friend of yours getting kissed" (66).

Remembering the night before when, out-of-doors, he had put his arm around Mattie and she had not resisted, he hopes his news may open the way "to a harmless caress, if only a mere touch on her hand" (67). Instead, Mattie blushes and draws her handwork out of his hands. In the warm, lamp-lit room, she seems far away from him, beyond his reach.

Ethan eases up to the table again; Mattie sews on in silence without looking at him. He grows fascinated with the way "in which her hands went up and down above the strip of stuff" on which she is sewing (68). In the silence, he picks up the thread of his fantasy, tilting the conversation in a direction that again arouses Mattie's anxiety and prompts her to raise questions concerning her future status as Zeena's helper. Her questions momentarily interrupt his illusion of intimacy. Mattie falls silent, "her hands clasped on her work," and it seems to Ethan

> that a warm current flowed toward him along the strip of stuff that still lay unrolled between them. Cautiously he slid his hand palm-downward along the table till his finger-tips touched the end of the stuff. A faint vibration of her lashes seemed to show that she was aware of his gesture, and that it had sent a countercurrent back to her; and she let her hands lie motionless on the other end of the strip.(69)

Ethan's body and brain ache with indescribable weariness, yet his dream tarries. His hand completely covers the end of Mattie's sewing "as if it were a part of herself . . . and without knowing what he did he stooped his head and kissed the bit of stuff in his hold" (69).

> As his lips rested on it he felt it glide slowly from beneath them, and saw that Mattie had risen and was silently rolling up her work. She fastened it with a pin, and then, finding her

thimble and scissors, put them with the roll of stuff into the box covered with fancy paper which he had once brought to her from Bettsbridge. (69–70)

Pin. Scissors. Threatening imagery to Ethan whose dream suddenly implodes.

"Is the fire alright?" asks Mattie, the author continuing metaphors that suggest the heat of passion. Moments later the lonely man and woman go to their separate rooms. Only then does Ethan remember that he has not even touched Mattie's hand.

An Entry in Wharton's Diary

The emotional and erotic fantasy which Wharton's novel depicted appears to have been drawn from feelings the author noted in a personal diary in February 1908, soon after her forty-sixth birthday. At the time her husband, Teddy, was in poor health, and Edith was enjoying a new, deepening intimacy with another man. While Teddy was away from home in February, the other man—Morton Fullerton—and Edith began sharing a number of day trips and evenings alone together.

The biographer R.W.B. Lewis reports what happened in Edith's living room on one of those intimate evenings. Fullerton sat near a lamp and read aloud from an article while Edith sat nearby with her sewing. In her diary she later noted:

> Ah, the illusion I had, of a life in which such evenings might be a dear accepted habit![7]

In his relations with other women, Fullerton indulged playfully in shifting conversations abruptly from the abstract to the erotic. However, when he interrupted Edith's illusion by making several suggestions unrelated to what he was reading, he aroused her anxiety. Underestimating his current companion's lifelong emotional and erotic defenses, he destroyed the evening's "special quality of mental communion" for Edith Wharton.

> Why did you spoil it? . . .You hurt me—you disillusioned me—

and when you left me I was more deeply yours . . . Ah, the
confused processes within us![8]

Like Mattie, Edith Wharton became uneasy when her male com-
panion's conversation veered from the impersonal to the passionate.
Perhaps each woman used threadwork to shield herself from the possi-
bility of emotional and physical intimacy. Wharton had experienced
using the impersonal and the intellectual as shields in a marriage that for
years had lacked physical intimacy. Yet, in her budding relationship with
Morton Fullerton, she recognized something was different; thus, as she
noted in her diary, her feelings were confused.

Literary scholar Cynthia Griffin Wolff writes that at this point in her
life Edith "yearned to be released from the bondage of being mute, iso-
lated, and lonely; but implicit in that release was the necessity of
expressing passion and of having the courage to trust herself to emo-
tional intimacy."[9] Wharton's moral scruples were a barrier, but more
hindering to the relationship with Fullerton, concludes Wolff, was
Edith's "lifelong habit of denial and repression. She had always been
afraid of passion." The barrier was overcome a few weeks later.
According to Wolff, the intimacy of a three-year affair with Fullerton
enabled Wharton to explore her "passional self" and return her discov-
eries to "the fictions in novels that dealt primarily with passion."[10] *Ethan
Frome,* continues Wolff, signals a turning point in her writing. Wharton
wrote it soon after the affair with Fullerton ended.

The two editors of Wharton's *Letters* observe that the record of her
letters to Fullerton discloses her initial "enormous emotional arousal
and then emotional bruising and grief" as the affair slackened.[11] In ally-
ing herself to Fullerton, Edith Wharton acted like Ethan Frome in his
blind and hasty marriage to Zeena. Happily for Wharton and her read-
ers, her torment was not without gain.

One other detail in the background of the novel relates to our pres-
ent survey of threadwork images. According to biographer Lewis, soon
after Edith Wharton began writing *Ethan Frome* she wrote to a friend:

> I am driving harder and harder at that ridiculous nouvelle,
> which has grown into a large long-legged hobbledehoy of a
> young novel, 20,000 long it is already, and growing. I have to
> let its frocks down every day, and soon it will be in trousers!
> However, I see the end.[12]

Ethan Frome had lengthened from infant to awkward youth. Wharton's metaphor suggests how her sewing and writing skills were interwoven.

The Rainbow: Needlework in the Lawrence World

Almost one year after *Ethan Frome* appeared in print, English author D. H. Lawrence (1885–1930) began writing *The Rainbow* (1915),[13] a novel some consider a literary masterpiece. *Ethan Frome* depicts a relatively tranquil winter evening in an American farmhouse: a man is passionately arroused as he admires a needleworker sewing. As if in a cracked mirror, Lawrence offers glimpses into two Yorkshire households where a woman sewing provokes a mate's anger and his erotic passion.

In Lawrence's novel, Tom Brangwen is glad when evening comes: his outside work is finished, and he can be alone with his wife, Lydia. After their child is put to bed, Tom sits on one side of the fire "with his beer on the hob and his long white pipe in his fingers," conscious of Lydia who is sitting opposite him and working at her embroidery (55). Lydia is "curiously self-sufficient" and says little as she stitches, only occasionally lifting her head, "her grey eyes shining with a strange light" that has nothing to do with her husband (55). If she speaks at all, she reminisces about her girlhood with her father and about places far removed from Tom. As if unaware of him, Lydia stitches unheeding. When they go to bed after evenings like this, Tom:

> knew that he had nothing to do with her. She was back in her childhood, he was a peasant, a serf . . . a nothing. . . . And gradually he grew into a raging fury against her. . . . Only he lay still and wide-eyed with rage, inarticulate, not understanding, but solid with hostility.(57)

One senses a self-defeating element in Tom's ideal of a quiet evening by the fire. The intimacy that he hungers for seems beyond achieving, yet he persists in believing it can become a reality. His disappointments only deepen his frustration and anger.

For days after an evening of such furor, Tom walks about angrily and wills to be rid of Lydia. Then out of nowhere, as he is working in the fields, he feels "a connection between them again. . . . [A] passion-

ate flood broke forward into a tremendous, magnificent rush," inspiring Tom to believe he can "create the world afresh"(57). Later back in the house with Lydia, he buries "himself in the depths of her in an inexhaustible exploration"(58).

Another evening Lydia, now pregnant, is busy sewing. Again she is sitting opposite Tom, her face, from his perspective, "inscrutable and indifferent." Again, needlework barricades husband from wife, and Tom suffers hell in his loneliness:

> He felt he wanted to break her into acknowledgment of him, into awareness of him. It was insufferable that she had so obliterated him. He would smash her into regarding him. He had a raging agony of desire to do so. But something bigger in him withheld him, kept him motionless. . . . For he was afraid of his wife. As she sat there with bent head, silent, working or reading, but so unutterably silent that his heart seemed under the millstone of it, she became herself like the upper millstone lying on him, crushing him.(59–60)

Tom sees Lydia's needlework as emblematic of her self-absorption and withdrawal from him. Yet from her perspective, sewing provides her one opportunity during a day to feel independent, to sit peacefully and create beauty. She may believe it disguises evidence of her fear—her defense against unwanted physical and emotional intimacy with her husband. Whatever it is to her, Lydia's sewing represents a rival and a barrier to Tom.

The Pattern Is Repeated

Lawrence introduces needlework again in *The Rainbow* in the next generation when Lydia and Tom's child, Anna, becomes an adult married to Tom's nephew, Will. In a different Yorkshire cottage, an emotional atmosphere identical to the previous one prevails. Again it is evening. After clearing away the tea things, Anna turns to her work at a sewing machine and Will's soul rises in rage.

> He hated beyond measure to hear the shriek of calico as she tore the web sharply, as if with pleasure. And the run of the sewing machine gathered a frenzy in him at last.

> "Aren't you going to stop that row? he shouted. "Can't you do it in the daytime?"
>
> "No, I can't . . . I have other things to do. Besides, I like sewing, and you're not going to stop me doing it."
>
> Whereupon she turned back to her arranging, fixing, stitching, his nerves jumped with anger as the sewing-machine . . . stuttered and buzzed.
>
> But she was enjoying herself, she was triumphant and happy as the darting needle danced ecstatically down a hem. . . . [H]er fingers were deft and swift and mistress.
>
> If he sat behind her stiff with impotent rage it only made a trembling vividness come into her energy. On she worked. At last he went to bed in a rage, and lay stiff, away from her. And she turned her back on him. And in the morning they did not speak, except in mere cold civilities.(160)

Intimacy of all kind between husband and wife is avoided or destroyed by a dancing needle.

The following evening Will comes in from work feeling contrite for the night before. He finds Anna busy at the sewing machine. Calico clippings cover the whole house, the kettle is not on the fire heating water for his tea. Anna has lost track of time, she says. But Will believes that as she sewed, she also lost track of him. His impulse to make amends for his anger the previous night dies an instant death. Instead, he abruptly stalks out of the house.

Lawrence is a genius at conveying how quickly human feelings swing from gentleness to rage, from hate to remorse, from anger to physical passion. After Will walks angrily from the house, Anna guiltily turns from her sewing to prepare his tea. But Will does not return for hours. His tea and toast chill while Anna waits in distress. Then her mood grows harder. What right has Will "to interfere" with her sewing? How can he presume to arrogate authority over her time and her interests? As she pushes this line of self-defense to extremes, she draws back from the impulse to be left alone permanently. She does not know what she would do, writes Lawrence, if Will left her, or if he turned against her.

When Will finally returns, saying he will get his own food, Anna

nevertheless brings out food for him. "And it pleased him that she did it for him. He was again a bright lord"(162). Moments later Will comes over to Anna and touches her delicately. "Her heart beat with wild passion, wild raging passion . . . the rising flood carried her away. They loved each other . . . passionately and fully"(163).

To Be a Woman in an Earlier World

In *The Rainbow,* D. H. Lawrence conveys his sensitivity to a skilled artisan's perceived sovereignty over her world of stitchery. In this respect he is like Hawthorne. As Hester is mistress with her needle and thread, so Lydia and Anna reign over a small realm while they sew; none reigns, however, footloose and fancy free. Lydia and Anna express passion in bed as well as in sewing. Hester sublimates her erotic passion in, among other things, exotic and intricate needlework. Mattie Silver, while sewing by lamplight, innocently arouses Ethan Frome's amorous feelings. Although the four seamstresses have their distinctions, their creators' association of their needlework with passion is deliberate and unmistakable.

In *Ethan Frome* and *The Rainbow,* readers may dismiss passages related to needlework as incidental to the theme of each novel. On the other hand, *The Scarlet Letter* is alive with stitchery and with textile imagery. Despite the variance in attention to needle and thread by the three authors, when closely examined, the novels convey a sense of power in the hands of a woman with a needle or sewing machine. This power may be liberating, inhibiting, redemptive or hostile, creative or destructive; a foe, a rival, or a benign, practical means to a useful end.

Nathaniel Hawthorne set his novel in his native landscape before smokestacks and tumbling mill wheels invaded New England villages. During the years D. H. Lawrence worked on *The Rainbow,* he lived abroad, having escaped from the "shabbiness" of England's industrial Midlands, but he set his novel in his rural homeland. Edith Wharton had abandoned her urban roots in Manhattan and settled in Paris before she wrote her picturesque tale of rural New England.

In their own ways, the authors used needlework to color a world they believed had been lost—a simpler world where needlework was a

natural element, an expected part of a woman's daily life. In such a world, as in ancient Greece and medieval Europe, to be a woman was to be involved—whether of necessity or for pleasure—with needle and thread.

Notes

1. Annette B. Weiner and Jane Schneider (eds.), *Cloth and Human Experience* (Washington: Smithsonian Institution Press, 1989), p. 222; note 10, p. 236.

2. James R. Mellow, *Nathaniel Hawthorne in His Times* (Boston: Houghton Mifflin Company, 1980), p. 162.

3. Nathaniel Hawthorne, *The Scarlet Letter, The Centenary Edition of the Works of Nathaniel Hawthorne*, vol. 1, edited by William Charvat, Roy Harvey Pierce, et. al. (Columbus, Ohio State University Press, 1962), p. 33. Subsequent quotations are from this edition; page numbers follow each quote.

4. Mellow, p. 55.

5. Edith Wharton, *Ethan Frome* (New York: Collier Books, Macmillan Publishing Company, 1987). Subsequent quotations are taken from this edition; page numbers follow each quotation.

6. Hawthorne, p. 32; Wharton, p. 69.

7. R.W.B. Lewis, *Edith Wharton: A Biography* (New York: Harper & Row, Publishers, 1975), p. 205.

8. Ibid., p. 206.

9. Cynthia Griffin Wolff, *A Feast of Words: The Triumph of Edith Wharton* (New York: Oxford University Press, 1977), p. 149.

10. Ibid., p. 161.

11. R.W.B. Lewis and Nancy Lewis, *The Letters of Edith Wharton* (New York: Macmillan, Collier Books, 1988). p. 17.

12. Lewis, *Edith Wharton*, p. 297.

13. D. H. Lawrence, *The Rainbow* (New York: Viking Press, Viking Compass, 1988). Subsequent quotations are from this edition; page numbers follow each quotation.

Battle Yarns

The now-empty cells of the Conciergerie, a French Revolution prison standing on the banks of the Seine in Paris, testify to the reality of the eighteenth-century Terror. Here Marie Antoinette, Danton, Robespierre, and thousands of others were lodged while they awaited execution. A visitor who walks inside the stone fortress today and peers into the darkened cells can almost hear the sounds of iron-barred doors clanging as they did at all hours of the night when guards herded doomed prisoners out into horse-drawn carts for transportation to the Place de la Concorde and the guillotine. Such sights and sounds are the dark side of war's glamour—its dashing figures in colorful uniforms, marching bands, waving flags, and cheering crowds. Another nightmare of war is an inadequate supply of uniforms, socks, blankets, bandages, and other textile provisions essential for military personnel and civilians.

At least three very different authors of the nineteenth century— Charles Dickens (1812–1870), Louisa May Alcott (1832–1888), and Mary Chesnut (1823–1886)—depict women from varying social backgrounds who knit and/or sew during wartime. These needlecrafters are connected not only by their gender, needlework, and wartime settings; they also share personality traits that help them endure hardships and overcome disappointments. With threadwork, they continue an age-old tradition maintained by children, women, and men in times of war.

The Real Madame Defarge

Charles Dickens' novel of the French Revolution, *A Tale of Two Cities* (1859),[1] is like a hall of mirrors: one character reflects another; one scene forecasts a later setting; one incident echoes an earlier vignette. Dickens knits the numerous corresponding parts of his historical masterpiece together with yarn in the hands of the irrepressible Therese Defarge, a woman traditionally seen as nefarious. A *New York Times* journalist alluded darkly to her in the 1990s at the height of a political scandal: "We do not want an [independent counsel] office that attracts every suburban Mme Defarge."[2]

Of the many mirror images in *A Tale of Two Cities,* the two most directly related to our larger theme of threadworkers are those of young Lucie Manette and middle-aged Therese Defarge. In many respects the two women are opposites. Lucie Manette—a devoted daughter, beloved wife, and loving mother—represents the ideal of the conventional Victorian woman. Although readers encounter Lucie on three occasions at her "usual work," the precise identification of her work is a mystery. The nearest Dickens comes to suggesting that needlework occupies Lucie is his reference, after her marriage to Charles Darnay, that sometimes as she sits in their still house, "her work would slowly fall from her hands" (210). Elsewhere Dickens refers to Madame Defarge's knitting as "her work in her hands" (177). The author nonetheless emphasizes that day by day Lucie is a valuable "golden thread" in her father's life.

> She was the golden thread that united him to a Past beyond his misery, and to a Present beyond his misery; and the sound of her voice, the light of her face, the touch of her hand, had a strong beneficial influence with him almost always. (74)

In sharp contrast to the beloved Lucie, Dickens lashes out at Therese Defarge at the novel's climax as she, with a loaded pistol hidden in her bosom and a sharpened dagger concealed at her waist, walks along Paris streets to find and kill Lucie Manette:

> There were many women at that time, upon whom the time laid a dreadfully disfiguring hand; but, there was not one among them more to be dreaded than this ruthless woman. . . . Imbued from her childhood with a brooding sense of wrong,

and an inveterate hatred of a class, opportunity had developed her into a tigress. She was absolutely without pity. (348)

Heretofore, Madame Defarge rarely appears without knitting in her hand, often in an atmosphere brooding with sinister overtones. How easy it became for readers to associate knitting with this "ruthless woman."

Differences between the "golden thread," a constant benevolent influence in the lives of others, and the perpetual knitter, a ruthless tigress, are readily apparent. But Dickens also creates similarities between his rivals, and he uses these to help tie his suspenseful tale together. Consider how the two women are alike.

Both, on more than one occasion, demonstrate courage in the face of life-threatening danger. At seventeen, Lucie, accompanied by a faithful maid, journeys abroad with a stranger to seek her father from whom she has been separated since infancy. Therese Defarge, the dauntless wife of a wineshop keeper in an impoverished suburb of Paris, looks boldly into the face of one of the area's aristocrats, the Marquis de St. Evrémonde, as his carriage tears recklessly through the streets of her village. Her cowed neighbors dare not raise an eyebrow, knowing from experience what this brutal nobleman can do to them. Additionally, Dickens portrays both Therese and Lucie as Victorian women who are the strength of the men in their lives. Lucie's presence is vital to her elderly father's emotional and physical stability after his release from long imprisonment. Madame Defarge's husband depends upon her to manage the affairs of the wineshop while he "walks up and down through life." Finally, both women inspire loyalty in others and are themselves loyal, intelligent, and resourceful.

Despite slowly weaving similar traits into the characters of Lucie Manette and Madame Defarge, Dickens' design for his suspenseful plot necessitates that the two women collide in a life-and-death struggle. And while the innocent and loving Lucie Manette may be the apparent heroine of *A Tale of Two Cities,* the resolute Therese Defarge is the author's more memorable character. He allows his knitter more verve, colorful imagination, energy, and determined grit than his "golden thread," whom he repeatedly characterizes as eternally passive and gentle. She hears in the years after marrying Charles Darney "none but friendly and soothing sounds" while she is "ever busily winding the

golden thread that bound them all together, weaving the service of her happy influence through the tissue of all their lives" (201).

Madame Defarge is perpetually in motion, from the moment she is introduced picking her teeth with a toothpick behind the counter of the wineshop, with her knitting before her on the counter, to her fatal struggle at the novel's climax. Through much of the novel, however, she appears in sinister settings which overshadow her commendable traits. When, for instance, a comrade accompanies the wine keeper and his wife to Versailles, he is dismayed by seeing Madame Defarge knit as she waits with the angry crowd demanding to see the king and queen. She is known to register the names of enemies in her knitting and the friend worries on this particular Sunday that she might include his name among her enemies.

In another episode Madame Defarge is "knitting away assiduously" when an English spy visits the wineshop. She casually fills the new customer's order for a little glass of old cognac and resumes her knitting. The visitor, whom she recognizes as a spy, compliments the cognac and then, after a few moments of watching her nimble fingers, compliments her for mastery of her needlework.

> "You knit with great skill, madame."
> "I am accustomed to it."
> "A pretty pattern too!"
> "You think so?"
> "Decidedly. May one ask what it is for?"
> "Pastime," said madame, still looking at him with a smile,
> while her fingers moved nimbly.
> "Not for use?"
> "That depends. I may find a use for it one day." (172–3)

As Dickens continues this vignette, his brushwork reveals the knitter's striking intellect, self-confidence, and self-control. The spy lingers in the shop, deliberately endeavoring to entrap the husband and wife as revolutionaries. Monsieur Defarge listens with alarm, and his hand becomes untrustworthy as he attempts to light his pipe behind the little counter. In contrast, Madame Defarge knits steadily, with no hint that the spy's words are having any effect on her. Once he departs, however, it is apparent that she has fully comprehended the spy's identity and threatening intentions.

The village where the Defarges live, writes Dickens, "turns itself

inside out" during summer evening hours. Neighbors sit on doorsteps, window ledges, and street corners, visiting with one another after their day's labor. At such times Madame Defarge, with her knitting underway, walks about the village, visiting with her neighbors. And she is not the only person in the village with needles in hand on such evenings.

> All the women knitted. They knitted worthless things; but the mechanical work was a mechanical substitute for eating and drinking; the hands moved for the jaws and the digestive apparatus. . . . But, as the fingers went, the eyes went, and the thoughts. . . . Darkness closed around . . . as the women sat knitting, knitting. (177)

Dickens' spotlight, however, is on one knitter—the "dreaded and ruthless" Madame Defarge, "a Missionary . . . such as the world will do well never to breed again" (348, 177). Yet his pejorative image of her contrasts with his portrayal of her as a victim. In the longest unbroken passage in his 362-page novel, he reveals the horrendous episode which lies behind Madame Defarge's animosity toward people of privilege and her outburst of violence against the innocent wife and young daughter of Charles Darnay. In this extended passage Dickens writes that when Madame Defarge was scarcely more than a child, her older, pregnant sister died after a vicious sexual assault by Charles Darnay's uncle, the Marquis de St. Evrémonde. The rapist and his brother, members of the privileged nobility, were also responsible for the deaths of Madame Defarge's father, brother, and brother-in-law. As her brother lay dying, he vowed that revenge would be taken someday against the two noblemen and even their heirs.

> In the days when all these things are to be answered for, I summon you and yours, to the last of your bad race, to answer for them. (314)

Madame Defarge only learns of her brother's dying vow at the peak of the revolutionary Terror. She then warns her husband:

> . . . that peasant family so injured . . . is my family. . . . those dead are my dead, and that summons to answer for those things descends to me! . . . [T]ell Wind and Fire where to stop . . . but don't tell me. (328)

The Terror is horrific. In four days, the air of the city of Paris is tainted by the slaying of "eleven hundred defenseless prisoners of both sexes and all ages . . . killed by the populace" (260). The executioners complain at times of exhaustion, but the slaughter continues. One rebel calmly devises a personal system for measuring the speed with which an executioner works; he discovers that sixty-three victims are guillotined while he smokes two pipes of tobacco.

In the heat of this irrational slaughter, Madam Defarge insists that she must exterminate the descendants of the two nobles who destroyed her relatives. She places her knitting in the hands of a friend and instructs the person to "have it ready for me in my usual seat" (347) at the guillotine. She then sets out to destroy the wife and child of her enemy. Like Hecuba, the queen of Troy who determines to avenge the murders of her son and daughter in Euripides' fifth-century play, Therese Defarge attempts to get revenge, but the winekeeper's wife accidentally kills herself with the weapon intended for murdering Lucie Manette.

Social Class and Knitting in Dickens' World

Dickens expressed his personal feelings in such characters as Madame Defarge. Her class consciousness reflects the author's, according to the biographer Peter Ackroyd, who notes Dickens' "private distaste for the 'aristocratic' class" and his belief that the ancien regime had provoked the French Revolution.[3] The revolution, according to Dickens' own statements, "was a struggle for the overthrow of a system of oppression, which in its contempt of all humanity . . . and in the systematic degradation of the people, had trained them to be the demons that they showed themselves when they rose up and cast it down for ever."[4] Ackroyd reports further that Dickens "often adopted in his imagination the role of victim, and was thus able to deal in [a] powerful and poignant manner with the sufferings of the poor and afflicted. It often seems, in fact, that his reforming zeal sprang from a sense of personal injury or personal fear."[5]

What might have been Dickens' intention when he created the redoubtable Madame Defarge's hobby? Perhaps her obsessive knitting satirized that of genteel English ladies for whom knitting became a fashionable pastime after the defeat of Napoleon at Waterloo. After that bat-

tle, the English began importing fine Merino wool from Saxony, the birthplace of young Queen Victoria's bridegroom, Prince Albert. Even the queen noted in her journal on April 9, 1841, "Albert read to me out of 'Oberon,' whilst I knitted."[6]

Other contemporary circumstances may suggest the author's inspiration for Madame Defarge's handwork. A short time before *A Tale of Two Cities* was published, England fought the Crimean War (1854–56) to stem the spread of Imperial Russia and, for the first time, the English at home knitted for their armies overseas. Richard Rutt, author of *A History of Hand Knitting*, reports on a patriotic Yorkshire woman's colorful letter published in *The London Times* on December 5, 1854.[7] The writer addressed herself to the women of England, asking them to knit brown worsted socks and stockings for the English soldiers. Her suggestion for financing the needlework project brings to mind the class structure of Dickens' eighteenth-century France: English ladies were to donate their knitting to the war effort while poorer women were to be given yarn and paid to knit socks for the men in service. Dickens was likely aware of this wartime knitting. In the postwar years, two knitting terms—cardigan and raglan—were derived from the names of prominent English officers of the war: the earl of Cardigan led the charge of the light brigade at Balaclava and Lord Ragland was "the unfortunate commander-in-chief who was made scapegoat for the many mistakes of the war."[8]

Historical circumstances also may have influenced Dickens' contemporary, Leo Tolstoy, when he was writing his novel on Napoleon's early nineteenth-century invasion of Russia, *War and Peace* (1865–69). Wartime knitting was a tradition in Tolstoy's native land, and he alludes to this when his heroine, Countess Natasha Rostova, sits knitting a stocking by the deathbed of her fatally wounded husband.

> She had learned to knit stockings since Prince Andrew had casually mentioned that no one nursed the sick so well as old nurses who knit stockings, and that there is something soothing in the knitting of stockings. The needles clicked lightly in her slender, rapidly moving hands, and he could clearly see the thoughtful profile of her drooping face.[9]

Knitted stockings had been required for Russian army regiments as early as the 1630s; hand knitters in the Moscow, Vladimir, and Galitc districts

worked to supply this early demand. Russian military officers in the eighteenth century were required to wear sumptuous, knitted silk sashes, and some of these were also likely knitted by hand.

A third possible inspiration for the knitting in Dickens' novel is the fact that until the revolutionary costume of striped trousers *(sans culottes)* replaced them, stockings and knee britches were the standard menswear in France.[10] Hand-knit stockings were thus in great demand and a reliable source of income for the French working poor, just as they were in other European countries in the eighteenth century. Dickens had access to detailed historical background on his subject in the famed history of the French Revolution written by his friend Thomas Carlyle. Furthermore, he knew the territory from experience; he commuted between Paris and London for months at a time a few years before he wrote the novel.[11]

Perhaps Madame Defarge helped to start a fad among Dickens' readers. Some years after the novel appeared, one observer reported that knitting in public places, such as at concerts in Albert Hall, was "a new freak" in London. He described one lady's hands as "white and covered in jewels" and ventured the opinion that her knitting in public "was intended to display these beauties."[12] Two hundred years earlier, in 1660, sixty-three London ministers had signed a complaint protesting against those in their congregations who continued their "ordinary callings in knitting and sewing of garments" in public assemblies, including even "in the time of God's public worship."[13] Bitter cold winters and poorly heated buildings combined to sustain a high demand for wool socks, shawls, and sweaters that provided at least some protection from freezing.

Little Women

Ten years after *A Tale of Two Cities* was published in England, Louisa May Alcott became famous in America with the publication of *Little Women* (1868–69).[14] In this fictionalized story of her own early years with three sisters in a hardscrabble New England family, Alcott introduces threadwork and the Civil War as she opens her narrative. The March sisters' father is fighting with Union forces, and although at least one of the girls is "dying to go and fight with papa," all four are knit-

ting blue army socks at home (3). With evening's arrival,

> out came the four little work-baskets, and the needles flew as
> the girls made sheets for Aunt March. It was uninteresting
> sewing, but tonight no one grumbled. They adopted Jo's plan
> of dividing the long seams into four parts, and calling the quar-
> ters, Europe, Asia, Africa, and America, and in that way got on
> capitally, especially when they talked about the different coun-
> tries as they stitched their way through them. (8)

Needlework figures prominently as necessary work as well as recre-
ation in the March family, just as it did in the Alcott family. Teen-aged
Jo's daily employment is serving as companion to her Aunt March, who
has more financial means than Jo's parents. Jo's chores include reading
aloud to her aunt and winding yarn. Beth, the youngest March sister,
starts working on a pair of slippers for the family's elderly neighbor after
he invites her to play on his idle grand piano. "She was a nimble little
needlewoman, and they were finished before any one got tired of them"
(49). Meg, the eldest sister, stitches wristbands at her "little work-table"
(96) or while sitting on a cushion in the yard (112).

Whether compelled to sew or sewing voluntarily, the March sisters
sew or knit when at home more than they engage in any other single
activity. During their father's absence, they "sewed as usual, while their
mother read aloud" in the evening (60). Daughters of the more well-
to-do families in their town also find energy enough to sew if only for
amusement; they embroider with fine woolen yarn that had derived its
name from the city of Worsted in England as early as the fourteenth cen-
tury (70).

Aside from their father's absence, the world of the March sisters
seems relatively untouched by the Civil War. No blood flows in the
streets, and no heads are severed here as in *A Tale of Two Cities*. The
American war rages in the distance while ordinary life goes on for the
four sisters; threadwork continues unabated. Needlework is mentioned
less frequently in the novel's second half which covers postwar days in
the March family. Meg makes her own wedding gown, "sewing into it
the tender hopes and innocent romances of a girlish heart" (200). Jo
gives herself credit for being able to use a needle as well as a pen in New
York where she is both a teacher and a seamstress.

In the novel's closing scene, as in the opening one, needlework again appears. The extended family gathers to celebrate Grandmother March's sixtieth birthday, and her granddaughter presents a gift she has made. "Every stitch Daisy's patient little fingers had put into the hand-kerchiefs she hemmed was better than embroidery to Mrs. March" (395). As *Little Women* closes, the tradition of sewing—in war and peace—passes from one generation to the next.

"Work is handled playfully by Louisa May Alcott," writes Ellen Moers in *Literary Women,* "but it is not confused with play. It is some-thing real, lasting, serious, necessary, and inescapable as Monday morn-ing." Moers contrasts the importance of work in Alcott's novel with its place in Mark Twain's *Tom Sawyer* (1876) in which "work is presented as something to be avoided at all costs and with all ingenuity, whether through the swindle, the ruse, or flight."[15]

The Letters of Louisa May Alcott

Needlework was an integral part of the Alcott women's struggle to survive in a household headed by a beloved but impractical man, Amos Bronson Alcott. He was born in western Connecticut on a farm called Spindle Hill because for three generations the family's chief occupation was growing and spinning flax. Bronson's mother pulled flax while his father made baskets and brooms.

Letters that Louisa May wrote as a young adult show how closely *Little Women,* the most famous of her more than three dozen published books, reflected her real life.[16] On her own in Boston in 1856 at age twenty-four, the author boasted that she would receive ten dollars a month for a story—nearly enough to cover her board—and if she failed to find additional work as a governess, she could "easily make up the other" needed dollars by sewing (20). When one of her stories was rejected a few weeks later, Louisa May reassured her older sister Anna: "Don't be alarmed . . . I can sew like a steam engine while I plan my works of art" (27). The following night, she reported that she had sewed, taught one of her pupils, and attended a lecture that day. A day later Louisa May was exuberant after receiving a Christmas gift from a cousin—"a handsome silk gown, the first I ever had. Mrs. K. says it is a very nice one and will last a long time, it is one strip bronze and black and one of silvery grey. Lu says she is going to have it made for me in

great style; so now she has got me fixed up like a [C]hristian and I feel made" (29).

Hard times followed the good times in her Boston experience. Louisa May was almost desperate for work in October 1858; she began calling on women, asking if they had sewing she could do for them. She admitted to one woman that "we were poor [and] I must support myself," that she was willing to do anything "honest—sew, teach, write, housework, nurse, etc" (35). Her search rewarded her with seamstress work sewing ten hours a day at a reform school, "making and mending" for thirty girls. The pay at first would be small, she informed her family, "but it is a beginning and honest work" (35).

The determined would-be author was not content to "make and mend" forever. Later in 1858, she found a governess job that paid a small salary, thus she needed to sew only to pay her board. Happy with this arrangement, Louisa May soon boasted that she "fell to sewing as a Saturday treat" (39). She was aware that back home, her sisters had little choice but to sew part of every day. When her younger sister died, Alcott expressed her sadness to a friend: "She has sewed constantly till the last week, then her 'needle felt heavy' she said & she put away her work neatly & carefully never to take it up again" (32).

Soon after the Civil War started in 1861, Alcott began making her personal contribution to the war effort. Writing to a friend, she explained: "If I had not been sewing violently on patriotic blue shirts for the last month I should have written . . . & having at last done my share of the five hundred azure envelopes I lay down my needle to take up my pen with great contentment, the first article being my abomination & the last my delight" (64). Her letters reveal a strain of humor which endured despite the war; by December 1862, she allowed that "if the war goes on we shall be so poor we shall have to dress in newspapers. . . . " (81). The same month she began planning to go to Washington to volunteer as a nurse, a decision which unexpectedly opened the door to the publication of *Hospital Sketches*, a small volume based on her brief experience there.

During the six weeks that she attended the wounded in Union Hotel Hospital, prior to becoming seriously ill herself with what may have been typhoid fever, she sent her family letters "written on inverted tin kettles, in my pantry, while waiting for gruel to warm or poultices to cool, for boys to wake and be tormented" (xxiv). *Hospital Sketches*

consisted of extracts from those letters to her family; its publication established her reputation as a writer. Now the woman who had previously struggled to peddle her writing while she sewed for other people could put her needle aside and indulge her preference for pen and ink.

Metaphors in her letters and journal during the early years of her newfound success as an author also reveal her previous experiences as needleworker. To the publisher of *Hospital Sketches,* she admitted: "We like the extracts from the letters, & I wait to see my second book in its go abroad gown" (88). In her journal at about the same time she varied her dressmaker's metaphor: "On the 25th . . . at night up came my book in its new dress" (90). Responding to a letter of commendation from a reader of *Hospital Sketches,* she admitted that she was "anxious to be busied in some more loyal labor than sitting quietly at home spinning fictions" (96–7). However, spinning fictions was her destiny and to the publisher of *Little Women* she complained, "I don't see how it can be spun out to make twenty-four chapters" (116). When she was able to send him ten more chapters, she admitted that not having her own copy of the first half of the book "was rather a disadvantage, as I don't remember it very well, so may have missed some of the threads" (117).

The Diaries of Mary Boykin Chesnut

While Alcott's sympathies were with Union forces, a free-spirited woman in the South, Mary Boykin Chesnut, occupied herself with affairs of the Confederacy. Her wartime diaries became the basis for her reputation as the most brilliant diarist of her time; it is in these diaries that we find occasional threadwork imagery.

Mary Boykin remembered from her childhood visiting her grandparents' prewar plantation with the loom room in the slave community

> where the weaving never stopped—Once in the store room—I was happy—negroes came from the plantation—for Medicine, for shoes—for clothes—for hours she [Mary's grandmother] was ministering to their wants—We measured a shirt or a pair of pantaloons by holding them up and guessing if they would fit. . . . Grandma stood by a table—& sung hymns & cut out Negro clothes all day—& I ran up & down & carried them up

to the sempstress room—where half a dozen stitched away
from Morn til dewy eve. . . .[17]

When Mary Boykin and James Chesnut Jr. married in 1840, they
went to live with his parents and two older sisters at his family's
South Carolina plantation, Mulberry. The senior Mrs. Chesnut spent
hours daily cutting out baby clothes for infants born to Mulberry
slaves during this prewar period; the young bride and her two sisters-
in-law devoted their afternoons to stitching tiny garments for the
newborns.

Unlike Alcott, Chesnut never sewed to earn money, but her sewing
was important to the economy of plantations where she lived in child-
hood and early adulthood. Her descriptions of plantation household
scenes, where mistresses and slaves cut and sewed garments, are similar
to mythical settings Homer described such as the Phaeacian island
palace of Queen Arete and King Alcinous. There Odysseus saw fifty
maids weaving and spinning, "fingers flickering quick as aspen leaves in
the wind," and he found the queen at the hearth weaving yarn of sea-
purple stain. Or the royal palace in Sparta, where three servants
arranged the silver work basket, "heaped to the brim with yarn" for
Queen Helen to weave.

The definitive edition of Chesnut's Civil War diaries appeared in
1984 as *The Private Mary Chesnut*, edited by C. Vann Woodward and
Elisabeth Muhlenfeld.[18] It consisted of her surviving diary entries pre-
served at the University of South Carolina. Prior to this 1984 edition,
Chesnut's work was known only through two editions, titled *A Diary
From Dixie*, published in 1905 and in 1949. Both were based on an
untitled manuscript that Chesnut wrote in the 1880s long after she had
written her Civil War diaries. In the postwar manuscript, Chesnut
"turned third-person narrative into dialogue, put her thoughts in the
mouths of others, telescoped or expanded entries, occasionally shifted
dates and often rearranged incidents to heighten dramatic impact"
(xviii). The manuscript's references to threadwork illustrate how it took
liberties with her wartime diaries.

The Private Mary Chesnut, which consists of seven original volumes
of diaries, includes only two brief sentences relating to stitchery for the
date August 27, 1861:

> The knitting mania rages. You never see a woman without her needles are going. (143)

Yet for that same August date in *A Diary From Dixie,* an expanded entry reads:

> I do not know when I have seen a woman without knitting in her hand. 'Socks for the soldiers' is the cry. One poor man said he had dozens of socks and but one shirt. He preferred more shirts and fewer stocking. It gives a quaint look, the twinkling of needles, and the everlasting sock dangling.[19]

In her original diaries, the threadwork references are consistently brief, lending support to the theory that other matters during the war were more important to her than knitting. References to threadwork are buried in hundreds of others noting battles, newspaper reports, gossip, generals, politicians, the weather, travel, fashions, and the civilian social scene. Chestnut recognized, nonetheless, that knitting was important to civilian morale and perhaps to the war effort itself, and she contributed some of her own energy to it.

> [August 17] Wm. Shannon . . . called last night . . . again today . . . laughed at my knitting socks. (128)

> [August 21] Went to see Mrs. Roper. Saw there Mrs. Gregg & Mrs. Wm. Preston knitting socks. (134)

> [August 30] Had a large meeting of ladies last night—all knitting, no scandal. . . . I sat knitting. In rushed M. H. B.—all in tears. (148)

> [September 26] Thursday. Rainy day—knit—& arranged my things. (163)

> [October 1] Went up to the Society. . . . Nothing was said worth remembering. . . . Everybody knitting. (166)

Before the Civil War, Mary Chesnut lived happily in Washington, D.C., for two years when her husband served in the United States Senate. Early during the war, Louisa May Alcott also lived there briefly. Ironically, Alcott's writing about her nursing experiences in the Union

hospital opened her future to fame and a degree of fortune while after the defeat of the Confederacy, unpaid debts and fears of poverty were never far from Mary Chesnut's mind. After Lee's surrender at Appomattox, she used the back of an old recipe book to record life around her, whereas when the war began, she kept her diary in a red leather-bound, gilt-edged diary secured with a brass lock. During her Washington days before the war, Mary's Philadelphia dressmaker had offered her two Point Alençon lace capes at $110 and $120. After the war, such an extravagant wardrobe purchase was impossible for Chesnut to consider. In 1886, the Confederate widow wrote a friend from the Washington days that Sarsfield, the house in which she lived, contained "a splendid library. No end of old china glass—silver—Stuart portraits . . . 50 acres—4 Jersey cows and an income of $140 . . . dont [sic] mistake—one hundred & forty dollars!"[20]

Fabrics of Patriotism

In 1824, when William Driver of Salem, Massachusetts, received command of his own ship at the age of twenty-one, his mother and other women in Salem made him an American flag to fly from his ship. They made the flag's stripes from English wool bunting and its twenty-four stars from cotton fabric. The young captain dubbed his personal flag Old Glory and proceeded to carry the homemade Stars and Stripes around the world.[21]

After his wife died in 1837, Driver retired from the sea and moved to Nashville, Tennessee. There he remarried and continued to fly Old Glory on July 4 and other holidays, on his birthday, and on election days. In 1860, the second Mrs. Driver repaired the flag and also brought the number of stars up-to-date; she added a white anchor on the right hand corner of the flag to symbolize and commemorate the captain's career at sea.

William Driver remained a staunch Union man after Tennessee seceded from the Union in 1861. When word reached the captain that local secessionists had threatened to burn Old Glory, he took his flag to some pro-Union women in his neighborhood who concealed it inside a comforter. It remained safely hidden until advance units of the Union army reached Nashville on February 25, 1862. Shortly afterward, Driver tore open the comforter in the security of his own home and

revealed the flag to a surprised captain of an Ohio regiment. Then with the flag folded in his arms, Driver and his escort of Union soldiers walked to the Tennessee statehouse. Driver climbed to the dome, reportedly saying as he raised Old Glory over the city: "Thank God! I lived to raise Old Glory on the dome of the capitol of Tennessee. I am now ready to die and go to my forefathers."[22] The publicity surrounding this moment gave national recognition to William Driver's private nickname for his flag. Soon Old Glory became a synonym for the flag of the United States. In 1922 the original flag was presented to President Warren G. Harding, who gave it to the Smithsonian Institution, where it remains.

Another flag from the Civil War period reportedly rested uneasily in the drawer of a cabinet inside the Minnesota History Center in the spring of 2000. During Pickett's Charge at Gettysburg, as thousands of Confederate soldiers rushed up Cemetery Ridge, a Union private from Minnesota captured the flag carried by a lieutenant in the 28th Virginia Infantry Regiment. One hundred forty years later Virginians, using "fusillades of moral and political as well as legal arguments," asked in vain for the flag's return to their state.[23]

An even more remarkable illustration of humans bonding with wartime flags occurred in France in April 1814. As the defeated Napoleon prepared to leave Paris for exile on the island of Elba, he summoned the Old Guard for an emotional farewell in the palace courtyard. He called for the standard of the First Regiment of Grenadiers, kissed the flag, then departed in his carriage. Afterward members of the Old Guard burned all their flags and, "so as not to be separated from them, swallowed the ashes."[24]

Women, Men, Needlework, and War

The writings of Dickens, Alcott, and Chesnut offer insights into the role of threadworkers as civilians in wartime, a role historians and others have largely overlooked.[25] Apparently, there is no serious work in English that deals with the design and manufacture of military uniforms before the late eighteenth century, although standardized dress for soldiers had become common by the end of the seventeenth century and existed even earlier for certain units such as Swiss Guards in the Vatican, who wore uniforms designed by Michelangelo.[26] The fabrication of uni-

forms was one of the first instances of mass production in modern society, but the sources documenting this innovation are scattered or lost.

A number of historians are currently working to recover information regarding women's roles in wartime, including their help in producing uniforms. A 1997 volume on the French army of the Grand Siecle contains a modest beginning of this effort:

> The work of women with the troops remained primarily that associated with gender roles in civilian life—food preparation, laundry chores, needlework, amateur nursing, and, of course, sex, although this last was not as dominant as might be supposed, particularly by the end of the [seventeenth century]. . . . The army could not afford to march without any women at all, since their work was essential to the appearance, comfort, discipline, and health of the soldiers.[27]

When the new French Republic faced revolt from within and attack from other powers in Europe in the early summer of 1793, the National Convention declared the levee en masse. This declaration conscripted women, men, and children of all ages for war duty.

> From this moment and until all enemies are driven from the territory of the Republic the French people are in permanent requisition for army service. Young men shall go to battle; the married men shall forge arms and transport provisions; the women shall make tents and clothes and shall serve in the hospitals; the children shall turn old linen into lint. . . .[28]

The huge demand in England for standardized uniforms during the Napoleonic Wars caused a labor shortage in London's tailoring establishment, and tailors' wages—for a seventy-two-hour, six-day week—inflated to a peak in 1813. This inflation led to the practice of outworking, the polite euphemism for sweating.[29] Large military contracts for clothing were given to tailors, who subcontracted piecework to women and children willing to work at home for less money than shop tailors were paid.

When Germany formally declared war on France in the late summer of 1914, author Edith Wharton wasted no time in finding a useful wartime occupation for Parisian seamstresses, like her own, who were suddenly without their customary source of income:

> Within a fortnight of the outbreak of hostilities Edith had
> established [a workroom] . . . a few blocks from her apartment
> and had admitted several dozen seamstresses.[30]

According to her biographer, Wharton's primary effort on behalf of the project "was to procure sizable work orders—lingerie, dresses, handkerchiefs, stockings, children's clothes—through her far-ranging connections in France and America." Knowing of her enterprise, the Belgian government asked her to provide similar help for children whom officials picked up in the cellars of wrecked houses and on abandoned farms after the heavy shelling of Belgium began. By the end of 1915, the Children of Flanders Rescue Committee had taken care of 750 children. It held lessons in sewing and English for young people and established schools in lacemaking and French for older Belgian girls. After the war, the president of France made Edith Wharton a chevalier of the Legion of Honor, the highest order he could award, and the king of Belgium named her a chevalier of the Order of Leopold.

During World War II knitting was popular among civilians in America where well-known bandleader Glen Miller recorded a musical hit titled, "Knit One, Pearl Two." The Red Cross supplied yarn to elementary-school girls who volunteered to knit wool scarves for soldiers and civilians in war-torn areas.[31]

Refugees have also used their threadwork skills during wartime. For example, shortly after the Soviets began bombing Afghan villages in 1980, Afghanistan women refugees began weaving symbols of their resistance against the war into traditional rug designs. According to one report:

> Images of tanks and warplanes, Ak-47's (used by Soviet soldiers) and American-made M-16 rifles (used by Afghan insurgents) began to appear in the rugs. . . . The rugs started as a spontaneous narrative of life in a war-torn country. But their success with journalists, dealers and Soviet soldiers, who exchanged weapons for rugs, prompted middlemen to set up production sites in refugee camps in Pakistan, where men also started weaving.[32]

Two decades later, rugs woven during the nine-year war were "fast disappearing into the hands of collectors" who valued them as contempo-

rary folk art or woven historical documents comparable to the medieval Bayeux Tapestry. These Afghan weavers, like Helen of Troy, captured war's horror with wool and their fingers.

In wartime, some of those in service and even war prisoners may stitch or knit with whatever supplies they can obtain. Patrick O'Brian, a twentieth-century British author of Napoleonic war novels, reminds his readers that standardized uniforms came slowly to the Royal Navy. In occasional scenes aboard ship, British seamen take needles and thread in hand:

> [T]his was a make-and-mend afternoon, and for the new hands at least it meant turning the yards and yards of duck they had been given that morning into hot-weather clothes. It was not only the foremast jacks who were busy with their needles.[33]

One of the new youngsters is learning how to darn his stockings "under the eye of . . . a bearded man . . . a capital darner who had attended to the Admiral's table-cloths in his time." Someone else is showing "yet another squeaker the best way of sewing on a pocket. . . . 'There,' he said to the youngster, 'you finish it off by running it through half a dozen times and casting a round knot in the last turn.' He cut the thread and handed the boy the spool and scissors."[34]

Off the shores of England in World War II, Commander Lionel P. Skipwith, considered by others as "rather an individualist," embroidered for relaxation. He was said to be "adored" by his men, "perhaps for his tendency to bend the rules to get things done right."[35] The chief gunner's mate on his vessel, an experienced career sailor, considered Skipwith "the finest captain" he had ever served under.

Knitting helped Hans von Luck, a German war prisoner in the Caucasus Mountains of Georgia, survive nearly five years of imprisonment after World War II ended.[36] Snatching moments from forced labor at heavy jobs, von Luck knitted socks with insulation yarn salvaged from electrical cables. With the socks, he earned a small amount of money which helped to keep him from starving.[37]

A common theme running through the stories of all who stitch or knit while battles rage is the irony that their weapons against fear, despair, and perhaps boredom are not swords or bayonets, but needles and thread.

Notes

1. Charles Dickens, *A Tale of Two Cities* (Philadelphia: David McKay Co., 1936). Subsequent quotations are from this edition; page numbers follow each quote.

2. Anthony Lewis, "Lord High Executioner," *The New York Times,* January 26, 1998.

3. Peter Ackroyd, *Dickens* (New York: Harper Collins Publishers, 1990), p. 739.

4. Ibid., p. 858.

5. Ibid., p. 737.

6. Richard Rutt, *A History of Hand Knitting* (Loveland, Colorado: Interweave Press, 1987), p. 112.

7. Ibid., p. 134.

8. Ibid., p. 135.

9. Leo Tolstoy, *War and Peace,* tr. by Louise and Aylmer Maude (New York: Simon and Schuster, 1942), p. 1088.

10. Philippe Perrot, *Fashioning the Bourgeoisie: A History of Clothing in the Nineteenth Century,* tr. Richard Bienvenu (Princeton: Princeton University Press, 1994), pp. 30–31.

11. Ackroyd, pp. 747–52.

12. Rutt, p. 18.

13. Ibid., p. 84.

14. Louisa May Alcott, *Little Women* (New York: Grosset & Dunlap, 1915). Subsequent quotations are taken from this edition; page numbers follow each quotation.

15. Ellen Moers, *Literary Women* (Garden City, New York: Doubleday & Company, 1976), p. 89.

16. Joel Myerson and Daniel Shealy, eds. *The Selected Letters of Louisa May Alcott* (Boston: Little, Brown and Company, 1987). Subsequent quotations from Alcott's letters are from this volume; page numbers follow each quotation.

17. Elisabeth Muhlenfeld, *Mary Boykin Chesnut: A Biography* (Baton Rouge: Louisiana State University Press, 1981), p. 15.

18. C. Vann Woodward and Elisabeth Muhlenfeld, eds., *The Private Mary Chesnut: The Unpublished Civil War Diaries* (New York: Oxford University Press, 1984). Subsequent quotes from the diaries are taken from this edition; page numbers follow each quote.

19. Mary Boykin Chesnut, *A Diary from Dixie,* ed. Ben Ames Williams

(Boston: Houghton Mifflin Co., 1949), p. 121.

20. Muhlenfeld, p. 218.

21. In April 1998, in a conversation with Harold D. Langley, I learned about the origin of Old Glory. Langley is curator emeritus of the Division of Naval History, National Museum of American History, Smithsonian Institution, Washington, D.C.

22. Wm. R. Furlong and Byron McCandless, with the editorial assistance of Harold D. Langley, *So Proudly We Hail: The History of the United States Flag* (Washington, D.C.: Smithsonian Institution Press, 1981), p. 204.

23. Kathy Sawyer, "Capture the Flag," *The Washington Post,* April 23, 2000.

24. Evangeline Bruce, *Napoleon and Josephine* (New York: Scribner, 1995), p. 475.

25. *Profil,* an Austrian magazine, reported in 1997: "The German clothing factory that eventually became the international menswear powerhouse Hugo Boss AG manufactured Nazi uniforms during World War II . . . most likely . . . using slave labor." A curator at the United States Holocaust Memorial Museum in Washington, D.C., noted that "even looking at some of these uniforms . . . fills a lot of people with dread and terror." A company spokesman said, "We would never be in such a business now." (Robin Givhan, "Fashion Firm Discovers Its Holocaust History," *The Washington Post,* August 14, 1997.)

26. This information was acquired in personal correspondence of December 18, 1997, from Peter Paret, professor emeritus at the School of Historical Studies, The Institute for Advanced Study, Princeton, N.J.

27. John A. Lynn, *Giant of the Grand Siecle: The French Army, 1610-1715* (Cambridge: Cambridge University Press, 1997), p. 337.

28. Steven T. Ross, *Historical Dictionary of the Wars of the French Revolution* (Lanham, Maryland: The Scarecrow Press, Inc., 1998), p. 91.

29. Richard Walker, *Savile Row: An Illustrated History* (New York: Rizzoli, 1989), pp. 42, 69.

30. Lewis, *Edith Wharton*, p. 365.

31. I remember knitting a monstrous gray scarf for the war effort when I was a seventh grader.

32. Marianne Rohrlich, "Images of War, Made Graceful on a Rug," *The New York Times,* January 16, 1997.

33. Patrick O'Brian, *The Far Side of the World* (New York: W.W. Norton & Company, Inc., 1992), pp. 98–99.

34. Ibid.

35. David Kahn, *Seizing the Enigma: The Race to Break the German U-Boat Codes, 1939-1943* (Boston: Houghton Mifflin Company, 1991), p. 174.

36. *The Washington Post,* May 1994.

37. An embroidery program, Fine Cell Work, helps inmates pass time prof-

itably in eight English prisons; it reportedly continues "a long tradition of soldiers and prisoners of war doing needlework." In the United States a dozen programs in federal prisons teach convicts to crochet and quilt; nine are community service projects and three provide vocational training. (Libby Copeland, "Crewel and Unusual Punishment?" *The Washington Post*, June 20, 2000.)

8

Sewing for Bread in Years Gone By

Woman's natural place was in the home, not the labor market, according to conventional wisdom after 1830. This ideology of domesticity developed about the same time as the idea of the family wage which stressed that men's earnings should be sufficient to support wives and children. Employers paid higher wages to males who were expected to remain in the labor force than to female employees who were considered temporary workers. Society also justified as inevitable that women, regardless of their needs, earn less than men because good-paying jobs, like magnets, might draw married women out of their homes and into the labor market. At the same time, laborers and their spouses complained that women desperate for employment would accept lower wages than men and thus could reduce wages for male breadwinners who were supporting families. Some also protested that wage-earning women threatened traditional values and family patterns. They denounced women's employment in shops and factories as "uncivilized. . . . [T]he loveliest of God's creation . . . reduced to the menial condition of savage life."[1] The result of these assorted views was that widows and older single women had no alternative but to accept their lower wages. To be permanently unmarried was to go against "the natural social order" and—in most instances—led to a lifetime of financial stress.

Threadwork, a traditional domestic task for women, fit neatly into this arbitrary economic system; it provided low-paying employment for

laborers who in most instances needed little training (because they had already been trained in the family) to perform their jobs. In the nineteenth century, however, *where* persons sewed and *what* persons sewed made all the difference in social status. A proper lady sewed, and the art of sewing was basic in her early education. In literature of that period, when this fine lady appears, she sews exclusively for her own satisfaction, not to earn money, and when a less privileged woman is seen attempting to support herself with needle and thread, she seldom is content in her work.

On the other hand, diverse sources of public records and personal memories confirm that many individuals, male and female, have needed to work with textiles to earn daily bread, and at least some of them have sustained and even inspired others by their own adaptability, imagination, perseverance, and courage.

Working-Class Seamstresses: Elizabeth Gaskell's England

Needlework as an occupation is an essential element in two novels by mid-nineteenth-century English author Elizabeth Gaskell (1810–1865). Her first novel, *Mary Barton* (1848),[2] dramatizes an imagined confrontation between factory owners and workers in early industrialized England. Young Mary Barton is the only daughter of an embittered weaver whose wife and two young sons perish in poverty while the mill owner's family prospers. Mary's father, John Barton, vows that his motherless daughter will never work in a factory where employment is unsteady and young girls are prey to immoral men. When Mary turns sixteen, she has two other employment options in their town: domestic service and dressmaking.

Because her father considers domestic servitude "a species of slavery; a pampering of artificial wants on the one side, a giving-up of every right of leisure by day and quiet rest by night on the other" and because he dislikes the idea of losing the daughter who is "the light of his hearth, the voice of his otherwise silent home," he determines that Mary will become apprenticed to a dressmaker (61–62). Mary has a somewhat different ambition for herself—to become a lady. In her youthful innocence, she thinks of dressmaking as her means to a higher rank in society; thus she becomes an apprentice with "a certain Miss

Simmonds," a milliner and dressmaker whose workwomen are called "young ladies."

In return for being taught the business, Mary promises to work for two years without pay and to begin work by six in summer, "bringing her day's meals" with her. (In winter she is permitted to come after breakfast.) Her workday ends irregularly, depending on the amount of work Miss Simmonds has for her young ladies to do. Once she successfully completes her training, Mary is allowed to "dine and have tea" at Miss Simmonds' expense and receive "a small quarterly salary (paid quarterly, because so much more genteel than by week)" (63).

Mary complies with the stringent terms of her apprenticeship. While her father and many other unemployed factory workers are going hungry, she is "secure of two meals a day" at Miss Simmonds'. Even Mary, however, loses one of her daily meals when the dressmaker eventually feels "the effect of bad times, [and] left off giving tea to her apprentices, setting them the example of long abstinence by putting off her own meal until work was done for the night, however late that might be" (158).

During the months at Miss Simmonds' place of business "in a respectable little street," Mary Barton is relatively secluded from the serious tensions that are progressively maddening her father. In the dressmaker's work room,

> the chief talk was of fashions, and dress, and parties to be given, for which such and such gowns would be wanted, varied with a slight whispered interlude occasionally about love and lovers. (140)

In her relatively sheltered world, Mary slowly becomes swept up in her own affairs and detached from her father's deprivations. As an attractive brunette walking alone to her work mornings and evenings, she catches the eye of the factory owner's unmarried son, who soon steals moments to be alone with the flattered young dressmaker. Stitching by the hour at Miss Simmonds', Mary focuses her thoughts on "visions of the future . . . on the circumstances of ease, and the pomps and vanities awaiting her" as she imagines herself married to the heir of the factory (160). But the tensions of the outside world finally invade Mary's immature dreams, and the sewing room's relatively placid atmosphere

abruptly changes as Miss Simmonds calls out sharply to the self-absorbed, young seamstress:

> Miss Barton! as I live, dropping tears on that new silk gown of Mrs Hawkes'! Don't you know they will stain, and make it shabby forever? . . .Or, if you must cry . . . take this print to cry over. That won't mark like this beautiful silk. (272)

Mary Barton's image as an ambitious but self-centered apprentice contrasts sharply with that of Ruth Hilton, the naïve, guileless heroine of Elizabeth Gaskell's novel *Ruth* (1853).[3] In this later work, Gaskell's theme again concentrates on the hardships of the industrially oppressed, as she, a minister's wife, observed them in England's textile manufacturing center of Manchester. Like Mary Barton, Ruth Hilton, an adolescent orphan who must be self-supporting, apprentices herself to a dressmaker. But the harsh scenes in Mrs. Mason's establishment, where Ruth sews late into the night, contrast markedly with those at Miss Simmonds' where Mary Barton stitches midst visions of a future life of ease.

Ruth is introduced as she returns from an errand for Mrs. Mason and enters the dressmaker's workshop "one January night . . . years ago":

> [S]trictly speaking, it was morning. Two o'clock in the morning. . . . And yet more than a dozen girls still sat in the room into which Ruth entered, stitching away as if for very life, not daring to gape, or show any outward manifestation of sleepiness. . . . [T]hey knew . . . the work-hours of the next day must begin at eight, and their young limbs were very weary. (3)

Mrs. Mason finally recognizes that her apprentices are nearly exhausted, so she allows a half-hour rest—with bread, cheese, and beer provided by a servant. "You will be so good as to eat it standing—away from the dresses—and to have your hands washed ready for work when I return," she adds before leaving the room. Immediately, the sewing room comes alive:

> One fat, particularly heavy-looking damsel, laid her head on her folded arms and was asleep in a moment. . . . Two or three others huddled over the scanty fireplace. . . . Some [ate] their bread and cheese, with as measured and incessant a motion of

the jaws . . . as you may see in cows. . . . Others stretched
themselves into all sorts of postures to relieve the weary mus-
cles. (4)

The moment Ruth is free, she rushes to the only window in the
room and presses her forehead against the cold glass. With aching eyes,
she gazes out at the snow that has fallen since the previous evening. She
longs to snatch up a shawl and strike out into the exquisite night.
Gaskell's heroine is an artist at heart and somewhat impractical. Beauty
and freedom mean more to her than bread and cheese. When another
seamstress advises Ruth to have supper, she responds: "One run—blow
of the fresh air would do me more good"(5). The experienced cowork-
er knows that Ruth will need more than beauty and fresh air to endure
five years of apprenticeship in the "oppressive stillness which lets every
sound of the thread be heard as it goes eternally backwards and for-
wards" in the dressmaker's workroom.

Many are the dresses that Mrs. Mason has promised to deliver
"without fail" in the morning to be worn in the evening at the town's
annual hunt ball. She is determined not to disappoint any of her clients,
lest they take their future business to a new dressmaker in the neigh-
borhood. When she returns to her apprentices after the rest period, Mrs.
Mason attempts to breathe additional new life into their flagging efforts
by offering a reward to the most deserving of them:

> I may as well inform you, young ladies, that I have been
> requested . . . to allow some of my young people to attend in
> the ante-chamber of the assembly-room with sandal ribbon,
> pins, and such little matters, and to be ready to repair any acci-
> dental injury to the ladies' dresses. I shall send four—of the
> most diligent. (7)

With the publication of *Mary Barton* and *Ruth*, Gaskell established
herself as a successful author and commentator on social problems in
nineteenth-century England. The two novels remain classic documents
of women in the labor class in that period, yet Gaskell's heroines would
have found a number of other occupations available had they lived in
London. In the larger city jobs for females included scullion (dishwash-
er), sackmaker, collierwoman, brickmaker, chairmaker, nailmaker, paper
mill girl, costergirl (fruit seller), fisherwoman, dustwoman, parlour

maid, maid-of-all-work, chimneysweep, envelope maker, milkwoman, mine tip girl, cullercoat lassie, bait girl, and gymnast. Women pursuing these occupations particularly interested Arthur Munby, a trained barrister, strait-laced civil servant, and friend of literary figures Gabriel Rossetti and John Ruskin. Munby kept a diary in which he recorded extensive descriptions such as one of a young woman who was likely transporting sections of garments being assembled piecemeal by workers in scattered areas of London:

> She wore an old gown of nameless material, sodden with laborious sweat; her broad breast (for she was a tall, strongly built wench of twenty or so) was loosely covered with a red and orange kerchief . . . a tattered blue and white apron hung from her wide waist, and her gown, gathered up under it, showed beneath a short and very ragged petticoat, below which were a pair of strong ankles and large feet, clad in dirty white stockings and muddy masculine boots, worn and shapeless.[4]

Needlework—even in workrooms as confining as those of Mrs. Mason and Miss Simmonds—provided a more genteel work environment than any described by Munby. And Elizabeth Gaskell's plots called for Mary Barton and Ruth Hilton to aspire to become members of the newly developing English middle class. It is quite likely that some of those in Munby's real-life sample preferred rougher work environments because the women felt more at ease working in these settings than they would have stitching dresses in a confining room under the watchful eye of an ever-present authority.

Upper-Class Views of Needlework

In July 1863 a *Punch* cartoon titled "The Haunted Lady, or 'The Ghost' in the Looking-Glass" appeared.[5] The cartoon, drawn by John Tenniel, pictures a fashionably dressed lady admiring her own reflection in a mirror which also contains the specter of an exhausted seamstress. The cartoon appeared shortly after a twenty-year-old seamstress named Mary Ann Walkley died after working continuously twenty-six hours in a poorly ventilated room. Seamstresses customarily worked fourteen to twenty hours a day during the London social season between March and July.

"Dress was so linked to status," reports Michael Hileys, the editor of Munby's diary, "that the demands of fashion were thought by some to be of paramount importance. A lady would place an order at tea-time—4 P.M.—for a ball dress to be sent home that same night—'any time before 12 would do.' And a silk dress took between eight and nine hours to sew by hand. . . . A lady ordered a dress and was told that [seamstresses] must sit up all night to make it. All she said was, 'I hope it will fit.'"[6]

The simplest rudiments of stitchery held no interest for nine-year-old Maggie Tulliver, a prosperous mill owner's daughter in George Eliot's novel *The Mill on the Floss* (1860). When encouraged by her mother to come indoors and "go on with your patchwork, like a little lady," Maggie replies in a cross tone:

> "I don't *want* to do my patchwork."
> "What! not your pretty patchwork to make a counterpane for your aunt Glegg?"
> "It's foolish work," said Maggie, with a toss of her mane—"tearing to pieces to sew 'em together again."[7]

Maggie's rebellious sentiments were echoed by an Australian-born writer, Elizabeth von Arnim (1866–1941), whom readers rediscovered near the end of the twentieth century. The author's first and most famous novel, *Elizabeth and Her German Garden* (1898), may reflect her married life on an estate in Prussia. Early in the novel, the narrator observes:

> The people round about are persuaded that I am . . . exceedingly eccentric, for the news has travelled that I spend the day out of doors with a book, and that no mortal eye has ever yet seen me sew or cook. But why cook when you can get some one to cook for you! And as for sewing, the maids will hem the sheets better and quicker than I could, and all forms of needlework of the fancy order are inventions of the evil one for keeping the foolish from applying their hearts to wisdom.[8]

Von Arnim's heroine would be a stranger in the world of Penelope and Hester Prynne whose work with yarn or thread made their isolation, uncertainty, and anxiety tolerable, thereby enabling them to apply their hearts to wisdom.

Edith Wharton's New York Society

Needlework of the fancy order compulsively occupies Newland Archer's mother and sister in *The Age of Innocence* (1920),[9] Edith Wharton's novel of nineteenth-century New York high society. Such sewing is a "rite" which ladies perform in the drawing room after dinner while gentlemen smoke "below stairs":

> [A]ccording to immemorial custom, Mrs. Archer and Janey trailed their long silk draperies up to the drawing-room, where . . . they sat beside a Carcel lamp . . . and stitched at the two ends of a tapestry band of field-flowers destined to adorn an 'occasional' chair in the drawing-room of young Mrs. Newland Archer. (41)

On another occasion, before dinner, Newland finds his mother in the drawing room where she raises "a troubled brow from her needlework" to ask him about a matter related to his forthcoming marriage. Their conversation is interrupted by a butler announcing an unexpected caller, and Mrs. Archer drops her needle and pushes her chair back "with an agitated hand." Moments later she draws her embroidery "out of the basket into which she had nervously tumbled it" and uses the needlework to cover a dead silence that follows the surprise caller's startling news (86–88).

The two drawing room scenes reveal multiple uses that nineteenth-century "high-born" ladies had for needlework: it created not only social bonds and recreation but also could mask inner feelings in awkward situations. Mrs. Archer is a lady who likes to feel in control of the world around her and begrudges any stranger's attempt to upset the established order of her world. Newland's future mother-in-law, like Mrs. Archer, feels secure only in a rigidly structured environment. Thus she requires a long engagement for her daughter, with time to prepare a proper trousseau containing "twelve dozen of everything—hand-embroidered" (80).[10]

In one novel depicting Wharton's New York high society, a woman with limitless privilege takes needle in well-groomed hand to while away the hours, whereas in another, a needle stands between an upper-class woman and her final ruin. Lily Bart hopes to avoid her downfall in Wharton's novel, *The House of Mirth* (1905).[11] Like Mrs. Archer and her

daughter in *The Age of Innocence,* Lily has been reared to be provided
for by others. Unlike the Archers, however, Lily Bart falls from her priv-
ileged position among the socially prominent to a place among the
impoverished of New York. A time comes when Lily has only her own
hands to make her way in the world. She turns to Gerty Farish, her one
friend who is an employed woman as well as a fringe member of the cir-
cle of rich people among whom Lily has lived. She confesses to Gerty:

> I'm nearly at the end of my tether. And then what can I do—
> how on earth am I to keep myself alive? (267)

Gerty remembers how beautifully her friend could trim her own hats in
a happier time and suggests that a solution lies in Lily finding someone
who will finance a fashionable milliner's shop for her. This idea revives
Lily's "hopes of profitable activity."

> Here was, after all, something that her charming listless hands
> could really do; she had no doubt of their capacity for knotting
> a ribbon or placing a flower to advantage. And of course only
> these finishing touches would be expected of her; subordinate
> fingers, blunt, grey, needle-pricked fingers, would prepare the
> shapes and stitch the linings, while she presided over the
> charming little front shop. (283)

The "charming little shop," however, is not to be Lily's because she
cannot obtain financing for it. Instead, she finds herself among the
needlewomen with "blunt, grey fingers" in a millinery establishment
belonging to Mme. Regina.

Two months after starting work, Lily is still unable to sew spangles
on a hat frame. "Look at those spangles, Miss Bart—every one of 'em
sewed on crooked," exclaims Mme. Regina, dropping the rejected work
on the table in front of the chagrined Lily (282). At that moment twen-
ty other women are bent over wire creations in the hot, stuffy room,
and they overhear the rebuke. Gone now are Lily's dreams of exercising
her talents of design and management. She had hoped to win the
respect of the other workwomen by displaying "a special deftness of
touch." Instead, she senses their scorn of her, not merely as a failure in
the sewing room but as a "fallen star" who has "gone under" in her
social class. Rather than feeling that her talents are superior to these sal-

low-faced workwomen, Lily "burned with vexation" as she hears them contemptuously gossiping about the women whose hats they, with nimble fingers, are now fabricating, women with whom Lily recently moved in high society (285).

The Fallen Woman and Orphan Daughters

Lily discovers that the vanity and self-indulgence of persons like herself give rise to the camaraderie in the "underworld of toilers." The constant chatter of other workers is debilitating to Lily, while the stillness in Mrs. Mason's workshop is oppressive to Ruth Hilton in Gaskell's novel. Both Lily and Ruth feel isolated even though surrounded by others. For these two fictional characters, threadwork creates no social bonds, and neither apprentice completes her training. Mrs. Mason accuses sixteen-year-old Ruth, who later becomes an unmarried mother, of having immoral relations with a lover and orders the apprentice not to show her face again at the dressmaker's house. Mme. Regina "downsizes" her staff and dismisses Lily, whose earlier downfall in her own circle had followed suspicions of her sexual and financial indiscretions.

The image of the "fallen woman" thrives in Victorian and Edwardian fiction. Mary Barton and Ruth Hilton are undone as aspiring dressmakers because their youthful bodies attract gentlemen lovers. Lily Bart's downfall follows her unwittingly or unwisely attracting married male admirers. The priggish attitude toward sexual behavior in nineteenth-century England and America contrasted with the permissive social environment of Paris. There writers described the *grisette*—typically a young seamstress, glove maker, or milliner wearing a gray wool dress—as the "most incontestable Parisian woman."[12] They portrayed the *grisette* as a sixteen- to thirty-year-old working woman who "*gave* her sexual favors to young men of a 'better' and more 'elegant' class"—notably to middle-class students from the Latin Quarter.[13] She was not "a kept woman" or courtesan, but a hard worker who was supposedly happy to "live on the labor of [her] little fingers" because of her privilege of working with the "luxurious" and "artistic" trade of fashion or flowers. Mimi, the heroine of Puccini's opera *La Bohème* (1896), is a fictional illustration of this "elegant duchess of the street."

Another popular fictional theme at this time was that of the orphan

or solitary working woman. Lily Bart, Ruth Hilton, and Hester Prynne are orphans while Lucie Manette and Mary Barton are motherless daughters. Ironically, while authors Wharton and Gaskell endeavored to expose real-life problems of women confined in rigid social patterns, both—by creating unsuccessful apprentices—may unwittingly have increased the prevalent fear among females of failure in their society.

Theodore Dreiser and *Sister Carrie*

An American novel considered immoral when it appeared was written by the son of a devout Catholic German immigrant father and Pennsylvania-born Mennonite mother. Drawing on the example of his older sister's liaison with a married man and on the conventional theme of a small-town girl arriving in the big city, Theodore Dreiser opened *Sister Carrie* (1900)[14] with vivid images of young Carrie Meeber anxiously seeking employment in 1889 in Chicago.

> Into this important commercial region the timid Carrie went. . . . She walked bravely forward, led by an honest desire to find employment and delayed at every step by . . . a sense of helplessness amid so much evidence of power and force which she did not understand. (15)

At last Carrie notices a sign on a door of a firm which makes caps for boys: "Girls wanted—wrappers and stitchers." Going inside, she sees at workbenches young girls who are "drabby-looking creatures, stained in face with oil and dust, clad in thin, shapeless, cotton dresses and shod with more or less worn shoes." When a foreman appears, Carrie asks him, "Do you need any help?" "We like experienced help," he replies. "We've hardly got time to break people in. . . . We might, though, put you at finishing" (23).

Carrie passes up the chance to become a stitcher of caps, but in a shoe factory she quickly learns to operate a machine that punches eyeholes in leather for men's shoes. "It isn't hard to do," says the girl asked by a foreman to show the new girl "how to do what you're doing." Soon Carrie is attaching pieces of leather, one at a time, to clamps and then pushing a small steel rod at a machine which—with sharp, snapping clicks—cuts holes in the leather.

The pieces of leather came from the girl at the machine to her right, and were passed on to the girl at her left. Carrie saw at once that an average speed was necessary or the work would pile up on her and all those below would be delayed. She had no time to look about. . . . As the morning wore on the room became hotter. She felt the need of a breath of fresh air and a drink of water, but did not venture to stir. The stool she sat on was without a back or foot-rest. . . .[and she] could scarcely sit still. Her legs began to tire and she wanted to get up and stretch. Would noon ever come? (34-35)

On a rainy autumn day Carrie catches a bad cold, misses work, and loses her job. A traveling salesman, who remembers meeting the shy, young woman on the train bound for Chicago, chances to encounter Carrie again, and he's too sharp to miss an opportunity for his own gain when he finds her dispirited and out of work. "What are you going to do?" he inquires, quickly pulling some loose bills out of his vest pocket and offering them to her. "Let me help you," he says (57–58). He presses two ten-dollar bills into Carrie's hand, and the rest is easy to imagine. As a "kept woman," Carrie never again supports herself with anything remotely related to needlework. With publication of the notorious *Sister Carrie,* Dreiser, like Gaskell and Wharton, added to the belief—long current in society—that female needleworkers for hire were often only one step removed from the workhouse, prostitution, or suicide.

Many kinds of needlework were available to females in Chicago near the close of the nineteenth century. An investigator for the Knights of Labor, one of the first industrial-craft unions in America, reported in 1888 that in Chicago women were employed as shirtmakers, children's shirt operatives, cloakmakers, buttonmakers, corsetmakers, furriers, shoeworkers, dressmakers, gents' neckwearmakers, suspendermakers, and in producing knit goods, millinery, and even bookbinding. Few of the employed women were organized, according to the report, and "a great deal of dissatisfaction seemed to exist on account of small wages and arbitrary dealing. A seal plush cloak, selling from $40 to $75, is made by the cloakmakers of this city for 80 cents and $1 apiece, one being a day's work for an expert operative."[15]

Sewing, Surviving, and Getting Ahead

Many nineteenth- and early twentieth-century women and men worked in textile crafts and kept or helped to keep their families fed, housed, and clothed with their incomes. Some nurtured children who went on to achieve success built on their parents' example of disciplined work. Shy or bold, failures or successes, these individuals worked the needles in factories and in homes that were sewing together the legal, social, and economic fabric of a young nation. Their names now may be almost as unknown as are those of medieval embroiderers, yet the family histories of four widely recognized individuals suggest that, in recent memory, countless threadworkers have supported families in this and other lands.

In his famed *Autobiography* (1931), Lincoln Steffens recalls the experience of his immigrant mother, a seamstress gifted with "practical intelligence" who knew how to "earn a living . . . anywhere" in the 1860s:

> My mother . . . was an English girl who came from New York via the Isthmus of Panama to San Francisco in the sixties to get married. It was rumored about the east that the gold rush of '49 had filled California with men . . . who were finding there gold, silver, and everything else that they sought, excepting only wives. . . . My mother . . . knew that she, like all girls, wanted a husband . . . and took steps to find one. . . . She would go west. A seamstress, she could always earn a living there or anywhere.[16]

Elizabeth Steffens continued sewing after her son Lincoln was born, occasionally employing her thimble in his early days in a perhaps not unusual way for a mother trying to sew with a noisy child nearby.

> My mother . . . had a most annoying habit of thumping me on the head with her thimbled finger. . . . I would be playing Napoleon and as I was reviewing my Old Guard, she would crack my skull with that thimble . . . a thimble is a small weapon. But imagine Napoleon at the height of his power . . . getting a sharp rap on his crown from a woman's thimble.[17]

When comedian Charles Chaplin wrote the bittersweet story of his turn-of-the-century boyhood in London, he drew on memories of his widowed mother's efforts to support herself and two small children with needlework. She was expert with her needle and was able to earn a few shillings dressmaking. Even so, the single-parent family slowly "sank further into poverty." Installment payments on his mother's rented sewing machine fell behind, and it was taken away. She finally decided that their only means of survival would be to enter a workhouse even though she and the boys would be separated into the different wards for women and children. Chaplin remembered when the brothers were first allowed in the women's ward for a short time to see their mother: "From her apron she produced a bag of coconut candy which she had bought at the workhouse store with her earnings from crocheting lace cuffs for one of the nurses."[18]

Carl Sagan, a twentieth-century American scientist widely known for his work with NASA and his success on television, also had links to those who have earned their way in the company of threadworkers. Born in Brooklyn in 1934, Sagan was the son of a man who emigrated from the Ukraine and became a fabric cutter in a garment factory in the United States.[19] And the heritage of successful American author Francine du Plessix Gray includes the example of a wage-earning needleworker. In 1942 Francine, her Russian mother, and her stepfather emigrated from Paris to New York where Francine's mother "was soon sewing hats at Bendel's to make ends meet."[20] Her stepfather launched his own career and ultimately became an executive at *Vogue* and finally editorial director of *Condé Nast*.

Collars, Shoes, Shirtwaists, Dreams, and Daily Bread

An enterprising wife in Troy, New York, in 1827 invented a detachable shirt collar for men which could be washed, starched, and ironed without laundering an entire shirt. Soon after Hannah Lord Montague's detachable collar appeared, sewing machines were invented enabling workers to produce a variety of collars, cuffs, and shirts in factories in Troy. By the 1860s, Troy had become the nation's top producer of detachable collars and was known as Collar City. Historian Carole Turbin indicates that with the mechanization of collar-making:

the work process was divided into tasks that became associated with particular groups of workers. . . . [C]ollar cutters, usually men, were the most highly paid workers. Machine operatives included runners, who did straight stitching; turners, who turned collars inside out; and banders, who stitched, turned, and restitched bands attached to sewn collars. . . . Workers in different shops developed expertise appropriate for collars of different sizes, styles, quality, and materials.[21]

Entrepreneurs in Troy built commercial laundries to wash, starch, and iron men's collars in preparation for retailers both in this country and abroad; laundresses specialized in only one stage of the three-stage laundry process. While the collar-makers were predominantly second- or third-generation Americans, the laundresses were primarily Irish immigrants.[22] According to Turbin, Irish women and men were more likely than other working-class immigrants or native-born residents to expect women to work continuously throughout their lives.

Had Carrie Meeber been working as a shoemaker in the real world of Massachusetts, she would have been one among more than twenty-two thousand women shoeworkers employed in that state in the mid-nineteenth century. At that time, only female textile operatives outnumbered women manufacturing shoes in Massachusetts. Lynn was the center of the state's shoe industry. Before mechanization developed, "women worked at [hand]stitching and lining the upper halves of boots and shoes in their own kitchens," writes historian Thomas Dublin. "They worked for their shoemaker husbands, who took from them the bound shoe uppers and turned out completed shoes in their artisan workshops."[23] Women's handstitching of leather gave way to stitching by sewing machines during the 1850s and 1860s when stitching shops or factories began to develop in Lynn along with shoe machinery.

While textile mills, shoe factories, and collar manufacturers employed thousands of women and men in urban areas in the 1800s, less populated parts of the United States also needed expert seamstresses. In the iron-making area of western Pennsylvania, for example, sewing provided a reliable income for women seeking to earn a living. In Joseph E. Walker's history of Hopewell Village, one reads that while married women did most of the sewing for their families, men without wives needed the services of women who sewed for an income, and the

local iron furnace company itself employed women who did sewing. A certain Margaret Benson, writes Walker, was for six years paid a weekly wage for sewing, quilting, and making carpets for the company.[24] Benson supplemented her threadwork earnings by selling butter and dried peaches. Four male employees of the furnace company paid another seamstress, Margaret Cook, $11.50 in 1829, perhaps enough to cover her boarding costs for several months; she continued to earn money with her needles for the next four years.[25] Another woman in the community specialized in knitting and selling stockings. Records from the company store of Hopewell Village indicate that their inventory included supplies of buttons, trimmings, needles, pins, thimbles, scissors, and patterns.

In 1870, Nathalia and Julius Gumpertz and their four children occupied a small apartment in a building built in New York City by an immigrant from Saxony, Edward Glockner, who rented units to other immigrants. On October 7, 1874, Julius left the apartment for his job cutting heels at Levy's shoeshop on Dey Street. He never returned, and whether he was killed or chose to abandon his family is unknown. Afterward Nathalia supported her children by dressmaking. Today the Glockner building is the location for the Lower East Side Tenement Museum founded by Ruth J. Abram. The museum honors past generations of immigrants, many of whom were needleworkers.[26] Among its displays is an apartment occupied during the Great Depression by immigrants from Sicily, Adolfo and Rosaria Baldizzi, who are said to have "eked" out an existence. Adolfo worked as a mason; Rosaria sewed at home. A penciled notation on one of the doors in their apartment, which had been boarded up from 1935 until shortly before the museum opened in 1994, lists "200 pants, 400 collars, 600 shirts." This cryptic notation may suggest that Rosaria sewed at home on piecework for a manufacturer.

A short distance from Mr. Glockner's tenement building, twenty-year-old Celia Walker left for her job one morning in March 1911. She worked with some nine hundred others at the Triangle Shirtwaist Company. Her job was checking the finished shirtwaists stitched by other, mostly young, immigrant girls at 240 sewing machines on the ninth floor of a building near Washington Square. On the floor below Celia, a similar number of Triangle seamstresses also worked fourteen

hours daily producing the sheer lacy blouses that were then the rage of New York, Boston, and other cities.[27] The standard attire of thousands of young ladies employed in industry and commerce was a long tailored skirt set off by a sheer cotton blouse styled with tucks, darts, and frilly lace. Triangle outproduced all other shirtwaist firms in the States and had reached a million-dollar volume.

Celia's steps that morning led to one of two elevators which lifted her and other workers to the upper levels of the Triangle Shirtwaist Company. None of the ascending workers knew that before nightfall, one hundred forty-six of them would be dead or dying, victims of a fire which broke out in their workplace about 4:45 that afternoon, minutes after they were handed their pay envelopes. The blaze quickly spread through the piles of flimsy fabric, lace, and ribbons in the crowded workrooms. Desperate women, discovering the exit door on the ninth floor locked, the fire escape blocked, and the elevators jammed with people, began jumping from windows to the streets far below.

Celia Walker managed to reach one of the two elevators just as it began its slow, final descent to the street. Others around her began to jump onto the roof of the descending elevator. In his account of the Triangle fire, Leon Stein reports Celia's recollections of what happened at that moment:

> Behind me the girls were screaming. I could feel them pushing more and more. I knew that in a few seconds I would be pushed into the shaft. I had to make a quick decision. I jumped for the center cable. I began to slide down. I remember passing the floor numbers up to five. Then something falling hit me.[28]

Later in St. Vincent's Hospital, a nurse congratulated Celia for having had the presence of mind to "wrap something around her hands in order to save them from injury." Celia knew the real reason she had worn the fur muff: after having saved for weeks to buy it, "Fire or no fire, I wasn't going to lose that muff."[29]

Two years after the disastrous Triangle fire, the torch that lit up the dangerous working conditions for many seamstresses employed in New York City, Rosa Parks was born in the small Alabama town of Tuskegee, home of a school for blacks founded in 1881 by Booker T. Washington. Four decades later, Rosa Parks became nationally known after her arrest

launched the Montgomery Bus Boycott. Until her arrest, however, she had been a law-abiding citizen quietly earning a living as a seamstress. In a small, rural school, she learned before her eleventh birthday to sew, crochet, and knit as well as to read and write. She and her classmates also were taught to weave baskets out of corn shucks and pine needles. In order to continue schooling after the sixth grade, Rosa lived away from home and attended the privately operated Montgomery Industrial School where she swept floors, emptied wastebaskets, and cleaned blackboards to help pay her tuition. The school's domestic science classes emphasized cooking and sewing, including how to make garments. What she learned best, she wrote later, "was that I was a person with dignity and self-respect, and I should not set my sights lower than anybody else just because I was black. . . . I had learned [this] from my grandparents and my mother too. But what I had learned at home was reinforced by the teachers I had at . . . school."[30]

Rosa's evolving sense of dignity and self-respect reinforced her intelligence and her practical skill at needlework. This combination of traits equipped her for life much as similar assets had empowered the young English immigrant, Elizabeth Symes, a century earlier and Hester Prynne, the dauntless heroine in Hawthorne's novel of colonial American life. Starting work in a shirt factory when she was sixteen, Rosa alternated between domestic and seamstress work until the 1950s. At the time of her arrest in December 1955, for refusing to yield her seat to a white man on a public bus in Montgomery, she worked as an assistant tailor in a department store in that city. Her anonymity ended soon afterward and so did her job in the department store. By then the Montgomery Bus Boycott had begun under the leadership of Martin Luther King Jr. and other local black leaders; the civil rights March on Washington and the Selma-to-Montgomery March followed later along with the Civil Rights Act of 1964 and the Voting Rights Act of 1965. Through those turbulent years of change in American society, Rosa Parks continued to support herself at times with needle and thread even as invitations to speak, along with honors and awards, increasingly came to her from around the country. By 1992, when the story of her life was published, she had become known as the Mother of the Civil Rights Movement. In 1999, when she was eighty-six years old, the former assistant tailor was awarded the Congressional Gold Medal.[31]

Notes

1. Carole Turbin, *Working Women of Collar City: Gender, Class, and Community in Troy, New York, 1864–86* (Urbana: University of Illinois Press, 1992), pp. 8–9.

2. Elizabeth Gaskell, *Mary Barton: A Tale of Manchester Life* (New York: Penguin Classics, 1985). Subsequent quotations are from this edition; page numbers follow each quote.

3. Elizabeth Gaskell, *Ruth* (New York: Oxford University Press, 1985). Subsequent quotations are from this edition; page numbers follow each quote.

4. Michael Hiley, *Victorian Working Women: Portraits from Life* (Boston: David R. Godine, 1979), p. 11.

5. Ibid. The cartoon is reproduced on p. 25 of Hiley's book.

6. Ibid., pp. 24–25.

7. George Eliot, *The Mill on the Floss* (New York: Airmont Publishing Company, 1964), pp. 18–19.

8. Elizabeth von Arnim, *Elizabeth and Her German Garden* (London: Virago Modern Press, 1985), pp. 5–6.

9. Edith Wharton, *The Age of Innocence* (New York: Collier Books, Macmillan Publishing Company, 1986). Subsequent quotations are from this edition; page numbers follow each quote.

10. Tradition from at least the sixteenth century to World War I called for a bride and her family to have accumulated sheets, tablecloths, and other linens in chests or cupboards in preparation for marriage. The custom of accumulating linens in multiples of three, six, twelve, or more appeared in the eighteenth century when the wealthy counted by twelve dozen, just as Wharton illustrates in this passage. Fancy embroidery only made a trousseau richer. In nineteenth-century France, wealthy urban mothers had their daughters' linen stitched and embroidered by a linen maid or in a convent such as Clairvaux Abbey, while the poorest of rural unmarried young women went from house to house, begging pieces of linen with which to stitch their trousseaus. (See Françoise de Bonneville, *The Book of Fine Linen* (Paris: Falmmarion, 1994), pp. 20–24.)

11. Edith Wharton, *The House of Mirth* (New York: Penguin Classics, Viking Penguin Inc., 1986). Subsequent quotations are taken from this edition; page numbers follow each quotation.

12. Valerie Steele, *Paris Fashion: A Cultural History* (New York: Oxford University Press, 1988), p. 70.

13. Ibid., pp. 71–72.

14. Theodore Dreiser, *Sister Carrie* (New York: Oxford University Press, 1991). Subsequent quotes are taken from this edition; page numbers follow quotes.

15. From Leonora Barry, "Report of the General Investigator of Women's Work," in Knights of Labor General Assembly, *Proceedings,* 1888. Quoted by Ruth B. Moynihan, Cynthia Russett, and Laurie Crumpacker, eds., in *Second to None: A Documentary History of American Women,* Volume II, *From 1865 to the Present* (Lincoln: University of Nebraska Press, 1993), p. 85.

16. Lincoln Steffens, *The Autobiography of Lincoln Steffens* (New York: The Literary Guild, 1931), p. 4.

17. Ibid., pp. 92–93.

18. Charles Chaplin, *My Autobiography* (New York: Pocket Books, 1966), p. 19.

19. Marie Arana-Ward, "Carl Sagan," *The Washington Post,* January 9, 1994.

20. Marie Arana-Ward, "Francine Du Plessix Gray," *The Washington Post,* February 13, 1994.

21. Turbin, p. 24.

22. Kate Mullany, an Irish immigrant, is honored in Troy, New York, today for her role in organizing women's collar laundry workers in the 1860s. Sarah Booth Conroy, "Saluting a Half Century of Preserving the Past," *The Washington Post,* October 25, 1999.

23. Thomas Dublin, *Transforming Women's Work: New England Lives in the Industrial Revolution* (Ithaca: Cornell University Press, 1994), p. 119.

24. Joseph E. Walker, *Hopewell Village: The Dynamics of a Nineteenth Century Iron-Making Community* (Philadelphia: University of Pennsylvania Press, 1967), p 321.

25. Ibid., p. 322.

26. Michael T. Kaufman, "A Portal to Life in America," *The New York Times,* January 7, 1994.

27. A three-month walkout by 20,000 apparel workers in New York City in 1909 was the first mass strike by women in American history.

28. Leon Stein, *The Triangle Fire* (New York: J.B. Lippincott Company, 1962), p. 64.

29. Ibid., p. 65.

30. Rosa Parks [with Jim Haskins], *Rosa Parks: My Story* (New York: Dial Books, 1992), p. 49.

31. Lonnae O'Neal Parker, "A Token of Gratitude," *The Washington Post,* June 16, 1999.

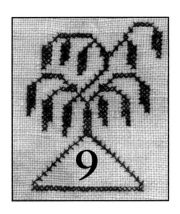

9

Fortunate Daughters and Sons

The mid-December opening of the movie *Gone With the Wind* in 1939 was a sensational Christmas gift to American moviegoers from Hollywood producer David O. Selznick. War had begun in Europe in September, and emotions on this side of the Atlantic wavered nervously between fear of being drawn into the conflict and hope that a military buildup here would lift the nation's economy, thereby ending the Depression. Into this uncertainty came the roguish Rhett Butler, the coquettish Scarlett O'Hara, and a flaming Atlanta, Georgia.

Six decades later, the American Film Institute ranked *Gone With the Wind* fourth in a listing of the top one hundred movies of the twentieth century.[1] On the other hand, in 1998 as the movie was released to theaters for the sixth time, one reviewer panned the film for being "long, stupid, ugly" and "probably the most beloved bad movie of all time."[2]

At its original release in 1939, the movie's exceptional length and highly advertised sensationalism added to its mystique and popularity as well as to its notoriety. But the public's desire to see *Gone With the Wind* was due even more to the popularity of the film's inspiration—a novel which had hit like a tidal wave three years earlier when bread lines and soup kitchens were a common sight in many American cities. Nearly seventeen percent of the workforce was unemployed, and the average wage of those with jobs was less than twenty-five dollars a week. Yet in

the second half of that year, over one million copies of the novel *Gone With the Wind* sold for the exceptionally high price of three dollars each, and the novel's previously unknown author received the unimaginable sum of $150,000 in royalties.

On the first day the book appeared in stores—June 30, 1936—some buyers snatched copies from other customers in their determination to get a first-edition copy before all were sold. The novel's young author, Margaret Mitchell, experienced instant national fame comparable in America's past only to that bestowed on Charles Lindbergh after his solo flight across the Atlantic.

A Rosewood Sewing Box

Although Margaret Mitchell had finished writing most of *Gone With the Wind*[3] before the Depression started in 1929, her tale of America's Civil War and Reconstruction days was about individuals who "had suffered crushing misfortunes and had not been crushed," about people who had not whined at their fate but had "hammered [the worst] into the best" (421). Thus the novel's theme of survival resonated with the deep hunger in 1930s Americans who wished to believe in their ability to overcome difficulties in another era of hard times. Mitchell's protagonists are members and friends of the wealthy O'Hara family, proud owners of Tara, a plantation in Georgia. They suffer unexpected defeat in the war and lose their former way of life. The postwar survivors in the family are led by the strong-spirited daughter, Scarlett, whose will to overcome adversity is reinforced by loving memories of her parents.

Needleworkers plying their craft rarely appear in this thousand-page novel, but their handwork is frequently presented. Consider the first paragraph of Mitchell's narrative:

> Scarlett O'Hara was not beautiful, but men seldom realized it when caught by her charm. . . . her magnolia-white skin . . . so carefully guarded with bonnets, veils and mittens against hot Georgia suns. . . . [s]he made a pretty picture. (3)

The bonnets, veils, and mittens might suggest sallow-faced young milliners, lace makers, and seamstresses like those working for Miss

Simmonds or Mme. Regina, but Mitchell omits references to the underworld of toilers who contribute to Scarlett O'Hara's charm.

In her opening scene, the author outfits Scarlett in a "new green flowered-muslin dress" with "twelve yards of billowing material" spread over hoops, and matching "flat-heeled green morocco slippers her father had recently brought her from Atlanta" (3). Before Scarlett goes out to charm the southern gentlemen gathered for prewar festivities at a neighbor's plantation, she spends two hours at Tara, trying on and rejecting dresses spread around her "on the floor, the bed, the chairs, in bright heaps of color and straying ribbons."

> The rose organdie with long pink sash. . . . The black bombazine, with its puffed sleeves and princess lace collar. . . . The lavender barred muslin . . . with those wide insets of lace and net about the hem. . . . The green plaid taffeta, frothing with flounces and each flounce edged in green velvet ribbon. . . . varicolored cotton dresses . . . ball dresses and the green sprigged muslin. (75)

Margaret Mitchell's lavish wardrobe descriptions appeared in print when ordinary American women were fortunate to own as many as two nice dresses. Young shop girls, who were no doubt among the primary buyers and readers of the thick novel, escaped momentarily from the realities of their macaroni-and-cheese lives into Scarlett's world of organdy and lace. And some were probably inspired by Scarlett's indomitable spirit to concentrate on devising means for surviving their own current hardships, secure in the belief that a better tomorrow would come for them.

Clothes and fabrics are the language Mitchell uses to convey information about other characters as well as to add colorful details that transport the reader into the nineteenth-century north-Georgia world of the novel. For example, early in the novel Scarlett flirts with the young Tarleton twins who are "clothed in identical blue coats and mustard-colored breeches" (3). As the twins and other young gentlemen in the South rush to enlist before a single battle brings a speedy end to the war, ladies begin making uniforms, knitting socks, and rolling bandages.

> Train loads of troops passed through Jonesboro daily on their way north. . . . Some detachments were gaily uniformed in the

> scarlets and light blues and greens of select social-militia companies; some small groups were in homespun and coonskin caps; others, ununiformed, were in broadcloth and fine linen. (129)

This initial flurry of uniform production contrasts with the subsequent shortages of rebel uniforms as the war drags on. When Scarlett's secret love, Ashley Wilkes, comes home on furlough at Christmas after the Confederates' defeat at Gettysburg in 1863, he arrives in a faded gray uniform that his slave-valet, Mose, who "never had a needle in his hand before the war," has patched with blue cloth cut from the uniform of a captured Yankee (267). Ashley's wife, Melanie, sees her husband looking "like a ragamuffin" and is all the more thankful for a length of gray broadcloth given her when gray wool for uniforms was "almost literally more priceless than rubies" (267). She hurriedly engages a tailor to make Ashley a new coat from the broadcloth, wishing she had enough cloth for britches too.

Scarlett's Christmas gift to the man she secretly loves is a small, flannel packet "containing the whole precious pack of needles Rhett [Scarlett's blockade-running admirer] had brought her from Nassau, three of her linen handkerchiefs, obtained from the same source, two spools of thread and a small pair of scissors" (269).

The foremost needleworker in Mitchell's tapestry of prewar affluence and wartime suffering is Scarlett's mother, Ellen Robillard O'Hara—someone with an answer for everything, who awes and soothes her daughter. Scarlett never sees her mother sit down "without a bit of needlework in her hands."

> It was delicate embroidery if company were present, but at other times her hands were occupied with Gerald's ruffled shirts, the girl's dresses or garments for the slaves. (40–41)

Scarlett cannot imagine her mother's hands "without her gold thimble." A small slave girl's only duty is to remove basting threads and carry a rosewood sewing box from room to room as Ellen O'Hara moves about the house "superintending the cooking, the cleaning and the wholesale clothes-making for the plantation" (41).

> Scarlett regarded her [mother] as something holy and apart from all the rest of humankind. . . . To her, Ellen represented

> the utter security that only Heaven or a mother can give. She
> knew that her mother was the embodiment of justice, truth,
> loving tenderness and profound wisdom. (60)

It is no wonder that after her mother's death and after war has ravaged the family's plantation, Scarlett shoots a Yankee marauder standing "in the door of the dining room . . . his pistol in one hand and, in the other, the small rosewood sewing box fitted with gold thimble, gold-handled scissors and tiny gold-topped acorn of emery" (440). Scarlett identifies the sewing box with her mother so profoundly that she feels as if the intruder has physically violated Ellen herself as he holds the fragile box in his rough hands. Without a word, she shoves a gun into the startled soldier's bearded face, pulls the trigger, and kills the man. The sewing box slips from his hand, its contents spilling about him as he falls to the floor.[4]

Ellen's thimble reappears when a number of Yankees ransack Tara, breaking china and mirrors, ripping mattresses and upholstery with swords, and taking what food they can find. As one of the soldiers questions Scarlett about valuables hidden elsewhere in the house as he turns a small, bright object in his hand:

> Scarlet saw it was Ellen's gold thimble that he held. How often she had seen it gleaming in and out of Ellen's fancy work. The sight of it brought back too many hurting memories of the slender hand which had worn it. There it lay in this stranger's calloused dirty palm and soon it would find its way North and onto the fingers of some Yankee woman who would be proud to wear stolen things. (467)

This time the gold thimble disappears from Tara forever, just as Ellen has.

Sunflowers on a Blue Background

Anna Quindlen's novel *One True Thing* (1994)[5] also contains forceful images of a needleworking mother and a strong-willed grown daughter. In Quindlen's book, the daughter is a career woman who belongs to post-1970s culture while the mother, Kate Gulden, has many of the good-as-gold traits which Margaret Mitchell's nineteenth-century novel associates with Ellen O'Hara. Kate's daughter, Ellen

Gulden, narrates the story of their relationship from her perspective eight years after the crisis at the novel's center. Throughout the novel, needlework is a symbol of Ellen's mother. Like the bare, rocky mountains and sagebrush in a John Ford Hollywood western, Kate's needlepoint and other handwork add emotions and sensory reality to the narrative without dominating its strong characters. Needlework also is symbolic of the daughter's deepening understanding of her mother.[6]

Harvard graduate Ellen comes home from her job as an editorial assistant in New York to care for her terminally ill mother and discovers that she had never really known her mother before coming home to watch her die. When Ellen is called home by her father, she returns "vaguely contemptuous" of her mother whose life has seemed to consist entirely of domestic pursuits such as embroidering pillows, caning chair seats, and refinishing furniture (17). In Ellen's view, Kate is someone who has "lived a domestic life double time" (24)—knitting while something was simmering on the stove. Kate has succeeded, Ellen admits, in making a modest house beautiful with her hard work: she has trimmed the rooms with hand stenciling, made a cushion for a wicker rocker on the front porch, refinished the antique oak table in the kitchen and cross-stitched their family tree on the sampler hanging above the table. This is the mother whom Ellen has scorned, the woman who has taken lifelong "pleasure . . . in making things pretty" (128).

When Ellen comes home at twenty-four, Kate knows her daughter well enough to suggest a project that will give shape to their days, one that "will guarantee" that Ellen won't be bored. Kate proposes that they read novels and discuss them with one another, forming what she playfully calls "the Gulden Girls Book Group." Together they go to Duane's Book Store and buy two paperback copies of each of three books: *Pride and Prejudice, Great Expectations,* and *Anna Karenina.* The books lead to a surprising discovery for Ellen and an opportunity for Kate finally to have "the relationship she had always imagined would accompany . . . the scrapbooks she kept of report cards . . . the hours she spent on birthday parties and Care packages to college and camp" (63). Through their weeks of reading and discussing situations imagined by Bronte, Dickens, and Tolstoy, it becomes clear to Ellen that house and handwork are not, as she once thought, Kate's "whole life."

These are merely the background for her life with her children and in her community.

Kate voices no dissatisfaction in these final months except the regret that she has failed her daughter over the years. Sewing eyelet night-gowns for her young daughter and making a canopy for Ellen's four-poster bed pleasured Kate, but she clearly has not been deeply happy in the past while psychologically and intellectually isolated from her daughter. Near the end of her life, she confesses to Ellen, "I think of how everything important you learned the first twenty-four [years] you learned from your father and not me, and it hurts my heart, to know how little I've gotten done" (170).

When Kate's cancer is diagnosed, she is still able to needlepoint—a blessing because she has always kept dozens of projects going at once. She immediately begins work on a needlepoint design of sunflowers on a blue background (40). As Kate's strength declines over the following months, Ellen takes up the needlepoint canvas and continues stitching the blue background of the sunflowers while her mother sleeps. After her mother's death, Ellen has the completed canvas made into a pillow at the shop where Kate had often bought fabric to finish off her needlework.

Eight years later the sunflower pillow is on the pullout couch in Ellen's tiny New York apartment. "Do you do needlepoint?" the occasional female guest asks (280). "No," replies Ellen, but the young doctor doesn't need to sew to experience her mother. Now an adolescent psychologist, she sees her mother in a different way:

> Whenever anyone is called a homemaker now — and they rarely are — I think of my mother. She made a home painstakingly and well. She made balanced meals, took cooking classes, cleaned the rooms of our home with a scarf tying back her bright hair, just like in the movies [B]ut we had so misunderstood her, this woman who had made us who we were while we barely noticed. (15, 285)

Anna Quindlen identifies the sunflower pillow as a primary symbol of the mature understanding and love that survives a mother's death. In this late-twentieth-century novel, threadwork reflects the timeless, biblical association of sewing and life itself.

Still Life in Old Quilts

The action in *Gone With the Wind* and *One True Thing* spans years, time enough for characters to develop deeper and fuller understandings of one another. In contrast, only one or two hours elapse in "Everyday Use," Alice Walker's short story about a mother and her two radically different grown daughters.[7] If any change is to occur, it must happen in the twinkling of an eye, and the author offers only staccato insights into the three characters in this family. The story's narrator is Mama, a self-educated, proud woman. She reflects on bittersweet memories of her elder daughter's recent trip home. Hungering love and heartbreaking anger mingle in Mama's narration as she contrasts the arrogant visitor, Dee, with the shy daughter, Maggie, who still lives at home. Two quilts become the catalyst for shearing the thin mantle of false conviviality in which college-educated Dee wraps herself as she sweeps in to take possession of family things she once rejected but now wants for her own pleasure.

Dressed in the latest fashion and bolstered by the company of a stranger, Dee arrives to find her overweight mother and foot-shuffling younger sister sitting under the elm tree in the hard clay yard. Awkward kisses on the forehead and clammy handshakes give way to a dinner of pork and collards. After dinner Dee walks to a trunk and starts "rifling through it." She pulls out two quilts and says sweetly, "Mama, can I have these old quilts?" (140) Both quilts, Mama remembers, are made of scraps of clothing worn by her mother and father fifty or more years ago and even a piece of an ancestor's Civil War uniform.

> They had been pieced by Grandma Dee and then Big Dee and me had hung them on the quilt frames on the front porch and quilted them. One was in the Lone Star Pattern. The other was Walk Around the Mountain. (140)

These simple woven and stitched threads form the line Mama draws in the sand. The daughter for whom Mama has worked and sacrificed to give advantages she never had herself, this daughter that Mama has hoped would one day express appreciation and affection to her mother, has only become increasingly self-centered, selfish, and unaware of what really matters in life. Mama has had enough of Miss Dee.

> Why don't you take one or two of the others? . . . These old
> things was just done by me and Big Dee from some tops your
> grandma pieced before she died. (140)

"No," answers her spoiled daughter. "I don't want those. Those are
stitched around the borders by machine." She claims for herself the
ones her grandma pieced, "all this stitching [done] by hand." A reader
can imagine Mama angrily thinking: "You fool! Me and my sister
worked side-by-side on those quilts. That means nothing to you!"

Accustomed to having her way, Dee holds the two quilts out of
Mama's reach, "clutching them closely to her bosom" (140). She is
oblivious to the line drawn in the sand. But Mama is unmoved by her
daughter's aggressiveness and determination. "The truth is," she speaks
up, "I promised to give them quilts to Maggie, for when she marries
John Thomas" (140). Dee protests that her sister is too backward to
appreciate the quilts, to know they are "art" and can hang on the wall.
Maggie, she says with disgust, would probably just "put them to every-
day use" on a bed and in less than five years "they'd be in rags" (141).

Thin and homely Maggie knows her sister's temper and, as fury
threatens to erupt over the old quilts, she attempts to broker peace
between Dee and Mama. Quickness passed her by, writes Walker. Yet
Maggie has learned to quilt, and she is gifted with common sense. She
leaves the dishpan in the kitchen and shuffles to the doorway, keeping
her eyes on the floor and trying to hide her scarred hands in the folds
of her dress as she speaks: "She can have them, Mama. . . . I can 'mem-
ber Grandma Dee without the quilts" (141). Mama looks at her
younger daughter, recalling it was Grandma Dee and Big Dee who
taught Maggie how to quilt with her scarred hands. A sudden epiphany
is evoked for Mama by her shy daughter's self-abnegation:

> When I looked at her like that something hit me in the top of
> my head and ran down to the soles of my feet. Just like when I
> am in church and the spirit of God touches me and I get happy
> and shout.(141)

Swiftly Mama does something she's never done before—she hugs the
soft-spoken Maggie. Next she snatches the quilts out of Dee's hands
and dumps them into Maggie's lap. Moments later, Dee is off with the
stranger, leaving the quilts, her mother, and Maggie behind.

The genius of Alice Walker's story lies in the author's perception of the unique human identity incarnate in each piece of threadwork and of the blasphemy implicit in failing to respect the sanctity and meaning of this incarnation. Threadwork, a reader may infer from Walker's few words, is not something merely to be admired primarily for its age or craft or beauty. Instead, from Mama's perspective, threadwork encompasses the mysterious uniqueness of those who weave, cut, and/or stitch it, and these crafters are resurrected when the living remember them. This is the eternal life which totally eludes Dee, who sees the old quilts only as objects that will rebound to her credit for owning and displaying them.

"The Ballad of the Harp-Weaver"

In 1923 the American poet Edna St. Vincent Millay was awarded the Pulitzer Prize for a poem that, as noted in an earlier chapter, evokes memory of the Welsh bard who wove the English king's shroud on a harp. "The Ballad of the Harp-Weaver"[8] is a portrait of a starving weaver and her young son; it conveys the essence of a mother's unselfish love combined with a threadworker's magic. The voices speaking in Millay's ballad are those of the weaver and her son:

> "Son," said my mother,/ When I was knee-high,/ "You've
> need of clothes to cover you,/ And not a rag have I.
>
> There's nothing in the house/ To make a boy breeches,/
> Nor shears to cut a cloth with/ Nor thread to take stitches.
>
> There's nothing in the house/ But a loaf-end of rye,/
> And a harp with a woman's head/ Nobody will buy. . . . "/

The night before Christmas, the freezing boy cries himself to sleep like a two year old. Then "in the deep night," he feels his mother rise and stare down upon him "with love in her eyes." He sees his mother sitting on the one good chair, the harp with a woman's head leans against her shoulder:

> Her thin fingers, moving/ In the thin, tall strings,/
> Were weav-weav-weaving/ Wonderful things.

> Many bright threads,/ From where I couldn't see,/
> Were running through the harp-strings/ Rapidly,
>
> And gold threads whistling/ Through my mother's hand,/
> I saw the web grow,/ And the pattern expand.

His mother is weaving a red cloak so regal he exclaims, "She's made it for a king's son, and not for me." A pair of breeches, a pair of boots, a little cocked hat, a pair of mittens, a little blouse. All night his mother weaves "in the still, cold house."

> She sang as she worked,/ And the harp-strings spoke;/
> Her voice never faltered,/ And the thread never broke.
> And when I awoke,—
>
> There sat my mother/ With the harp against her shoulder/
> Looking nineteen/ And not a day older,/A
> smile about her lips,/ And a light about her head,/ And
> her hands in the harp-strings/Frozen dead.
>
> And piled up beside her/And toppling to the skies,/
> Were the clothes of a king's son,/Just my size.

Although the fame of Millay's poem may have come and gone, her ballad has not lost its power to haunt. Her singular image of a loving weaver reflects the integrity and inner strength conveyed by other authors discussed above—Mitchell, Quindlen, and Walker—and by John Updike below. Additionally, Millay voices the deep gratitude of a son who remembers his mother's act of love and sacrifice.

From a Grandson's Perspective

The various chapters in this synthesis of documents, artifacts, myths, and memories linked to threadworkers have been drawn from sources attributed to both male and female authors and artists, yet the majority of sources have portrayed threadworkers who are women. The writer John Updike is no exception to this pattern. His personal reflection, "My Grandmother's Thimble," appeared in *The New Yorker* in the early 1960s.[9] The thimble was a wedding gift to Updike and his wife from his elderly grandmother when she was in her late seventies and enfeebled

with Parkinson's disease. At that time her clothes, her bed, and this silver thimble, a gift from her father elegantly inscribed with her maiden initials, were her last property. On a night several years after his grandmother's death, Updike chanced to come upon the tiny thimble.

> [I]t seemed incumbent upon me, necessary and holy, to tell how once there had been a woman who now was no more. . . . O Lord, bless these poor paragraphs, that would do in their vile ignorance Your work of resurrection.[10]

Updike associates his remembrance of his grandmother with her spiritual resurrection, a connection implicit, as suggested previously, in Alice Walker's short story. And in Updike's elegy, just as in Margaret Mitchell's novel, a needleworker's thimble is intimately identified with its original owner who now is gone. The night that Updike comes across the thimble, he feels at his back "a steep wave about to break over the world and bury us and all our trinkets . . . [I]t is this imminent catastrophe that makes it imperative for me to cry now, in the last second when the cry will have meaning, that once there was a woman . . . [who] was unique."[11]

The threadworkers in the five works considered above are silhouetted against threatening dark clouds. Ellen O'Hara's genteel world of order, security, and conferred privilege disappears violently in war; while her daughter goes forth with trepidation into the harsh, new world, she goes with a legacy of memories of Ellen's steadfast diligence. Kate Gulden's world also vanishes—a homemaker's world of balanced meals, lovely needlepoint pillows, and scrapbooks of fine report cards. A visual symbol of her mother's courage and values fortifies Kate's daughter in her helter-skelter world of moral ambiguities, of beepers interrupting rare evenings away from her medical practice, of an apartment with a small stove and refrigerator hidden by louvered doors in a closet. Pampered, self-absorbed Dee has failed to follow her mother's example of self-denial, yet her mother's common sense, fortitude, and hope endure in Maggie, the least of Mama's daughters. In Millay's poem, death comes for the impoverished harp weaver, but not before she clothes her son. John Updike continues this pattern of associating heroic individuals—who happen to be threadworkers—with a world that is vanishing. A catastrophe is imminent, he writes. (The Vietnam war was already in the wind in 1962 when his remembrance appeared in print.)

A steep wave is about to break over us, he warns. Before memories of his grandmother disappear under the flood, Updike resurrects her younger days and his own youth. A theme weaves its way through the narratives penned by the five authors: hold fast to memories of someone who had dreams and courage, who also cherished you.

A number of names can be recalled as we near the end of this survey of literary and historical threadworkers. Mysterious Eve and defiant Anna Brangwen. Penelope, the faithful wife. Madame Defarge, the tragic revolutionary. Hester Prynne, the abandoned mother. Hannah Lord Montague, the innovative collar lady. Rosa Parks who altered garments and the world around her. Although these individuals are exceedingly different in some respects, a common thread runs through their stories: they all look to the future. Indeed, their work in and of itself is forward looking. In contrast to lilies of the field which "take no thought for the morrow," threadworkers spin, weave, and sew for tomorrow as well as for today.

Looking Ahead

The long-range implications of technological changes and economic globalism for future literary images of threadworkers are impossible to forecast. Will writers pen sentimentalized stories in the twenty-first century about the textile mills and garment factories of Indonesia, Peru, and elsewhere? About the popular American quilting guilds of the late twentieth century? Will increasing numbers of writers look back with longing to "simple times?" To a world that has vanished? Or will some be writing futuristic fantasies about tennis shoe and soccer ball factories on Mars? Already the National Aeronautics and Space Administration (NASA) has announced its hopes to put man on Mars early in the twenty-first century. NASA's hopes are boosted by researchers at North Carolina State University who are working on a spacecraft made of composite textiles that would save one-third the weight of metals. Scientists at other American, European, and Japanese centers are also working on composite, or 3-D, textiles which are "specially woven or braided carbon fibers encased in graphite or epoxy." The fibers are woven and braided into three-dimensional shapes and could make composite textiles useful "in specific areas of stress, such as joints, which make up a large proportion of a spacecraft's weight."[12]

The Hubble Space Telescope has already signaled that threadwork and its products can be useful when an irreplaceable instrument three hundred fifty miles above the earth is "falling apart."[13] On February 17, 1997, two Discovery astronauts, Mark Lee and Steven Smith, "gathered parachute cord, alligator clips, and spare thermal blankets" in preparation for a four-hour spacewalk "to repair tattered insulation peeling away from the critical equipment bays" on the $3.1 billion Hubble Space Telescope. One side of the telescope was "cracking all over the place. . . . To repair one particular spot would just totally open up a few more." Thus engineers on the ground advised the astronauts to install "thermal blankets" over places on the telescope where insulation had peeled away. Amazing though it was, when a spacecraft—the epitome of Information Age technology—showed signs of wear and tear, its repair was facilitated with an adaptation of the simple craft introduced in the story of Eden.

In truth, times have never been simple for the laboring needleworker. Particularly not for the handcrafter or fiber artist. Beginning a project which one can foresee will require hundreds of solitary hours—with head bowed and body hunched forward, the better to see the intricate work; with gnarled fingers calloused from pushing sharply pointed needles or shuttles through threads—has likely always been a somber undertaking. An elderly Mennonite quilter, who had accepted a commission to hand-quilt an elaborate design on a king-size, white-work quilt, looked at the blank fabric and said softly: "I am almost afraid to start something that will take me so long to finish." Her visitor listened in respectful silence, knowing that the words reflected mature experience rather than greenhorn ignorance. The eighty-year-old quilter spoke with a hushed voice, as if she had forgotten anyone was standing nearby, as if she knew a long, familiar journey by hand lay ahead of her, and as if she remembered that her days would become lonely and her body weary before she reached her destination at some almost unforeseeable future date. This threadworker—like the artist or poet, musician or playwright—enters her work and becomes part of the design which, when completed, is beautifully highlighted by thousands of tiny stitches, immobile in midsummer sunlight and holding firmly on cold winter evenings.

Those who know from personal experience that the way to an embroidered, woven, or quilted masterwork is arduous and long stand

in awe of the finished creation, whether it is the Tree of Jesse embroidered on a thirteenth-century orphrey or a late twentieth-century piece of needle lace. The marvel is not simply the age or beauty of the item before us but the character of its maker who is the recipient of Athena's gift: "a genius for lovely work and a fine mind, too." Museum staffers may preserve the masterpieces, but it is the threadworkers themselves who are, as the Japanese say, national treasures. In many instances, identities of the artisans are lost long before their work appears in a museum collection, but the artisans deserve recognition in their own time and to be remembered with their work.

Fortunately, one can find today occasional instances of museum staffs making such recognition possible. Consider the example of the Victoria and Albert Museum in 1997. An interior courtyard of the museum was transformed by a startling exhibit of twenty-two opulent tent panels of Mogul art, which forty groups of needleworkers in Britain and in Bangladesh, Dubai, India, Ireland, Pakistan, South Africa, and the United States, designed and stitched.[14] The artistic textile display evolved from the ideas of Shireen Akbar, a museum staffer who had earlier invited South Asian women and girls living in London to visit the museum's gallery of Indian art. Encouraged to sketch objects they saw on display, some of the women began to associate the nomadic tent motifs in sixteenth-century Mogul miniatures with their own temporary dwellings in refugee communities. Soon the women began stitching tent panels depicting their present circumstances as well as their past histories, intermingling typical scenes from Mogul art with renditions of Big Ben and English manor houses. Their work spread by word of mouth to women living elsewhere, and the project was said to provide "the cultural soil from which true art springs."

Employing both traditional needlework stitches and innovative techniques, the women found the experience, in some instances, changed their lives. A woman from India reportedly wrote in the caption for one panel in the Victoria and Albert exhibit: "Today the life of my family hangs by the thread I embroider." Threadworkers might have written such words, as we have seen, during any century of human history. It is difficult to imagine a time in the future when words such as these will have lost the meaning they have had since the earliest of times.

More frequently than museum exhibits, however, reading may invite us to reflect on the many splendored crafts of threadworkers.

When we read references to Athena and Penelope, to Eve and Hester Prynne, to Ellen O'Hara or Kate Gulden, to medieval silks and ecclesiastical embroideries, to tapestries and to threadworkers in all lands, we are called to remember that human hands created this portion of our heritage, one thread at a time.

Notes

1. Richard Cohen, "The Books of Our Lives," *The Washington Post*, July 23, 1998.

2. Stephen Hunter, "Burn, Tara, Burn!" *The Washington Post*, June 28, 1998.

3. Margaret Mitchell, *Gone With the Wind* (New York: The Macmillan Company, 1936). Subsequent quotations are from this edition; page numbers follow each quote.

4. In the 1939 film adaptation of Michell's novel, jewelry rather than sewing implements spill from the box in the marauder's hands.

5. Anna Quindlen, *One True Thing* (New York: Random House, 1994). Subsequent quotes are from this edition; page numbers follow each quote.

6. The 1998 film adaptation of Quindlen's novel refers only indirectly to needlework, displaying it unobtrusively in bed quilts and crocheted caps Kate wears during her final days.

7. Alice Walker, "Everyday Use" (See: Christine Park and Caroline Heaton, eds., *Close Company: Stories of Mothers and Daughters* (New York: Ticknor & Fields, 1989), pp. 133–142. Subsequent quotations are from this edition; page numbers follow each quote.

8. Edna St. Vincent Millay, *Collected Poems,* ed. by Norma Millay (New York: Harper, 1956).

9. John Updike, "The Blessed Man of Boston, My Grandmother's Thimble, and Fanning Island," in *The New Yorker*, January 13, 1962.

10. Ibid., p. 28.

11. Ibid., p. 32.

12. Laurent Belsie, "Man May Go to Mars in a Textile Spacecraft," *The Christian Science Monitor*, December 1, 1993.

13. William Harwood, "Shuttle Crew Set for Final Fix-It Stroll," *The Washington Post*, February 18, 1997.

14. Paula Deitz, "Mogul Art: Tribute in Textiles," *The International Herald Tribune*, August 26, 1997.

Bibliography

The Bible. New Revised Standard Version. Nashville: Thomas Nelson Publishers, 1989.

The Bible. Authorized King James Version. New York: Collins' Clear-Type Press, 1941.

The British Poets, vol. LIII. Cheswick: C. Whittingham, College House, 1822 edition.

Ackerman, Phyllis. *Tapestry, the Mirror of Civilization.* New York: Oxford University Press, 1933.

Ackroyd, Peter. *Dickens.* New York: Harper Collins Publishers, 1990.

Adair, John. *The Pilgrims' Way: Shrines and Saints in Britain and Ireland.* London: Thames and Hudson, 1978.

Adams, Henry. *Mont-Saint-Michel and Chartres.* New York: Houghton Mifflin Company, 1933. First published, 1905.

Albrecht-Carrie, Rene. *Europe Since 1815: From the Ancien Regime to the Atomic Age.* New York: Harper & Brothers, 1962.

Alcott, Louisa M. *Little Women.* New York: Grosset & Dunlap, by arrangement with Little, Brown and Co., 1915. First published, 1868.

Amsden, Charles Avery. *Navaho Weaving: Its Technic and History.* Glorieta, N. M.: The Rio Grande Press, Inc., 1990. First printed, 1934.

Amt, Emilie. *Women's Lives in Medieval Europe.* New York: Routledge, 1993.

Ascher, Marcia and Robert. *Code of the Quipu: A Study in Media, Mathematics, and Culture.* Ann Arbor: University of Michigan Press, 1981.

Astor, Brooke. *Patchwork Child: Early Memories.* New York: Random House, 1993. First published, 1962.

Atkins, Elizabeth. *Edna St. Vincent Millay and her Times.* Chicago: University of Chicago Press, 1936.

Barber, E.J.W. *Prehistoric Textiles.* Princeton, N.J.: Princeton University Press, 1991.

Barber, Elizabeth Wayland. *Women's Work: the First 20,000 Years.* New York: W.W. Norton & Co., 1994.

Bartlett, Virginia K. *Keeping House: Women's Lives in Western Pennsylvania, 1790-1850.* Pittsburgh: University of Pittsburgh Press, 1994.

Bedell, Madelon. *The Alcotts: Biography of a Family.* New York: Clarkson N. Potter, Inc. Publishers, 1980.

Bemmett, Anna G. *Five Centuries of Tapestry: From the Fine Arts Museums of San Francisco.* San Francisco: The Fine Arts Museums of San Francisco, 1976.

Benn, Elizabeth, ed. *Treasures from the Embroiderers' Guild Collection.* London: E.G. Enterprises Ltd, 1991.

Bennett, Judith M. and Amy M. Froide, eds. *Singlewomen in the European Past, 1250-1800.* Philadelphia: University of Pennsylvania Press, 1999.

Bennett, Judith M., et. al. *Sisters and Workers in the Middle Ages.* Chicago: The University of Chicago Press, 1989.

Bennett, Judith M. *Women in the Medieval English Countryside: Gender and Household in Brigstock Before the Plague.* New York: Oxford University Press, 1987.

Bernstein, David J. *The Mystery of the Bayeux Tapestry.* Chicago: University of Chicago Press, 1986.

Bier, Carol, ed. *Woven from the Soul, Spun from the Heart: Textile Arts of Safavid and Qajar Iran (16th-19th Centuries).* Washington, D.C.: The Textile Museum, 1987.

Blackstone, Bernard. *English Blake.* Cambridge: Cambridge University Press, 1949.

Blake, William. *Songs of Innocence and of Experience: Showing Two Contrary States of the Human Soul.* New York: The Orion Press (in association with the Trianon Press, Paris), 1967.

Bloom, Harold, Lionel Trilling, Frank Kermode, and John Hollander, eds. *The Oxford Anthology of English Literature,* vol II. New York: Oxford University Press, 1973.

Boak, Arthur E.R. *A History of Rome to 565 A.D.* New York: The Macmillan Company, 1947.

Bonar, Eulalie H., ed. *Woven by the Grandmothers: Nineteenth Century Navajo Textiles from the National Museum of the American Indian.* Washington: Smithsonian Institution Press, 1997.

——. *British Museum Guide.* London: British Museum Publishers, Inc., 1976.

Brittin, Norman A. *Edna St. Vincent Millay.* New York: Twayne Publishers, Inc., 1967.

Bronowski, J. *William Blake and the Age of Revolution.* New York: Harper & Row, Publishers, 1965.

Brown, Peter. *The Cult of the Saints: Its Rise and Function in Latin Christianity.* Chicago: University of Chicago Press, 1981.

Bruce, Evangeline. *Napoleon and Josephine: The Improbable Marriage.* New York: Scribners, 1995.

Bullock, Alice-May. *Lace and LaceMaking.* London: B.T. Batsford Ltd., 1991. First published, 1981.

Burns, Robert. *Complete Works of Robert Burns,* vols. II and IV. Philadelphia: Gebbie & Co., 1886.

——. *The Poems and Songs of Robert Burns,* vol. III commentary. James Kinsley, ed. Oxford: The Clarendon Press, 1968.

Bythell, Duncan. *The Handloom Weavers: A Study in the English Cotton Industry During the Industrial Revolution.* Cambridge: Cambridge University Press, 1969.

Cantor, Norman, F. *The Medieval Reader.* New York: HarperCollins Publishers, 1994.

Caro, Ina. *The Road from the Past: Traveling Through History in France.* New York: Harcourt Brace & Company, 1994.

Carter, Phyllis Ann (pseud. for Irmengarde Eberle). *Spin, Weave and Wear: the Story of Cloth.* New York: R. M. McBride & Co., 1941.

Chaplin, Charles. *My Autobiography.* New York: Pocket Books, 1966. First published by Simon and Schuster, 1964.

Chaucer, Geoffrey. *The Legend of Good Women.* Trans. by Ann McMillan. Houston: Rice University Press, 1987.

——. *Chaucer's Canterbury Tales: An Interlinear Translation.* Trans. by Vincent F. Hopper. Woodbury, New York: Barron's Educational Series, Inc., 1948.

Chesnut, Mary Boykin. *A Diary from Dixie.* Ben Ames Williams, ed. Boston: Houghton Mifflin Company, 1949.

Cheyney, Edward. *The Dawn of a New Era: 1250-1453.* New York: Harper & Row, 1962. First published, 1936.

Christie, A.G.I. *English Medieval Embroidery.* Oxford: Oxford University Press, 1938.

Clayton, Muriel. *Catalogue of Rubbings of Brasses and Incised Slabs.* London: Victoria & Albert Museum, 1968.

Comte, Suzanne. *Everyday Life in the Middle Ages.* Trans. by David Macrae. Geneve: Minerva S.A., 1978.

Conway, Jill Ker Conway, ed. *Written by Herself.* New York: Random House, Inc., 1992.

Dalton, Ormonde Maddock. *East Christian Art: A Survey of the Monuments.* Oxford: The Clarendon Press, 1925.

Daniell, David. *William Tyndale.* New Haven, Conn.: Yale University Press, 1994.

Davis, Natalie Zemon. *Women on the Margins: Three Seventeenth Century Lives.* Cambridge, Mass: Harvard University Press, 1995.

de Bonneville, Françoise. *The Book of Fine Linen.* Trans. by Deke Dusinberre. New York: Flammarion, 1994.

Denny, Norman and Josephine Filmer-Sankey. *The Bayeux Tapestry: The Story of the Norman Conquest.* New York: Atheneum, 1966.

Dickens, Charles. *A Tale of Two Cities.* Philadelphia: David McKay Company, 1920. First published, 1859.

Dodds, Jerrilynn D., ed. *Al-Andalus: The Art of Islamic Spain*. New York: The Metropolitan Museum of Art, 1992.

Dodwell, Charles Reginald. *Anglo-Saxon Art: A New Perspective*. Ithaca: Cornell University Press, 1982.

Dreiser, Theodore. *Sister Carrie*. Oxford: Oxford University Press, 1991. First published by Doubleday, Page & Co., 1900.

——. *Jennie Gerhardt*. New York: Viking Penguin Inc., 1989. First published by Harper & Bros., 1911.

Dublin, Thomas. *Transforming Women's Work: New England Lives in the Industrial Revolution*. Ithaca: Cornell University Press, 1994.

Dudgeon, Phyl, et. al. *The Parliament House Embroidery: A Work of Many Hands*. Canberra: Australian Govt. Public Service, 1988.

Edwards, Anne. *The Road to Tara: the Life of Margaret Mitchell*. New Haven, Conn.: Ticknor & Fields, 1983.

Egbert, Virginia Wylie. *On the Bridges of Mediaeval Paris: A Record of Early Fourteenth Century Life*. Princeton, N.J.: Princeton University Press, 1974.

Eliot, George. *The Mill on the Floss*. New York: Airmont Publishing Co., Inc., 1964. First published, 1860.

Emery, Irene. *The Primary Structures of Fabrics: an Illustrated Classification*. Washington, D.C.: The Textile Museum, 1980. First published, 1966.

Erdman, David V. Blake, *Prophet Against Empire: A Poet's Interpretation of the History of His Own Times*. Princeton, N.J.: Princeton University Press, 1969.

Estep, William R. *The Anabaptist Story*. Grand Rapids: William B. Eerdmans, 1975. First published by Broadman Press, 1963.

Evans, Joan. *Life in Medieval France*. New York: Phaidon Press, Ltd., 1969. First published, 1925.

Finley, M. I. *The World of Odysseus*. New York: Viking Press, 1978.

Finley, Ruth E. *Old Patchwork Quilts and the Women Who Made Them*. Philadelphia: J. B. Lippincott Co., 1929.

Fitton, J. Lesley. *The Discovery of the Greek Bronze Age*. Cambridge, Mass.: Harvard University Press, 1996.

FitzGibbon, Kate and Andrew Hale. *Ikat*. London: Laurence King Publishing, 1997.

Ford, Franklin L. *Europe: 1780-1830*. New York: Rinehart and Winston, Inc., 1970.

Freeman, Margaret B. *The Unicorn Tapestries*. New York: The Metropolitan Museum of Art, 1976.

Furlong, William R. and Byron McCandless, with assistance of Harold D. Langley. *So Proudly We Hail: The History of the United States Flag*. Washington, D.C.: Smithsonian Institution Press, 1981.

Gaskell, Elizabeth. *Wives and Daughters*. Oxford: Oxford University Press, 1989. First published serially 1864–66.

——. *Mary Barton*. London: Penguin Books, 1970. First published, 1848.

——. *Ruth*. Oxford: Oxford University Press, 1985. First published, 1853.

Gaunt, William. *Flemish Cities: Their History and Art*. New York: G.P. Putnam's Sons, 1969.

Geijer, Agnes. *A History of Textile Art*. London: Pasold Research Fund in association with Sotheby Parke Bernet; Philip Wilson Publishers Ltd., 1979.

Gies, Frances and Joseph. *Cathedral, Forge, and Waterwheel: Technology and Invention in the Middle Ages*. New York: HarperCollins Publishers, 1994.

Gillow, James and Nicholas Barnard. *Traditional Indian Textiles*. London: Thames and Hudson Ltd., 1991.

Giraud-Labalte, Claire. *The Apocalypse Tapestry*. Ouest, France: CNMHS Editions, 1996.

Grant, Michael. *Myths of the Greeks and Romans*. New York: New American Library, Inc., 1962.

Gray, James. *Edna St. Vincent Millay*. (Pamphlets of American Writers, Number 54). Minneapolis: University of Minnesota Press, 1967.

Green, Peter. *Ancient Greece: A Concise History*. London: Thames and Hudson, 1973.

Gullickson, Gay L. *Spinners and Weavers of Auffay: Rural Industry and the Sexual Division of Labor in a French Village, 1750-1850*. Cambridge, England: Cambridge University Press, 1986.

Guthke, Karl S. *Last Words: Variations on a Theme in Cultural History*. Princeton: Princeton University Press, 1992.

Halperin, John. *The Life of Jane Austen*. Baltimore: The Johns Hopkins Press, 1984.

Hamilton, Edith. *Mythology*. New York: New American Library, Inc., 1963.

Harris, Jennifer, ed. *Textiles: 5,000 Years*. New York: Harry N. Abrams, Inc. Publishers, 1993.

Haskell, Francis. *History and Its Images: Art and the Interpretation of the Past*. New Haven: Brasseys, 1997.

Hauptmann, Gerhart. *The Weavers. Hannele. The Beaver Coat*. Trans. by Horst Frenz and Miles Waggoner. New York: Rinehart, 1951.

Hawkes, Jacquetta. *The Atlas of Early Man*. London: Macmillan London Limited, 1976.

——. *Dawn of the Gods*. London: Chatto & Windus, 1968.

Hawthorne, Julian. *Nathaniel Hawthorne and his Wife*, vols. I and II.. Boston: Ticknor and Company, 1888.

Hawthorne, Nathaniel. *The Scarlet Letter*. New York: The Heritage Club Edition, 1938. First published, 1850.

Hearder, H. *Europe in the Eighteenth Century: 1830-1880*. New York: Holt, Rinehart and Winston, Inc., 1966.

Hiley, Michael. *Victorian Working Women: Portraits from Life*. Boston: David R. Godine Publisher, 1979.

Homer. *The Iliad*. Trans. by Robert Fagels. New York: Viking, 1990.

——. *The Odyssey.* Tr. by Robert Fagels. New York: Viking, 1996.

——. *The Odyssey.* Trans. by William Cullen Bryant. Boston: Houghton, Mifflin and Co., 1899.

——. *The Odyssey.* Trans. by E.V. Rieu. Baltimore: Penguin Books, 1946.

——. *The Iliad and the Odyssey of Homer.* Trans. by Richmond Lattimore. Chicago: Great Books of the Western World/ Enclyclopedia Britannica, Inc., 1990. First edition published, 1952.

——. *The Iliad.* Trans. by E.V. Rieu. New York: Penguin Books, 1950.

——. *The Iliad of Homer.* Trans. by William Cullen Bryant. Boston: Houghton Mifflin Co., 1898.

Hood, Thomas. *The Complete Poetical Works.* Walter Jerrold, ed. Westport, Conn.: Greenwood Press, 1980. First published by Oxford University Press, 1920.

Houilan, Patrick, et. al. *Harmony by Hand: Art of the Southwest Indians.* San Francisco: Chronicle Books, 1987.

Hufton, Olwen. *The Prospect Before Her: A History of Women in Western Europe,* vol. I, 1500–1800. New York: Alfred A. Knopf, 1996.

Hunter, George Leland. *Tapestries: Their Origin, History & Renaissance.* New York: John Lane Company, 1912.

Irwin, John. *The Kashmir Shawl.* London: Victoria & Albert Museum in association with Her Majesty's Stationery Office, 1973.

Jackson, Anna. *Japanese Country Textiles.* New York: Weatherhill, Inc., 1997.

Jarry, Madeleine. *World Tapestry from Its Origins to the Present.* New York: G.P. Putnam, 1968.

Jensen, Joan M. and Sue Davidson,. *A Needle, A Bobbin, A Strike.* Philadelphia: Temple University Press, 1984.

Jerde, Judith. *Encyclopedia of Textiles.* New York: Facts On File, Inc., 1992.

Jones, Tom B. *Paths to the Ancient Past: Applications of the Historical Method to Ancient History.* New York: The Free Press, 1967.

Jones, David E. *Women Warriors: A History.* Washington: Brasseys, 1997.

Josephson, Hannah. *The Golden Threads: New England's Mill Girls and Magnates.* New York: Russell & Russell, 1949.

Kahn, David. *Seizing the Enigma: the Race to Break the German U-Boat Codes, 1939-1943.* Boston: Houghton Mifflin Co., 1991.

Kennedy, Charles W., trans. *Beowulf, the Oldest English Epic.* New York: Oxford University Press, 1940.

Kermode, Frank and John Hollander, eds. *The Oxford Anthology of English Literature,* vol I. New York: Oxford University Press, 1973.

Kisch, Herbert. *From Domestic Manufacture to Industrial Revolution: The Case of the Rhineland Textile Districts.* New York: Oxford University Press, 1989.

Knox, Bernard, ed. *The Norton Book of Classical Literature.* New York: W.W. Norton & Company, 1993.

Kollwitz, Hans, ed. *The Diary and Letters of Käethe Kollwitz.* Trans. by Richard

and Clara Winston. Evanston, Illinois: Northwestern University Press, 1988. First published by the Henry Regnery Co., 1955.

Kranzberg, Melvin and Joseph Gies. *By the Sweat of thy Brow: Work in the Western World*. New York: G.P. Putnam's Sons, 1975.

Kranzberg, Melvin and Carroll W. Pursell, editors. *Technology in Western Civilization*, vols. I and II. New York: Oxford University Press, 1967.

Kugel, James L. *The Bible as it Was*. Cambridge, Mass.: The Belknap Press of Harvard University Press, 1997.

Lambdin, Laura C. and Robert T. Lambdin, eds. *Chaucer's Pilgrims*. Westport, Conn.: Greenwood Press, 1996.

Langland, William. *The Vision of Piers Plowman*. Rendered into Modern English by Henry W. Wells. New York: Sheed and Ward, 1945.

Latourette, Kenneth Scott. *A History of the Expansion of Christianity*, vol.1, *The First Five Centuries*. New York: Harper and Brothers Publishers, 1937.

Lawrence, D. H. *The Rainbow*. New York: Viking, 1974. First published, 1920.

Le Goff, Jacques. *Time, Work & Culture in the Middle Ages*. Trans. by Arthur Goldhammer. Chicago: University of Chicago Press, 1980.

Lefkowitz, Mary R. and Maureen B. Fant. *Women's Life in Greece & Rome*. Baltimore: The Johns Hopkins University Press, 1982, 1992.

Levy, Santina M. *Lace: A History*. London: The Victoria & Albert Museum in association with W.S. Maney & Son Ltd., 1990. First published, 1983.

Lewis, R.W.B. and Nancy Lewis. *The Letters of Edith Wharton*. New York: Collier Books, Macmillan Publishing Company, 1989.

Lewis, R.W.B. *Edith Wharton: A Biography*. New York: Harper & Row, 1975.

Lipson, Ephraim. *A Short History of Wool and its Manufacture (Mainly in England)*. London: William Heinemann Ltd., 1953.

Lunt, W.E. *History of England*. Fourth Edition. New York: Harper & Brothers, 1957.

Lynn, John A. *Giant of the Grand Siecle: The French Army, 1610-1715*. Cambridge, England: Cambridge University Press, 1997.

MacKinney, Loren Carey. *The Medieval World*. Sixth Edition. New York: Rinehart & Company, Inc., 1955.

Martin, Thomas R. *Ancient Greece: From Prehistoric to Hellenistic Times*. New Haven, Conn.: Yale University Press, 1996.

Maurer, Warren R. *Gerhart Hauptmann*. Boston: Twayne Publishers, 1982.

McNeill, William H. *Venice, the Hinge of Europe, 1081-1797*. Chicago: The University of Chicago Press, 1974.

—— *The Rise of the West*. Chicago: University of Chicago Press, 1963.

Mellow, James R. *Nathaniel Hawthorne and His Times*. Boston: Houghton Mifflin Co., 1980.

Meyers, Carol. *Discovering Eve: Ancient Israelite Women in Context*. New York: Oxford University Press, 1991. First published, 1988.

Miles, Miska. *Anne and the Old One*. Boston: Little, Brown and Company, 1971.

Millay, Edna St. Vincent. *Collected Poems*. Norma Millay, ed. New York: Harper, 1956.

Miller, Malcolm. *Chartres Cathedral*. Andover, Hants.: Pitkin Pictorials, 1985.

Milton, John. *Paradise Lost*. S. Elledge, ed. New York: Norton, 1975.

Mitchell, Margaret. *Gone With the Wind*. New York: Macmillan Co., 1936.

Moers, Ellen. *Literary Women: The Great Writers*. Garden City, N.J.: Doubleday & Company, Inc., 1976.

Moynihan, Russett, and Crumpacker, eds. *Second to None: A Documentary History of American Women*, volume II: *From 1865 to the Present*. Lincoln: University of Nebraska Press, 1993.

Morris, Lloyd. *The Rebellious Puritan: Portrait of Mr. Hawthorne*. New York: Harcourt, Brace & Company, 1927.

Muel, Francis. *Tenture de l'Apocalypse d'Angers: l'Envers & l'Endroit*. Pays de la Loire: Inventaire General, 1990.

Muhlenfeld, Elizabeth. *Mary Boykin Chesnut: A Biography*. Baton Rouge: Louisiana State University Press, 1981.

Mussett, L. *The Bayeux Tapestry*. Nantes, France: Artaud Freres Publication, n.d.

Myerson, Joel and Daniel Shealy eds. *The Selected Letters of Louisa May Alcott*. Boston: Little, Brown and Co., 1987.

O'Brian, Patrick. *The Far Side of the World*. New York: W.W. Norton & Co., 1992. First published by William Collins Sons & Co. Ltd, 1984.

Oden, Jr., Robert A. *The Bible Without Theology: The Theological Tradition and Alternatives to It*. New York: Harper & Row, 1987.

Otto, Whitney. *How to Make an American Quilt*. New York: Villard Books, 1991.

Pagels, Elaine. *Adam, Eve, and the Serpent*. New York: Random House, 1989.

——. *The Gnostic Gospels*. New York: Random House, 1979.

Park, Christine and Caroline Heaton eds. *Close Company: Stories of Mothers and Daughters*. New York: Ticknor & Fields, 1989.

Patterson, Katherine. *Lyddie*. New York: Dutton, 1991.

Pelikan, Jaroslav. *Mary Through the Centuries: Her Place in the History of Culture*. New Haven, Conn.: Yale University Press, 1996.

Perrot, Philippe. *Fashioning the Bourgeoisie: A History of Clothing in the Nineteenth Century*. Trans. by Richard Bienvenu. Princeton: Princeton University Press, 1996.

Pinto, Vivande Sola. *William Blake*. New York: Schocken Books, 1965.

Plumb, J.H. *The Italian Renaissance*. New York: American Heritage Press, 1985. First published, 1961.

Power, Eileen. *Medieval People*. New York: Barnes & Noble Books/Harper & Row Publishers, 1963. First published by Methuen & Co., 1924.

Prelinger, Elizabeth. *Käthe Kollwitz*. New Haven, Conn.: Yale University Press, 1992.

Pyron, Darden Asbury. *Southern Daughter: the Life of Margaret Mitchell.* New York: Oxford University Press, 1991.

Quindlen, Anna. *One True Thing.* New York: Random House, 1994.

Renard, G. and G. Weulersse. *Life and Work in Modern Europe.* New York: Barnes & Noble Inc., 1968.

Reston, Jr., James. *Galileo: A Life.* New York: HarperCollins Publishers, 1994.

Risselin-Steenebrugen, M. *The Lace Collection.* Bruxelles: Musees Royaux D'Art Et D'Histoire, 1978.

Ross, Steven T. *Historical Dictionary of the Wars of the French Revolution.* Latham, MD: Scarecrow Press, 1998.

Rothstein, Natalie. *Woven Textile Design in Britain to 1750: The Victoria & Albert Museum's Textile Collection.* New York: Canopy Books, 1994.

Rowen, Herbert H., ed. *Sources in Western Civilization,* vol. VIII. *The Eighteenth Century.* George Rude, ed. New York: The Free Press, 1965.

Rutschowscaya, Marie-Helene. *Coptic Fabrics.* Paris: Adam Biro, 1990.

Rutt, Richard. *A History of Hand Knitting.* Loveland, Colorado: Interweave Press, 1989.

Saurat, Denis, ed. *William Blake: Selected Poems.* London: Westhouse, 1947.

Schama, Simon. *Citizens: A Chronicle of the French Revolution.* New York: Random House, 1989.

Scheid, John and Jesper Svenbro. *The Craft of Zeus: Myths of Weaving and Fabric.* Cambridge, Mass.: Harvard University Press, 1996.

Schmiechen, James A. *Sweated Industries and Sweated Labor: The London Clothing Trades, 1860-1914.* Urbana: University of Illinois Press, 1984.

Scott, Philippa. *The Book of Silk.* London: Thames and Hudson, Inc., 1993.

Shepherd, William R. *Historical Atlas.* Pikesville, Md.: The Colonial Offset Co., Inc., Eighth Edition, 1956. Seventh Edition, 1929.

Showalter, Elaine. *Sister's Choice.* Oxford: Clarendon Press, 1991.

Sinden, Margaret, ed. *Gerhart Hauptmann: The Prose Plays.* New York: Russell & Russell, 1957.

Smith, Lacey Baldwin. *This Realm of England: 1399-1688.* Second Edition. Lexington, Mass.: D.C. Heath and Co., 1971.

Spring, Christopher and Julie Hudson. *North African Textiles.* Washington, D.C.: Smithsonian Institution Press, 1995.

Staniland, Kay. *Medieval Craftsmen: Embroiderers.* Toronto: University of Toronto Press, 1991.

Steele, Valerie. *Paris Fashion: A Cultural History.* New York: Oxford University Press, 1988.

Steffens, Lincoln. *Autobiography.* New York: Harcourt, Brace and Co., Inc., 1931.

Stein, Leon. *The Triangle Fire.* New York: J.B. Lippincott Company, 1962.

Stenton, Sir Frank. *The Bayeux Tapestry: A Comprehensive Survey.* London: Phaidon Publishers, Inc., 1957.

Stephenson, Carl. *Medieval History: Europe from the Second to the Sixteenth Century.* New York: Harper & Brothers Publishers, 1943. First published, 1935.

Synge, Lanto. *Antique Needlework*. Poole, Dorset: Blandford Press, 1982.

Tharp, Louise Hall. *The Peabody Sisters of Salem*. New York: Book-of-the-Month Club, Inc., 1980. First published by Boston: Little, Brown, 1950.

Tilly, Louise A., and Joan W. Scott. *Women, Work, & Family*. New York: Routledge, 1989. First published by Holt, Rinehart and Winston, 1978.

Tolstoy, Leo. *War and Peace*. Trans. by Louise and Aylmer Maude. New York: Simon & Schuster, 1958.

Trapp, J.B., John Hollander, Frank Kermode, and Martin Price eds. *The Oxford Anthology of English Literature*, vol. I. New York: Oxford University Press, 1973.

Tuchman, Barbara W. *A Distant Mirror: The Calamitous 14th Century*. New York: Alfred A. Knopf, 1978.

Turbin, Carole. *Working Women of Collar City: Gender, Class, and Community in Troy, New York, 1864–86*. Urbana, Illinois: University of Illinois Press, 1992.

Updike, John. "The Blessed Man of Boston, My Grandmother's Thimble, and Fanning Island," in *The New Yorker* January 13, 1962; pp. 28–33.

van der Elst, Baron Joseph. *The Last Flowering of the Middle Ages*. Garden City, New York: Doubleday & Company, Inc. 1946.

Vermeule, Emily. *Greece in the Bronze Age*. Chicago: University of Chicago Press, 1972.

von Arnim, Elizabeth. *Elizabeth and her German Garden*. London: Virago Press Limited, 1985. First published in Great Britain by Macmillan & Company, Ltd., 1898.

Walker, Joseph E. *Hopewell Village: The Dynamics of a Nineteenth Century Iron-Making Community*. Philadelphia: University of Pennsylvania Press, 1974. First published, 1966.

Walker, Richard. *Saville Row: An Illustrated History*. New York: Rizzoli, 1988.

Walton, Perry. *The Story of Textiles*. New York: Tudor Publishing Co., 1936. First published, 1925.

Waterhouse, Mary E., trans. *Beowulf in Modern English: A Translation in Blank Verse*. Cambridge, England: Bowes and Bowes, 1949.

Weiner, Annette B. and Jane Schneider eds. *Cloth and Human Experience*. Washington: Smithsonian Institution Press, 1989.

Weissman, Judith Reiter and Wendy Lavitt. *Labors of Love: America's Textiles and Needlework, 1650-1930*. New York: Alfred A. Knopf, 1987.

West, Cornell. *Race Matters*. Boston: Beacon Press, 1993.

Wharton, Edith. *Novellas and Other Writings*. New York: The Library of America, 1990.

——. *The Age of Innocence*. New York: Macmillan Pub. Co., 1992. First published by D. Appleton and Company, 1920.

——. *The House of Mirth*. New York: Penguin Books/Viking Penguin Inc., 1986. First published by Charles Scribner's Sons, 1905.

——. *Ethan Frome.* New York: Collier Books/ Macmillan Publishing Co., 1987. First published by Charles Scribner's Sons, 1911.

White, E.B. *Letters of E.B. White.* Collected and edited by Dorothy Lobrano Guth. New York: Perennial Library Edition/ Harper & Row, 1989.

Williams, Selma R. *Divine Rebel: The Life of Anne Marbury Hutchinson.* New York: Holt, Rinehart and Winston, 1981.

Wilson, David M. *Anglo-Saxon Art: from the Seventh Century to the Norman Conquest.* Woodstock, N.Y.: The Overlook Press, 1984.

——. *The Bayeux Tapestry.* 1st American ed. New York: Knopf, 1985.

Wilson, Kax. *A History of Textiles.* Boulder: Westview Press Inc., 1982. First published, 1979.

Wilson, Mona. *The Life of William Blake* (A New Edition), ed.by Geoffrey Keynes. Oxford: Oxford University Press, 1971

Wolff, Cynthia Griffin. *A Feast of Words: The Triumph of Edith Wharton.* New York: Oxford University Press, 1977.

Woodward, C. Vann and Elisabeth Muhlenfeld. *The Private Mary Chesnut: The Unpublished Civil War Diaries.* New York: Oxford University Press, 1984.

Woolman, Mary and Ellen McGowan. *Textiles: A Handbook for the Student and the Consumer.* New York: Macmillan, 1938.

Index

"Holy Thursday," 103
Homer, 23, 24, 27-29, 31, 33, 35,
 143
Hood, Thomas, 103, 104
Hopewell Village (Pennsylvania),
 167
House of Lords, 102
House of Mirth, The, discussion of,
 160-162
Hubble Space Telescope, 186
Hungary, 18
Hus, John, 78
Hyland, David C., 16

iconography, *See* textiles
Iliad, 24-29, 31, 35
illuminated manuscript, *See Life of St.
 Denis*
immigrants, 66, 165, 167, 168, 170
Industrial Revolution, 19, 102
Information Age, 22n. 65
Institute of Archeology (Tel Aviv),
 37n. 21
Iran, 73
Iraq, 8, 16, 73
Irish, 167, 172n. 22
Islamic, 56
Israel, 16, 18
Israelites, 7, 9, 11, 12, 50
Istanbul University (Turkey), 16
Italian Renaissance, 65, 74
Italy, 43, 46, 67
Ithaca (Greece), 29, 31, 32, 118

Jacob, 8, 9, 13, 19
Jarmo (Iraq), 16
Jesus, 3
Jews, 2, 3, 6, 11, 14
Josefov (Prague), 11
Joseph, 7-9, 54
 robe of, 26
 window at Chartres, 53
Jubilees, Book of, 3

Judeo-Christian culture, 2

Kay, John, 100
Knight of the Lion, The, 59
knights, 45, 72
knitting, 10, 132-135, 144, 168, *See
 also* Defarge, Madam
 as pastime, 136
 as source of income, 138
 by Queen Victoria, 137
 in public places, 138
knitting in wartime
 "Knit One, Pearl Two," 148
 by prisoners, 149
 by Red Cross, 148
 of sashes, 138
 of socks/stockings, 137, 139, 144
Kollwitz, Kathe, 81, 105
Kugel, James L., 2, 42n. 21

La Boheme, 162
laboring class, *See* social classes
Lachesis, 38, *See also* Fate/Fates
landowners, *See* social classes
Langland, William, 48
Latimer, Hugh, 88, 101
laundresses, 167
Lawrence, D.H., 124-127
Lawrence, Sandra, 59
leather, 47
levee en masse, women's work, 147
Lewis, R.W.B., 122
Life of St. Denis, 67-69
linen, 1, 10-12, 25, 50, 56, 58, 71,
 147
 early weaving of, 15-17
 garments, 46, 47, 49, 104, 115,
 176
Little Women, 138-140
 family tradition of sewing, 140
 necessary needlework, 139
Logan Museum (Beloit College), 15
London, 36, 71, 92, 138, 157, 158